TREASURES OF THE ROYAL PHOTOGRAPHIC SOCIETY
1839–1919

Other books by
TOM HOPKINSON

A Wise Man Foolish
A Strong Hand at the Helm
The Man Below
Mist in the Tagus
The Transitory Venus
Down the Long Slide
Love's Apprentice
The Lady and the Cut-Throat
In the Fiery Continent
South Africa
Picture Post 1938–50 (ed.)
Much Silence: The Life and Work of Meher Baba
with D. Hopkinson

TREASURES OF THE
ROYAL PHOTOGRAPHIC SOCIETY
1839–1919

chosen and introduced by
TOM HOPKINSON

FOCAL PRESS, INC

A ROYAL PHOTOGRAPHIC SOCIETY PUBLICATION

First Published in the United States, 1980
by Focal Press Inc, 10 East 40th Street, New York, NY 10016

Library of Congress Cataloging in Publication Data

Bibliography. Includes Index
Royal Photographic Society of Great Britain, London
Photograph Collection
I. Hopkinson. Henry Thomas 1905– II. Title
TR6 G72L666 779 074 02142 79–27183
ISBN 0–8038–7214–3

Printed in Great Britain

CONTENTS

INDEX OF PHOTOGRAPHS

arranged alphabetically under photographer

FOREWORD

The purpose of this book is to make the collection of photographs in the possession of The Royal Photographic Society known to a wider public in Britain, the United States and the English-speaking world. The R.P.S., founded in 1853 as the Photographic Society, is the oldest such society still in existence. Its collection of photographs is one of the richest in the world, indeed as regards nineteenth-century photography it is generally considered to be the richest. Yet despite its immense interest and value, the Collection is much less well-known, even among students of photography, than it deserves to be.

In recent years a number of small-scale exhibitions mainly at the Society's headquarters, with one or two larger ones elsewhere, have done something to remedy this. The resources of the Collection have also been drawn on freely for purposes of book illustration; but these in the main have been specialised publications concerned with the work of an individual or group, or with some particular aspect of photography. Only one book on the Collection itself has previously been published, in the 1930s, and that dealt solely with pictorial photography. This is therefore the first attempt ever made to present an impression of the Collection as a whole.

In the exceedingly difficult task of choosing a small fraction for reproduction out of so vast and varied a range of achievement, the principle I have tried to follow is the one expressed by Alfred Stieglitz in 1902, speaking at the National Arts Club, New York: 'The result is the only fair basis for judgement. It is justifiable to use any means upon a negative or paper to attain the desired end.' But though I have tried to be impartial in choice of pictures, putting questions of the 'legitimacy' or otherwise of different methods on one side, I have not considered it necessary to exclude all opinion from the text. An editor must try to be fair, but it is not necessary for him to be null, or at least no more so than he is by nature. It seems honest therefore to make plain that for me photography as an art form stands in a unique relationship to the external world and to what, for want of a truer definition, we call 'reality'.

The camera is the instrument through which the photographer perceives his/her own vision or succession of visions in the world of time-space; isolates, captures and renders them permanent. It follows that, for me, that instrument is less truly employed in realising fantasies or images which the photographer has visualised beforehand and then brought into existence through posing of figures, arrangement of objects and settings, or through darkroom manipulation. This must further imply in the photographer a readiness to respond to the flow of life and a willingness to incorporate in his work some measure of the unexpected, the so-called 'accidental', rather than seeking to control everything in accordance with his personal formula. I am therefore more naturally sympathetic to what John Grierson, one of the founders of the documentary film, called 'the drama of the doorstep' than to the contrived drama of the studio.

9

The decision as to what period the book should cover has been one of the most difficult. The Collection is magnificent from the earliest days right up to 1939, when it falls sharply away, but if the decades between the two World Wars are included, then either much work of value must be excluded or the book made larger and more costly. It was decided therefore to limit this book to the first eighty years 1839–1919, leaving the possibility of further publications open.

The pattern I have followed is to try to give an impression of the Collection, dividing its contents into categories – inevitably somewhat arbitrarily – and in general accordance with current classifications which are sometimes far from satisfactory. After doing so I have outlined briefly some of the main events in the Society's long history, before recording how the Collection came into existence.

There is one notable nineteenth-century photographer whose work is not included in this book although the Collection contains some fine examples of it, that is Eadweard Muybridge (1803–1904), the great photographer of movement in animals and humans, whose pictures give the effect of a succession of film stills. The reasons for this omission are the similarity in visual effect of so much of his work; the fact that it is in general already so well-known; and that to be shown at its best requires a different size and shape of page.

This is a book for the general reader who can enjoy great photographs for the impression they make on his eye and heart, without going deeply into questions of technique or the contentions and rivalries of different schools, whose present-day partisans appear sometimes quite as antagonistic as the original contestants. Except in so far as it has involved dealing with photographs still far from completely catalogued, this is in no sense a work of erudition, or one that asks to be dignified with the title of research. For the dates of individuals and detailed information about them I have generally made use of the work done by others to which, I trust, I have given due credit.

While working on the Collection I have constantly been aware how much had been done in cataloguing by the former Curator, Miss Gail Buckland; in organisation and preservation by Professor Margaret Harker, Hon. F.R.P.S., for long Chairman of the Collection Advisory Committee, and other helpers. I owe much to the help and advice of Miss Valerie Lloyd, to Miss Carolyn Bloore for finding particular photographs, and to Mrs Christine Miller for finding and checking references in the library. I am also particularly grateful to Professor Margaret Harker for advice as to the book's arrangement; to Mr Arthur T. Gill, Hon. F.R.P.S., for valuable corrections made to a first draft, and to Miss Elizabeth Blair in the planning and coordination. I have to thank Mr Brian Coe for checking information about George Davison.

For information about William D. Young – some of whose admirable photographs of the construction of the Uganda Railway are here reproduced for the first time – I must thank Mr Fred Jordan, Keeper of the Railway Museum in Nairobi, Mr Brian Yonge, also of Nairobi, Mr Edward Rodwell of Mombasa, Mr Kevin Patience of Dubai in the Arabian Gulf, and Mr A. T. Matson of Seaford; also the editor of the *East African Standard*, through whom I was able to make contact with these authorities on the early history of East Africa.

Finally, a tribute must be paid to Mr and Mrs J. Dudley Johnston, whose knowledge, devotion and determination over many years built up the Society's Collection from almost nothing, and who, outside the membership of the R.P.S., have received, I consider, nothing like the credit and appreciation they deserve.

Tom Hopkinson

I THE R.P.S. COLLECTION AND THE FOUNDING FATHERS

A single room of modest size houses the Permanent Collection of photographs owned and built up, mainly over the last half-century, by The Royal Photographic Society, and a second smaller room is all that is generally available for exhibitions, though if adequately displayed, the Collection could fill a succession of galleries and giving lasting delight to lovers of photography. Of the number of pictures contained it is difficult to give a precise figure, since in addition to the thousands of prints housed in boxes, metal cabinets, drawers or frames, there are hundreds, less easily numerable, in books and albums, plus thousands of paper and glass negatives; but a fairly accurate figure would be between twenty-five and thirty thousand.

In addition there are in the Museum – which is largely devoted to early apparatus, both photographic and cinematographic, much of it on loan to the Science Museum in South Kensington – numbers of 'sun pictures' and early photographs, among them three by Nicéphore Niépce (1765–1833) which are among the oldest examples of photography in existence. Many hundreds of other prints are in the Library, considered to be the most comprehensive photographic library anywhere in the world, mostly contained in books, journals, portfolios and magazines. The Library's riches can be gauged from its possession of no fewer than two complete and one incomplete sets of the limited edition of Fox Talbot's *The Pencil of Nature*, the first work ever to be illustrated with photographs and the most coveted of all photographic publications. From a much later period it also owns one complete and two incomplete series of Alfred Stieglitz's *Camera Work*, of which it has been said that the reproductions are 'often better presentations of a photographer's work than his own prints'.[1] Many of the copies in the series were donated and autographed by Stieglitz.

This book concerns itself only with about fifteen thousand or so prints from the Permanent Collection. The idea of fifteen thousand photographs, however, tends to stun the normal mind more than to enlighten, and a clearer impression may be gained from considering what is to be found there of the work of individuals, and it will be natural to begin with the 'founding fathers'.

Once photography had become accepted, if not yet fully as an art form, at least as the most convenient and practical method of producing an accurate likeness – whether of people, landscapes, works of art or architecture – photographers soon began to specialise; and though many operated with success in several fields, it is usually possible to classify their main achievement under one heading or another. But this does not apply to the founders of photography who were anxious to explore the possibilities of the new medium to the utmost, and being men of wide interests, good educational background, strong artistic sense and the scientific knowledge required in the early days of development, have left proof of their talent in so many directions as to defy classification.

When a photographer's name appears in italics, examples of his work are reproduced among the selected photographs.

William Henry Fox Talbot (1800–77), who developed the negative-positive process on which almost all subsequent photography has been based, was born at Melbury in Dorset in 1800 into a prosperous family whose home at Lacock Abbey he would one day make famous. First at Harrow and then at Cambridge University, Fox Talbot studied the classics and mathematics, the latter to such effect that he was elected a Fellow of the Royal Astronomical Society in 1822, and ten years later was admitted Fellow of the Royal Society. At Lacock Abbey where he first went to live in 1827, remaining there, apart from interludes of foreign travel, until his death fifty years later, he began those experiments on sensitised paper which he called 'photogenic drawings', perfected in 1839, and which led to the full development of his calotype process in late 1840.

Fox Talbot's range of interests was extensive even for that day, when many fields of knowledge were still so little explored that it was possible to be regarded as an expert in a variety of subjects. He had been a Member of Parliament, as a Liberal, in the first Reform Parliament. He wrote freely both in prose and verse, and was an ardent amateur artist with an excellent sense of composition. His scientific studies enabled him not merely to develop his original process but to patent, in 1852 and again in 1858, the technique of photoglyphic engraving on steel plates from which, he claimed, thousands of prints could be produced without loss of quality.[2] He was also a botanist, astronomer, Biblical scholar and archaeologist; in his fifties he applied himself increasingly to the deciphering of Assyrian inscriptions, making an impressive contribution to the study, and publishing papers in the Journals of the Royal Society of Literature and the Society of Biblical Archaeology.

As a photographer he produced landscapes, farming and domestic scenes, portraits of individuals and groups, architectural studies, reproductions of sculpture and works of art – including a photographic inventory of his collections at Lacock Abbey – and also experimented in photomicrography. In the past Fox Talbot has usually been assessed from a scientific viewpoint and his photographs regarded primarily as experiments in, for example, the camera's capacity to record perspective or the responsiveness of lenses to degrees of light and shade. Such an estimate is certainly too narrow. Some recent assessments, however, not only assign a much higher place to his pictures in their own right, but also credit him with philosophical intentions which must surely be a matter of speculation. 'Fox Talbot . . . delighted in identifying those images where nature appeared to compose itself, where the repetition and symmetry which are so characteristic of human pattern-making seem justified by nature.'[3] And the importance rightly due to him as pioneer is extended over virtually the whole range of subsequent development: 'There is very little of consequence in the later history of photography which was not, in one way or another, anticipated in the work of Fox Talbot.'[4]

Fox Talbot had been approached to become the first President of the Photographic Society on its foundation in 1853,[5] and examples of his work in the Collection range from his earliest shadowgraphs or 'photogenic drawings' through every phase of his development. The Library also contains many of his letters, books and documents, and the Museum his original cameras, among much of his other photographic equipment. From the hundreds of his prints in the Collection I have tried to select a few which, while representing his best work, are not yet over-familiar.

Roger Fenton (1819–69) is chiefly known for his photographs of the Crimean War, but his photographic achievement was extremely varied, and he also played a crucial

part in the early development of photography and its wider acceptance in Victorian England. He was the second son of a Lancashire mill-owner and banker who was also a Liberal M.P. After taking an M.A. at London University, Fenton studied art in London and later in Paris under Paul Delaroche, whose oft-quoted remark on seeing an early daguerreotype – 'From today painting is dead!' – seems likely to ensure him greater immortality than his paintings. Working in the same studio was Gustave Le Grey, like Fenton a painter – photographer, best-known for his 'Brig upon the Water' which was said to be the first successful attempt to obtain good reproduction of both elements on a single photographic plate, and caused a sensation when exhibited in 1856.[6]

Roger Fenton: self portrait

As a painter Fenton achieved no great success and after two years he returned to London, where he took up the study of the law, which he later practised as a solicitor. In 1847 he was one of the twelve amateur calotypists who founded the Photographic Club, and in 1853, having in the meantime visited Russia, he conceived the idea[7] and played a leading part in the founding of the Photographic Society, which was eventually to become the R.P.S. He was its first secretary and when he gave up the post in 1856, Robert Hunt, a member of the Council who later became a Vice-President, declared that 'the Society would never have had an existence if it had not been for Mr Fenton . . . We cannot, therefore, too strongly express our thanks to Mr Fenton for the existence of the admirable Society of which he really is the parent.'[8] Two years later, Fenton was elected a Vice-President, and remained an active member until he gave up photography altogether in 1862.

Fenton's friendly relationship with the Royal Family had a considerable effect on his work, since he was summoned a number of times by the Queen to Buckingham Palace, Windsor Castle and Balmoral, to take pictures of the family and their homes. It was also under the Queen's patronage that he went out in 1855 to Balaclava and made nearly four hundred pictures in the Crimea. Though Fenton is usually described as 'the first war photographer', these were not war photographs so much as battlefield scenes, taken after the event; or else military groups and landscapes associated with the war, and frequently posed. These were later exhibited in London before being published, first in parts and later in portfolios, by Agnews, then of Manchester, who financed the expedition.

For seven or eight years after his return from the Crimea, Fenton was active in photography, copying sculpture and other exhibits for the British Museum; making many fine landscapes and architectural studies, particularly of cathedrals and abbeys; and a quantity of those imposing compilations of fruit, flowers and ornaments described as 'Still life', which appealed almost as much to nineteenth-century Britain as to seventeenth-century Holland. In 1862 he suddenly renounced photography, had his cameras and equipment sold by auction, and returned to practise law until his death at the early age of fifty.

In view of his long and close connection with the Photographic Society it seems only natural to find in the Collection a representation of Fenton's work in all its aspects which is unrivalled in the world. Some of his pictures of the Royal Family and their attendants were unusually informal for that period and are also less well-known than his other work, so it is from these that a selection has been made.

An associate and cousin by marriage of Fox Talbot was *John Dillwyn Llewellyn* (1810–82) whose calotypes of bathers and sun-bonneted onlookers among the rocks of the Welsh Coast, made in the 1850s, are among the earliest seaside holiday pictures

13

in existence. Almost forgotten for many years, Llewellyn's work has lately become better appreciated, partly as the result of a well-researched exhibition at the Fox Talbot Museum in Lacock early in 1977. J. D. Llewellyn was on the first Council of the Photographic Society which was elected on 20 January, 1853, and continued on it until 1855. He showed pictures in the Society's exhibitions for a number of years, and a letter in the Llewellyn family papers records that 'he exhibited the first instantaneous photographs at the Photographic Society's Exhibition in London, and great excitement prevailed at Penllergare when a 'Poste Haste' message arrived asking for fresh copies of two of his four instantaneous pictures, to replace those which Queen Victoria had admired so much she insisted on carrying them off!'[9]

Llewellyn was greatly interested in natural history, and in addition to his seascapes and a number of charming groups and portraits, made many studies of foliage and plant life on a corner of his estate, often with the addition of a stuffed bird or animal, a heron, pheasant, otter or deer. These were intended, no doubt, to convey an impression of life, but their stiff limbs and glazed eyes have rather the opposite effect of making the surrounding woodland seem unreal, a problem which would not be solved until much greater camera speeds became available so that wild creatures could be pictured in their natural state.

A close associate of both Fox Talbot and Fenton was *Antoine François Jean Claudet* (1798–1867), whose daguerreotype of Fox Talbot is probably the best-known portrait of the inventor of photography. It was made about 1845, the year after Claudet acquired from Fox Talbot the right to produce calotypes in the portrait studio behind the church of St Martin's-in-the-Fields at the corner of Trafalgar Square, in which until that time he had made only daguerreotypes. Later, both Claudet and Fenton were fellow-members of the Société Française de Photographie in Paris.[10] Claudet was an unusual mixture of artist, inventor and entrepreneur, whose early business career had included banking and glass manufacture in France, and the selling of glass shades and glass sheets in High Holborn, London. His portrait business was so successful that in 1851 he established an ornate 'temple to photography' in Regent Street, which was the most imposing building of the day devoted to photography. A Fellow of the Royal Society, Claudet was an enthusiastic scientist and made a number of significant inventions and improvements, particularly in stereoscopy; he was appointed 'Photographer-in-Ordinary to the Queen', and honoured also in France and Russia. In the Collection he is represented by a number of his *cartes de visite* portraits, mainly of the Le Neve Foster family, Peter Le Neve Foster having been one of the founder members of the Photographic Society in 1853.

II PORTRAITURE

Portraiture was inevitably one of the first and principal uses to which photography was put. It is a natural human desire to seek to render permanent the impression of our loved ones as we see them at this moment, and to possess some image we can

14

carry with us. There was also a strong demand among the fast-growing middle-classes for some inexpensive means of acquiring family portraits comparable to the paintings on the walls of ancestral mansions. In this role, a contemporary journal saw photography as a powerful democratising process: 'Photographic portraiture . . . has . . . swept away many of the illiberal distinctions of rank and wealth, so that the poor man who possesses but a few shillings can command as perfect a lifelike portrait of his wife or child as Sir Thomas Lawrence painted for the most distinguished sovereigns of Europe.'[11]

Portraiture was not only a popular, but a highly profitable, branch of photography; Richard Beard, a speculator who became a photographic entrepreneur, made £40,000 – at that time a vast fortune – in a single year out of his chain of daguerreotype portrait galleries. Virtually all the pioneers of photography took portraits, but it is noticeable that those whose pictures are today the most esteemed were not professionals concerned to make a living, but had purposes of their own for which photography supplied the means.

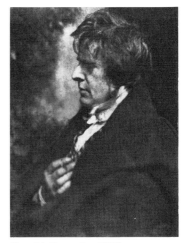

David Octavius Hill

The names of *David Octavius Hill* (1802–70) and *Robert Adamson* (1820–48) have been honoured among lovers of photography from the early 1840s, though even among them their reputation has known ups and downs, and at the time of Hill's death in 1870 he had been so far forgotten that no photographic journal made any mention of the fact. In late 1972 their names became known to a far wider public when the Royal Academy proposed to put on sale by auction three volumes of their photographs, which had been specially bound, inscribed and captioned for presentation to the Academy by D. O. Hill, shortly after the death of his young collaborator Robert Adamson in 1848. The uproar which followed led to the securing of the albums for the nation by the National Portrait Gallery, and later to the publication of three books devoted to the Hill-Adamson pictures within a period of about twelve months.

D. O. Hill was a painter of conventional landscapes and a book illustrator; he was also a capable administrator who took part in the founding of both the Scottish Academy of Painting and the National Gallery of Scotland. He turned to photography as the solution to a problem. In May 1843, when some hundreds of ministers of the Church of Scotland resigned their livings on a matter of principle, Hill resolved to commemorate their action in a huge painting which would contain their likenesses to the number of almost 500. When it was suggested to him that photography could be a help in this formidable undertaking, he got in touch with a young photographer, Robert Adamson, who had lately opened a calotype studio in Edinburgh. Hill's 'Signing of the Deed of Demission' painting was not completed until 1866, and did nothing for the artist's reputation,[12] but his generous impulse was rewarded by fame of another sort. The partnership with Adamson was a unique success, the abilities of the two men complementing each other, and before Adamson's fatal illness put an end to their work, they had made more than 1,500 calotypes in four years. In so doing they accomplished more to demonstrate the claim of photography to be accepted as an art form in its own right than all those successors who set out with a conscious intention to outdo painting. Various explanations have been given, based on such technical considerations as the length of exposure required by early lenses, but finally it remains, like all original artistic achievement, inexplicable how these two men, within five years of Fox Talbot's original invention, should have been turning out portraits, masterly in composition, deeply revealing of personality and of a

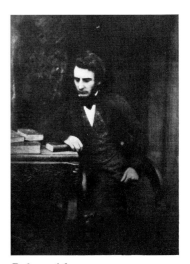

Robert Adamson

dignified simplicity which has never been surpassed. The R.P.S. Collection is extremely rich in examples of their portraits, architectural studies, landscapes, and the genre scenes they made, chiefly in Newhaven, a fishing village on the Firth of Forth. Besides their original prints, which are in varying shades of sepia, there are many of the fine photogravure prints made around 1890 by James Craig Annan. It was these prints, produced from the original calotype negatives, which caused a revival of Hill and Adamson's reputation after a lapse of some thirty years.

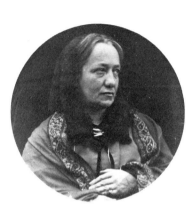

Julia Margaret Cameron by Herschel Hay Cameron

Today the name of *Julia Margaret Cameron* (1815–79) is probably the best known of all nineteenth–century portraitists. Several major exhibitions of her work in London and New York in post-war years and three books devoted to her in a single year (1975), have impressed, not only her originality and artistic sense, but something of her formidable personality on the minds of this generation a century after her death. Born in Calcutta, she was the only ill-favoured one in a family of seven sisters noted for their looks, and in her portraits she pursued beauty and nobility of feature with a passionate intensity that her sitters often found intimidating. In her early twenties she married Charles Hay Cameron, a jurist and classical scholar much older than herself; in 1848 they came to live in Putney, but it was not until fifteen years later, after they had moved to the Isle of Wight, that she found her purpose in life. Neighbours in the island at that time were Tennyson and his wife, whose presence ensured a succession of distinguished visitors. When given a large plate camera and equipment by a daughter and son-in-law in 1864, Mrs Cameron embarked on a period of intense creativity.

She had a passionate admiration of those she considered to be great, particularly poets, artists and scientists, and in the interests of her art pursued them ruthlessly. 'When I have such men before my camera,' she wrote in 1874, in her unfinished manuscript *Annals of my Glass House*, 'my whole soul has endeavoured to do its duty towards them, in recording faithfully the greatness of the inner as well as the features of the outer man.' In the next five years she took portraits of Tennyson, Browning, Longfellow, Thomas Carlyle, Charles Darwin, Holman Hunt, G. F. Watts, Anthony Trollope, and many other men of note; as well as exquisite portraits of Ellen Terry, her own niece May Prinsep and of another niece Mrs Herbert Duckworth, who later became the mother of Virginia Woolf and Vanessa Bell. She also constantly pressed into service as sitters, her own family, friends, members of her household, neighbours and villagers.

Uninterested in technical perfection, she aimed always at broad, bold effects, and her pictures aroused immediate controversy. G. F. Watts and others praised her lavishly, but photographers and the photographic press focused on her lack of technical proficiency. 'Admirable, expressive and vigorous,' was one opinion, 'but dreadfully opposed to photographic conventions and proprieties.'[13] In June 1864 Mrs Cameron became a member of the Photographic Society of London, predecessors of the R.P.S., and participated in many of their exhibitions, but was deeply disappointed when her pictures failed to win the prizes she hoped for. She was not, however, a woman to be easily done down and, it is recorded, 'even ventured into their (her critics) stronghold in this Society, and had it out with them.'[14]

After 1870 Mrs Cameron applied herself to a form of picture-making which today seems tedious and stilted, composing photographic illustrations to Tennyson's 'Idylls of the King', as well as to Biblical, Shakespearian and allegorical scenes. In

1875 she returned to Ceylon, settled down on her husband's estates, and made a number of pictures of the native workers and their families.

Despite some lack of appreciation in the past, the Society today is gloriously rich in examples of her work, possessing well over 400 of her prints – including very many variations on a single theme – many of them enlivened with her written comments and instructions or the remarks of her famous sitters. Not only is this the most complete collection of Mrs Cameron's photographs anywhere in the world, it is also the expression of a personality, noble and passionate though frequently incautious, and a visual record of a rich period in British literary, artistic and scientific life. Although it is among the best known of her pictures, I found it impossible to leave out the magnificent portrait of Sir John Herschel, the astronomer and chemist, but also include one of the less-known groups of peasants from her last years in Ceylon.

There are no portraitists who can be ranked as comparable to these until we come to the end of the century, and the American Frederick Holland Day and the Anglo-American Alvin Langdon Coburn, whose work will be considered in a later section. But *Frederick H. Hollyer* (1837–1933) made many fine portraits in the '70s and '80s, particularly of figures in the world of literature and art Thomas Annan (1829–1887) the father of James Craig Annan, is renowned for a haunting – and to judge from his expression – haunted portrait of Dr David Livingstone in 1864; and F. H. Evans, whose work was mainly architectural and will be considered in that category, for his picture of Aubrey Beardsley. Two agreeable surprises in the Collection are the portrait of Evans himself by *George Bernard Shaw* (1856–1950) who took up photography in 1898 and remained keenly interested for the remainder of his life.[15] The mount is inscribed in Shaw's highly legible handwriting: 'Just discovered among my old papers. It gives his gnome-like appearance to the life, and his characteristic attitude.' And, secondly, the portrait of Edward VII in Highland costume by *Lord Redesdale*, who was President of the Society from 1910–12.

Much excellent work was also done between 1860 and about 1900 by commercial firms with little artistic pretension, among them W. & D. Downey, Elliot and Fry, and *Maull and Polyblank*. The latter firm – which had a studio at Gracechurch Street in the City, and later moved to Piccadilly – is strongly represented in the Collection, mainly by portraits of eminent literary, theatrical, artistic and legal figures. The firm, whose prints are often distinguished by rounded upper corners, also became known at different times as Maull and Company, and Maull and Fox. The picture of Gladstone picnicking in 1893 is also the product of another well-known firm, *J. V. Valentine & Sons* of Dundee.

One name, however, deserves honourable mention not only on photographic but also on humanitarian grounds. *Dr Hugh Welch Diamond* (1809–86) had been one of the founders of the Photographic Society in 1853, and later was appointed Secretary and editor of its journal from 1858 to 1868. After some years of private practice in London – one of his patients was Frederick Scott Archer, the inventor of the wet collodion process – he became interested in mental disease and joined the staff of Bethlehem Hospital, from where in 1848 he was chosen out of ninety-nine applicants to become superintendent of the female department in the Surrey County Asylum. Here it was noted that 'in the third year from his appointment 112 patients were discharged cured, this number far exceeding in ratio any previous return.'[16] Dr Diamond formed the idea that by photographing his patients he might help other medical workers to recognise symptoms or stages of mental disease, and the fragile

fading prints of his women patients, sitting with folded hands and vacant stare, constitute a poignant record of human suffering and the desire for its alleviation.

A member of the Society of Antiquaries, Dr Diamond also took many photographs of archaeological subjects, as well as landscapes and still-lifes.

III TRAVEL PHOTOGRAPHY

During the middle of the nineteenth century, the work of watercolour painters such as David Roberts, James Holland and Edward Lear, and the engravings in such journals as the *Illustrated London News*, had opened up a tremendous demand for photographs of the Holy Land, of Greece, Italy, Egypt, and the monuments of antiquity. These were also the great days of British rule, when Britons felt they had a stake in every quarter of the globe, and when many would spend their lives in overseas territories, particularly in India. As a result of all this interest, vast profits could be made through the publication of illustrated books of travel and topography, and through the production of stereoscopic picture records for the use of scholars and historians, or for the drawing-room pastime of looking at stereoscopic views, a mild precursor of present day television, which was fashionable in the 1850s and 1860s. These productions supplied the resources which enabled adventurous photographers not merely to travel, as so many do today, but to mount massive expeditions in the style of the famous explorers.

Perhaps the best-known name in this field is that of Maxime Du Camp (1822–94), a Frenchman who travelled extensively in Egypt, Nubia, Palestine and Syria at a time when these countries were little known. The pictures he took began to appear in book form in 1851, and he enjoyed considerable success. There are a number of his original prints in the Collection; they are, however, not only more generally familiar, but also inferior in quality and interest to the work of contemporaries such as *Francis Frith* (1822–98).

A Quaker born in Derbyshire, by the time he was thirty Frith was already a successful businessman with his own printing firm. In 1856 he made the first of three photographic surveys to Egypt and the Near East, all of them highly successful, and on the third of which he went further up the valley of the Nile than any previous photographer, travelling the last part of the journey on dromedaries with a retinue of attendants. Frith worked with wet collodion plates, which presented almost insuperable difficulties in dusty surroundings and a climate of blazing heat; the collodion sometimes boiled in contact with the plate, and the close air of his darkroom tent almost suffocated him. Success added to his problems since he was obliged to take pictures three times over in different sizes – sometimes using plates as large as 16 × 20 inches – to suit different publications.

Almost inevitably under these conditions Frith worked at times too rapidly and with insufficient selectivity, but the best of his pictures of Egyptian monuments and temples have a grandeur worthy of their subjects. His photographs were published in splendid albums, original prints being lightly pasted or 'tipped in', usually with his

18

own accompanying text, to volumes which today are one of the Collection's treasures. Frith, the writer, was a long way behind Frith, the photographer; he wrote in a florid, jocose style, and on his superb picture 'The Approach to Philae', he observes: 'This is one of the few views which a photograph can render without, perhaps, greatly detracting from its artistic fame. Everybody has sketched it – many clever artists have painted it – Murray has engraved it for his *Guide*, and now, in these later days, the Sun himself condescends to pigmify it, and pop it bodily into the box which your artist provided. And it is a view which can bear all their treatment – this freedom of travellers – this robbery – above all, this unflattering picture-making, without loss of beauty or interest.'[17]

In addition to his Middle Eastern journeys and Nile voyages, Frith travelled throughout Europe, producing portfolios for most of the countries visited, and the views which he took all over Britain eventually became the mainstay of one of the world's biggest firms of postcard publishers, F. Frith and Co. of Reigate; though many pictures for this firm were also made by Francis Bedford (1816–1894).

Great as were the difficulties with which Francis Frith contended, they seem slight compared to those of his contemporary *Samuel Bourne* (1834–1912), whose glorious photographs of Indian architecture and the Indian landscape are now coming to be appreciated at their true worth after long oblivion. Bourne went out from Nottingham to Simla in 1861 and set up a photographic business with a partner. From this centre he made hundreds of pictures which later appeared in his album *Hill Stations of India*, besides photographing many notables, and then in 1863, he set off on the first of three expeditions to the Himalayas. Though extending over ten weeks and requiring thirty coolies to carry supplies and gear, this was no more than a prelude to his second in 1864, which took nine months and involved hiring more than fifty coolies to transport his photographic equipment, camp furniture and supplies. However, on his third expedition to the Higher Himalayas four years later, Bourne led a party as large as a small military expedition – eighty men, with ponies, a yak, supplies of all kinds and a flock of sheep and goats for food – up the Manirung Pass to a height of well over 18,000 ft.

Like Frith, Bourne had to contend with all the difficulties of the wet collodion process, but he had in addition to face perilous climbs, nights on glaciers, near-revolts from his hard-driven coolies, and extreme loneliness – hardships which he described in a series of articles for the *British Journal of Photography* during 1869 and 1870. But despite all difficulties, Bourne never fell into the trap of rushing his pictures, and he well deserves the tribute of a renowned present-day photographer: 'His work has a timeless perfection . . . All his prints, whether they were taken in the studio or thousands of miles out in the wilderness, are crystal-clear and with a full range of tones.'[18] It must always be difficult to select a few pictures out of hundreds to give an impression of a photographer's total achievement, but in the case of Bourne it proved almost painful because of the many, equally beautiful, which must be left out. On his return to Nottingham, Bourne went into trade, and his later years were devoted to water-colour painting; but he is little known in this field, and it is doubtful whether he made any paintings to compare with his photographs.

If Samuel Bourne's reputation suffered a long period of oblivion, another of the great traveller-photographers, fully worthy to be considered in the company of Frith and Bourne, has never enjoyed any reputation at all, and even today his unforgettable name is little known. *Captain Linnaeus Tripe* (1822–1902) was one of twelve children

of a family from Plymouth, who enlisted in the Madras Native Infantry at the age of seventeen, at a time when India was still ruled by the East India Company with its own army and courts of justice. In the eighteenth and early nineteenth centuries many army officers, particularly in the engineers, used to learn sketching so as to make accurate records of enemy positions, and in 1855 courses in photography were introduced for a similar purpose. In the same year Linnaeus Tripe, now a captain, was sent as official photographer to Burma, where he made many notable photographs. Tripe used the calotype process, with an unusually large negative, 15 × 12 inches, and sometimes added cloud effects by working slowly over the waxed paper negatives with a brush.[19]

The finest of his pictures, however, were made in the three to four years from October 1856, when Tripe was appointed Government Photographer to the Madras Presidency. During this period he travelled around Southern India compiling a magnificent photographic record of temples, forts, sculptures and views; these were then produced by the Madras Government in a series of elegant albums for Madura, Tanjore, Trichinopoly and other districts. The albums, with two volumes of stereophotographs taken in and around Madura, as well as many of his calotype negatives and his earlier Burmese pictures, are all in the R.P.S. Collection.

Almost as astonishing as Tripe's achievement is the fact that in the 1850s, less than twenty years after the invention of photography, there should have existed a government in Madras willing to appoint a fairly senior officer to the post of official photographer; provide him with the resources to travel all over the territory, making pictures whose main interest was historical and artistic; and publish the results with elegance and taste. Soon after 1859, when the British Government took over control of India from the East India Company following the Indian Mutiny, the post of Government photographer was abolished. Tripe rose rapidly to become a major and then a colonel, retiring to Plymouth in 1875 as an Honorary Major General, and he died in 1902 at the age of eighty.

With the name of *William D. Young*, whose dates have not yet been established, we pass from the less known to the virtually unknown. One of the treasures which came to light in the course of preparing this book was a thick red album of original photographs bearing the name 'William D. Young of Mombasa'. The album is undated, but it is evident that the fifty-odd photographs record an event crucial in the history of East Africa, the construction of what was originally called the Uganda Railway, later known as the East African Railway. The spot on the Athi Plain where an advance supply base was marked out in 1899 has become the great modern city and communications centre of Nairobi, and the Indians imported to construct the railway became the founders of Kenya's large Asian community. Young's hitherto unknown pictures give a vivid impression of the difficulties of the terrain and the arduous conditions endured by the labourers and engineers.

William D. Young came to Mombasa from India, where he had been a photographer with the Krishna Railway on the east coast towards the end of the century, and was employed as a freelance doing occasional work for the Uganda Railway – the first East African picture of his for which a date is known shows a group of railway officials in October 1900. Before long he had set up in business on his own, and during the years 1900–10 was operating studios both in Mombasa and Nairobi. He has been described as 'the first European professional photographer in East Africa', and achieved sufficient success to buy himself a farm in Kikuyu. In the 1920s he was

employed at the Swift Press, possibly as manager in the process department since his technical knowledge and experience was considerable.

Two photographers, each in his way unique, complete the list of those represented in the Collection who can be called 'travel photographers', as distinct from the many, often wealthy, amateurs who wandered around Europe in search of the picturesque. The first of these is *Herbert Ponting* (1871–1935), official photographer to the fatal second expedition of Captain Scott to the Antarctic in 1910–12, whose magnificent recording of the Antarctic landscape brought him world fame. The second is the *Earl of Carnarvon* (1866–1923), discoverer of the tomb of Tutankhamun, whose bromide prints strikingly convey the dusty, sunlit scene at his historic excavations.

IV ARCHITECTURE

The photographing of buildings for their architectural or archaeological interest was an important element in the work of almost all those we have been considering hitherto, with the exception of Mrs Cameron. In many pictures, of course, the architectural and landscape interest is so blended that they can be appreciated from either standpoint.

Among the pioneers, Fox Talbot showed a subtle appreciation of the effects that could be achieved with the simplest means, the angle of a wall, the overhang of a thatched roof, or the shadows between barns and outbuildings; settings into which the humans and their rustic implements seem to merge and become part. Roger Fenton, working on a larger scale, made use of sunlight and shadow on abbeys, colleges and castles to attain effects of grandeur and evoke impressions of antiquity – his visit to Russia yielding some of the most dramatic. Hill and Adamson, in addition to their portraits and genre pictures, made many architectural studies in Edinburgh, St Andrews, Linlithgow, Durham, York and elsewhere. The travel photographers Bourne and Frith concentrated quite as much on temples, forts and palaces as they did on river and mountain scenery; and for Linnaeus Tripe the historic buildings of Southern India afforded most of his finest pictures.

The achievements of these travellers in distant lands were paralleled by those of photographers at home who were attracted to churches, cloisters and cathedrals for their subjects, or else were drawn in the opposite direction to try and capture the activity of city streets. Francis Bedford was renowned both for his landscapes and architectural studies, many produced for showing in the stereoscope. In 1862 he was chosen by Queen Victoria to accompany the youthful Prince of Wales on a tour of Greece, Syria, the Mediterranean islands, Turkey and the Holy Land; nearly two hundred of his pictures later being published.

Philip H. Delamotte (1820–89) is known chiefly for his excellent pictures of the Crystal Palace at different stages of its construction. An early calotypist, he had also, like so many distinguished photographers then and now, worked and studied as an artist, and later became Professor of Drawing at King's College, London. As a young man he was commissioned by the Directors to make a weekly record of the re-

erection of the Crystal Palace, from the clearing of its new site in Sydenham to the magnificent opening ceremony on 10 June 1854, before the Queen, Prince Albert and the King of Portugal, to the accompaniment of massed bands and a choir of 1,800. Delamotte's photographs were later published in two splendid volumes.

Between 1856–65 *Valentine Blanchard* (1831–1901) made numerous 'instantaneous views', principally of London and Paris, by the wet collodion process. The flow of horse-drawn traffic and the bustle of the sidewalks were the impressions he sought to catch, and he was one of the first to appreciate that in rendering such scenes some degree of blur adds to the sense of movement, so that several of his 'instantaneous views' in the Collection look surprisingly modern for their time. Blanchard has left a lively account of himself photographing from the top of a cab, the inside of which had been fitted up as a darkroom; when a policeman approached as it was standing in Cheapside, the quick-witted cabman explained that his fare was 'a gentleman employed by the Government', and Blanchard, instead of being run in, was given full cooperation.[20]

Thirty years later, effective but uninspired impressions of the London scene were made by H. Bedford Lemère, an architectural and commercial photographer whose interest lay more in securing easily recognisable views of places of interest than in recording the flow of life. A Fellow of the R.P.S., he was also on its Council, and as late as 1941 was awarded its Hood Medal for his 'Record Photographs of London from 1884'.

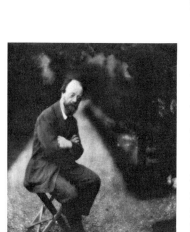

Frederick H. Evans by George Bernard Shaw

Cathedrals in Britain and on the continent of Europe were the focus of interest for *Frederick Henry Evans* (1852–1943), whose perspectives of soaring pillars, flights of steps, patches of sunlight on weathered stone floors, brought a new element into architectural photography. Evans began his working life as a bookseller at a shop in Cheapside frequented by writers and artists, among them William Morris, Bernard Shaw, and a young insurance clerk, Aubrey Beardsley, 'whom he had discovered long before the rest of the world did,'[21] and who would provide the subject for Evans' most famous portrait. Evans secured Beardsley his first assignment as an artist and accepted his drawings in payment for books; later, when he went in for private publishing, a collection of Beardsley's drawings, 'Grotesques', was among the books he produced. The success of his own magnificent series of the English cathedrals and of others in Europe, enabled Evans in his forties to give up bookselling and devote himself to photography and photographic journalism. Bernard Shaw, whose delightful portrait of him appears on the left, says that to leave the bookshop he pleaded sickness, though illness never stopped him from doing anything he really wanted, 'and the things he wanted to do and did would have worn out a navvy in three weeks'.[22]

Essentially a 'pure' photographer, he would allow no kind of retouching or manipulative process on either negative or print. Elected a Fellow of The Linked Ring in 1900 (see Section VI), he designed its photographic salon and for several years hung its exhibitions; however he remained in close contact with the R.P.S. and four of his photogravures of Lincoln Cathedral were among the first pictures to be acquired by the Collection, to which in 1924 he presented more than fifty pictures. Both his portraits and his architectural studies are well represented in the Collection, and between 1900 and 1972 the R.P.S. held four exhibitions of his work. Evans was also a prolific writer, contributing regularly to *Camera Work* from 1904–7.

In the early years of this century, *James McKissack, Arthur Marshall* of Not-

22

tingham, an architect, and J. R. H. Weaver were others who made many architectural studies in Spain and North Africa as well as at home.

The work of Alvin Langdon Coburn in London and New York, and of Alfred Stieglitz in New York and Paris, will be considered in a later section.

V 'HIGH ART' PHOTOGRAPHY

The first sentence of the first issue of the Journal of the newly-founded Photographic Society, published on 3 March, 1853, declared: 'The object of the Photographic Society is the promotion of the Art and Science of Photography . . .'

Though in this announcement 'Art' preceded 'Science', it was not long before the scientific aspects of photography were getting a good deal more emphasis in the Society's proceedings than the artistic. At the Annual General Meeting of 1856, the President, Sir Frederick Pollock, in the course of his address defined his own view on the matter: 'The Art – Gentlemen, I do not think I ought to call it an art; the real name of photography is, that it is a *practical science* . . .'[23] Four years later, at the A.G.M. of 1860, he returned to the same theme. 'I am really very impatient for the Photographic Society to do something more than merely contributing to Art – to be ancillary to Science, and from day to day more astonish the world. Gentlemen, I am very happy to say that I believe the Society is safely progressing from year to year: its communications are received, I believe, by the scientific and practical world more and more from year to year with greater confidence.'[24]

Sir Frederick Pollock's long term of office as President ran on from 1855 to 1869, and he was succeeded by James Glaisher, 'a photographic chemist, a pioneer in emulsion making, colour analysis and spectro-photography'[25], who was President from 1869 to 1892; and he in turn was followed by Sir William Abney, whose three terms of office extended, with two intervals, until 1905. His attitude was made plain in his first presidential address in which he advised his audience: 'One of the main objects, I should say *the* main object of the Society, must be to encourage the scientific aspect of Photography . . . It is the theoretical subject then that we should take up and foster in this Society. *Fiat justitia ruat coelum*, which for this occasion I should liberally translate as "stick to science though the art critics denounce".'[26]

Given the difficulties of photography in its early days and the many technical problems requiring to be solved, it was natural that there should be emphasis on science. Photography was an exacting hobby for the amateur; improvements in equipment and technique were being made all the time by individual practitioners, and the meetings of the Photographic Society provided the opportunity for acquiring information and testing out theories. From the earliest days, however, there were those whose interest in photography lay in its possibilities for artistic creation and who were by no means willing to accept that its highest purpose was to be 'ancillary to science'. Also from the very outset there had appeared an element of the allegorical and a wish to express imaginative ideas and fantasies through photographic means. Fox Talbot produced a strange picture, now in the R.P.S. Collection, in which a

23

Christlike face from an engraving appears to emerge out of a leaf. Hill and Adamson had dressed friends up in armour or in monkish robes to achieve some of the effects of contemporary painting on historical subjects, and about 1845, John Edwin Mayall of Philadelphia, and later of Regent Street, London, had made a series of daguerreotypes to illustrate the Lord's Prayer.

But now from the mid-1850s this element of the allegorical and narrative began to be stressed, and so-called 'High Art' photography achieved recognition in the work of Lake Price, O. G. Rejlander, and later of H. P. Robinson. Implicit in the title and practice of 'High Art' photography was the aim of 'raising' photography from its preoccupation with the mundane and external in order to achieve effects of the imagination which would rival those of painting. 'It is his (the photographer's) imperative duty', wrote H. P. Robinson, 'to avoid the mean, the base and the ugly, and to aim to elevate his subject. . . . A great deal can be done and very beautiful pictures made, by a mixture of the real and the artificial in a picture.'[27]

It is significant that all three men had originally been draughtsmen and painters. *William Lake Price* (1810-1896) a water-colour artist, took up photography in 1854 and quickly started to produce photographic compositions on familiar historic or literary themes much more realistic than those which were later contrived by Mrs Cameron. As a water-colourist he had been taught by Peter de Wint and also articled to A. C. Pugin,[28] from whom he may have derived his interest in architecture and interior scenes. He would certainly have been familiar with the historical paintings of a contemporary George Cattermole (1800–68), and his much greater predecessor, Richard Parkes Bonnington (1802–28) who, in addition to his exquisite land and seascapes, made many romantic-historical pictures; Lake Price's book, *A Manual of Photographic Manipulation* published in 1858, was among the first to emphasise the need to pay attention to artistic as well as technical considerations.

Oscar Gustave Rejlander (1813–75) was a Swede who studied in Rome, supporting himself by working as a painter and lithographer and by making copies of Old Masters. Having married an English girl, he settled in Wolverhampton and took up the study of photography to provide 'reference' for his own portrait painting. Before long, however, he gave up painting and started to produce photographic studies for use by other artists. Lighting and lighting effects intrigued him, as did the possibility of creating photographic 'assemblages' by multiple printing. His renowned 'Two Ways of Life', a huge moralistic fantasy, 31 by 16 inches, put together from more than thirty negatives, was produced for the Manchester Art Treasures Exhibition of 1857, in which, for the first time, photographs were to be displayed alongside the other visual arts on equal terms. Its success was instantaneous. Queen Victoria bought a copy for Prince Albert, and a writer in the photographic press commented: 'This magnificent picture, decidedly the finest photograph of its class ever produced, is intended to show of how much photography is capable . . .'[29] One may praise Rejlander's perseverance, without admiring either his artistic sense or his facile moralising on the themes of 'Industry' and 'Dissipation'.

Though he produced a few other compositions on a rather less grandiose scale, Rejlander soon abandoned this form of photography and took to making portraits, landscapes and genre pictures. Examples of his work in the R.P.S. Collection cover the whole range of his activities. There are his studio pictures of street urchins, not all falsified by his sentimentality and over-insistence on the picturesque. There are portraits and, particularly, self-portraits in various guises; nude and figure studies;

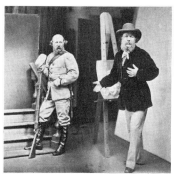

Oscar Gustave Rejlander: 'the artist Rejlander introduces the volunteer Rejlander.'

illustrations for Charles Darwin's survey *The Expression of the Emotions in Man and Animals* (1872); as well as two differing versions of his 'Two ways of Life'. Today, it would probably be true to say, Rejlander's work is esteemed in almost inverse proportion to the amount of effort he expended on it – some of his less carefully-composed street scenes show naturalness and charm, and some of his nudes a beautiful range of tones. His portrait of Gustave Doré has been arranged and lighted with effect and conveys a distinct impression of the sitter's personality.

Like Price and Rejlander, *Henry Peach Robinson* (1830–1901) had studied art and practised it; his painting was Pre-Raphaelite in style, and he had a picture in the Royal Academy of 1852. He was also an extremely prolific writer whose articles and books, *Pictorial Effect in Photography* (1869), *Picture-Making by Photography*, (1884), *The Elements of a Pictorial Photograph* (1896), exercised a dominating influence over several generations of photographers, particularly amateurs and exhibition enthusiasts. Like Rejlander, Robinson is renowned for a composite picture – what he called a 'combination photograph' – 'Fading Away' (1858) built up from five negatives. Though highly praised for its technical skill, 'Fading Away' – which shows a girl dying of consumption while her family pose in mourning attitudes – was criticised for its lack of taste, the subject being felt to be too painful. Undeterred, Robinson, by now established as a portrait photographer in Leamington, set himself to create a similar masterpiece every year and was given a standing order by Prince Albert for a copy of each one he produced. Few photographers can have made more determined efforts than Robinson to achieve the effects of painting by photographic means, and his combination of technical skill with conventional sentiment exercised an irresistible appeal for nineteenth-century viewers. His elaborately-prepared prints went the rounds of the exhibitions in Europe as well as in this country, and in thirty years he acquired more than a hundred medals.

Happily, however, there was another aspect to his work, and those who know him only through his pictorial constructions, or the assertiveness of his best-selling text-books, will be surprised by the freshness of his landscapes in which his eye for composition and knowledge of technique have been allowed to respond directly to the natural scene. The quantity of his prints and negatives owned by the Society constitute the largest such collection anywhere in the world, and were given by his son *Ralph W. Robinson* (1862–1942), himself a talented photographer on similar lines to the less affected work done by his father.

VI NATURALISTIC AND IMPRESSIONIST PHOTOGRAPHY

Just as concentration on the technical aspects had led to 'High Art' photography as a form of reaction, so the domination for nearly thirty years of 'High Art' and the ideas of its chief apostle, H. P. Robinson, led to a different kind of reaction.

Peter Henry Emerson (1856–1936) had been born in Cuba, the son of a rich plantation owner and a relation of Ralph Waldo Emerson. After some years of schooling in the United States, he came to Britain at the age of thirteen and later

qualified as a doctor, a career which he gave up on becoming passionately involved with photography. Emerson had a deep love of nature and the English countryside, particularly of the Norfolk Broads, an area in which, owing to its amphibious character and difficulty of access, many rural crafts and old ways of life still flourished. From 1882 Emerson began to take pictures on the Broads, which he exhibited with success from 1885. Emerson had an artist's eye and sensitivity, and his photographs are today highly esteemed, but he was also a difficult man, prone to fiery polemics and denunciations. His main target was H. P. Robinson, but his victims also included Turner[30] and the Pre-Raphaelites,[31] and he did not hesitate to take a powerful side-sweep at Michael Angelo.[32]

Emerson's main contentions – which he put forward in a book *Naturalistic Photography*, published in 1889 – were that photography is an art form in its own right, and that truth to nature and spontaneity of approach must be its guiding principles. Photography, he declared, 'possesses a technique more perfect than any of the arts yet treated of. . . . Its drawing is all but absolutely correct, that is if the lenses are properly used as has been shown . . . and it renders texture *perfectly*. . . . As a recorder of scientific facts and as an adjunct to the traveller, it has no equal, for nothing need be allowed for the personal equation of the individual. Its immense value in all the arts and sciences has been touched upon. . . .'[33]

Emerson's remark quoted above, 'if the lenses are properly used', was a reference to an important development in photographic technique which he had introduced. Greatly influenced by a work called *Psychological Optics* by H. von Helmholtz, he put forward the theory that the eye does not see a whole scene with equal clarity; the centre of its field of vision is sharply defined, but objects towards the periphery are blurred. In order to produce a similar effect in his pictures, a photographer should make use of differential focusing . . . 'the principal object in the picture must be fairly sharp, *just as sharp as the eye sees it, and no sharper*; but everything else, and all other planes of the picture, must be subdued, so that the resulting print shall give an impression to the eye as nearly identical as possible to the impression given by the natural scene.'[34] Acting on this principle Emerson made many beautiful photographs of natural scenes, which today are more highly valued than perhaps they have ever been.

Emerson, however, was as volatile as he was controversial, and in the following year, December 1890, partly under the influence of his friend, Whistler, and partly enraged by the success of 'Impressionistic Photography' and its leading exponent, George Davison, he recanted in a black-bordered pamphlet 'The Death of Naturalistic Photography.' 'In the fullness of my heart I dreamed a dream. I thought art might be taught by writing. I was wrong, I confess. I, even I, 'the lover of nature', – everyone is that now – preached that all art that did not conform to 'truth to nature' principle was bad – that was a fatal sermon to many. From this followed again the idea – mistaken, alas! – that photography *pure* – (not impure, on rough paper, touched up by clumsy hands) – was an art surpassing all black and white methods. Eheu! That this was ever believed!"[35]

Emerson's relations with the Photographic Society were as changeable as his opinions and he was elected to the Council in 1886, but resigned in 1890. Only a year later, however, he rejoined, and in 1895 was awarded the Society's Progress Medal for 'work in the advancement of artistic photography.' Having inveighed passionately against the awarding of medals – 'In our opinion all medals should be done

away with . . .' he took in later years to awarding his own medals, some posthumously to Hill and Adamson, Mrs Cameron and others, and some to living photographers, including Stieglitz and Brassai. However the contradictions of his life and writings have in the long run mattered little; his achievement was to bring photography back into a true path, provide inspiration to a number of successors, and leave behind several books of photographs which of their own type have never been surpassed. Among these are 'Life and Landscape on the Norfolk Broads' with T. F. Goodall (1886), 'Pictures of East Anglian Life' (1888), 'Wild Life on a Tidal Water', also with T. F. Goodall, (1890), and 'Marsh Leaves' (1895), the detail in the large plates being beautifully reproduced by platinotype and photogravure.

Towards the end of his recantation pamphlet, 'The Death of Naturalistic Photography', Emerson aimed some pointed shafts at a fellow member of the Photographic Society, *George Davison* (1856–1930), describing him as 'an amateur without training and with superficial knowledge. . . . He is now welcome to my cast-off clothes if he likes.'[36] Davison, a civil servant who later went into business, had been a follower and a defender of Emerson's views. Stimulated by his theories and by the first exhibition of French Impressionist paintings in London in 1889, he produced by means of a pinhole camera, a photograph having great depth and softness of focus throughout. This had no central area of sharpness such as Emerson recommended but gave much the effect of an Impressionist painting made with monochrome washes. Originally entitled 'The Old Farmstead' and later renamed 'The Onion Field,' it brought him immediate acclaim on its appearance in the Photographic Society's Annual Exhibition for 1890. This success and a lecture on 'Impressionism in Photography' which he gave the same year to the Royal Society of Arts, established Davison as a leading figure in 'Impressionist Photography' and aroused the spleen of Emerson who, in denouncing him, also ridiculed impressionism and impressionist as, ' "A term consecrate to charlatans", and especially to photographic impostors, pickpockets, parasites and vanity intoxicated amateurs.'[37]

As a photographer, Davison's interest lay chiefly in the countryside and the laborious life of the farmworker, but he was also an astute businessman who in 1900 became managing director of Kodak Ltd., in charge of the American parent corporation's European interests. After his retirement in 1908, he dabbled in anarchism and other subversive doctrines, though his investments in the Kodak company had already made him a man of wealth, and he retired to the mansion he had built for himself at Harlech in North Wales from which he continued to encourage 'freethinking' in all its aspects. In short, he was something of a Renaissance figure, possessing talents both for art and self-enrichment who, having raised himself to the level of a tycoon, was able to find the peasantry picturesque and the activity of revolutionaries stimulating.

Besides being a member of the Photographic Society, Davison was also a member of the Council and an exhibition judge. The Collection includes many examples of his work, including several prints of 'The Onion Field' and a number of versions of Harlech Castle. Most of these are gravure prints, but there is also a print on silk; the photograph 'Berkshire Teams', here reproduced, was presented by Paul Martin.

The hostility between Emerson and Davison, followed by a dispute over the hanging of pictures at the Photographic Society's annual exhibition of 1891,[38] triggered off an event which had dramatic consequences. A number of members of the Society walked out and set up their own organisation known as The Linked Ring,

among whose members were some of the best-known names, George Davison, Frederick Hollyer, Henry Peach Robinson and his son Ralph, Frank Sutcliffe, Alexander Keighley, Lyddell Sawyer. Their manifesto declared that the Ring had been founded 'as a means of bringing together those who are interested in the development of the highest form of Art of which Photography is capable'. Underlying their action was the dissatisfaction already referred to, felt by those who considered themselves 'artist photographers', at the domination hitherto exercised over the proceedings of the Photographic Society by members whose interests were scientific and technical.

There was also a question of status in relation to the outside world. The 1880s had seen the introduction of cheap, hand cameras, using dry plates and not difficult to manage, with the result that photography, which had hitherto required an expertise only attainable by the professional or the educated amateur, had rapidly become a pastime for the masses; and since 'anyone could now take a picture', those with special interest or ability felt impelled to introduce techniques and methods which would be beyond the reach of 'snapshotters'.

New ideas and new possibilities – no less than old enmities and rivalries – seemed to call for a new organisation through which they could be expressed, and The Linked Ring was felt by its founders to be the answer.

VII PICTORIALISM

The Linked Ring was set up during the spring of 1892, following a letter sent out in April to likely sympathisers. No one could apply to join; membership was limited to those who might, from time to time, be invited, and a single blackball from an existing member or 'Link' meant exclusion. Though the ideals and intentions of the founders were serious enough, a kind of jovial mateyness characterised the proceedings, which included dinners and suppers as well as discussions and business meetings. Titles such as 'High Executioner' and 'Chamberlain' were assigned to members who had certain duties, and the proceedings were written up in a 'mediaeval' style which was evidently regarded as humorous. Loyalty among members was to be paramount, particularly in the matter of sending pictures to The Linked Ring Salons in preference to other exhibitions.

The first steps in a general movement of secession had been taken in London, but new ideas both in painting and photography were fermenting throughout the western world, and it was not long before the Linked Ring Brotherhood had extended its influence to like-minded groups in Europe, notably in Vienna, Paris, Brussels and Hamburg, as well as in New York. British photographers showed their pictures in 'secessionist' exhibitions abroad, where in general they received high praise, and some leading members of European groups were invited to become members of The Linked Ring in London. Inevitably, photographers in different countries tended to use different techniques and to be more concerned with one aspect of photography than with another, but underlying the whole secessionist movement was the de-

termination to establish photography as an art in its own right, and a conviction that 'pictorialism' – which meant concentrating on the artistic and creative aspects of photography – was the means by which this would be achieved.

An important test for the new organisation was its first public exhibition in November 1893. It had been decided to give this the name of 'Photographic Salon' to mark its difference from other exhibitions, notably those of the Photographic Society, and the difference was indeed marked. Not only had the pictures been chosen to represent the very best in pictorial photography, but – in contrast to the crowded walls and sharp competitiveness of the Photographic Society exhibitions – each one was mounted, framed and placed to show to its own best advantage. Critics welcomed the Salon; the public flocked to attend; and for fifteen years the salon maintained its position as the most important annual event for photographers throughout the world.

Of those who were active in the early days of The Linked Ring, the work of George Davison, Frederick Hollyer, Henry Peach Robinson and Ralph Robinson has already been discussed, as has also that of F. H. Evans who joined before long. Outstanding among those who have not yet been considered is *Frank Meadow Sutcliffe* (1853–1941). The son of a water-colour painter and etcher, Sutcliffe resembled Emerson in his love of nature and his devotion to a particular corner of the east coast of England; the resemblance went further, in that both concerned themselves with the semi-amphibious life of those whose work lies on the water and in boats. Sutcliffe, however, was a man of milder temperament, more constant in his opinions, and in the life of the port of Whitby and the surrounding countryside he found a wider field of more varied activity than was afforded by the Norfolk Broads. While still a young man in 1875, Sutcliffe opened a photographic studio in Whitby, remained there virtually throughout his life, and spent his last seventeen years as Curator of the Whitby Gallery and Museum. Though he took many fine portraits, it was the rich opportunities for pictorial photography afforded by the shipping and harbour life, and his own capacity to capture them, which have made him famous.

Boats putting to sea, coming home, or heeled over against the mud at low-tide, frequently photographed against the light; fishermen baiting their hooks, mending nets or sitting idly on lobster-pots; women carrying, cleaning, selling fish, or gossiping in alley ways; children playing along the shore or bathing and splashing in the harbour; these were the scenes on which Sutcliffe played endless variations. In addition to seascapes and harbour pictures, he also made many delightful photographs of the countryside and the farmworkers inland, and it is plain from these that, though objecting to 'posing', he took extreme care in the arrangement of his shots, which often carry echoes of the paintings of J. F. Millet whom he greatly admired, as well as of Corot and artists of the Barbizon School.

Sutcliffe had belonged to the Photographic Society but, disagreeing with its policies and over-emphasis on technique, left it to become a member of The Linked Ring. In doing so, his biographer records, 'he had no trouble about resigning from the P.S. because, being a practical man, he had decided years before that he had other things to spend his money on than their annual subscription.'[39] Despite these differences, Sutcliffe was made an Honorary Fellow of the R.P.S. in 1935, and the great quantity of his work now in the Collection provides practical evidence of reconciliation.

James Craig Annan (1864–1946) had been brought up in photography, for his father, Thomas Annan, was a talented professional photographer and a friend of

D. O. Hill, with whom he collaborated in making portraits of Scottish notables for his 'Deed of Demission' painting after Robert Adamson, his original collaborator, had died while still in his twenties. In 1883 the young James Annan, having studied chemistry and 'natural philosophy', went to Vienna to acquire knowledge of the newly-developed photogravure process from its inventor, and on his return became the leading British exponent. He exhibited widely, mainly photogravure prints and photo-etchings; he was a friend of the well-known etcher, D. Y. Cameron, and often accompanied him on tours abroad. Annan's portraits were not simply studio likenesses; they show the subject at work in his own surroundings as though the photographer had just happened to look in. Similarly his views give picturesque glimpses of a city or port such as a traveller might encounter through some alley or gateway in the course of his wanderings, rather than generalised impressions; Spain, in particular was a happy hunting-ground for him.

The devotion and skill with which he reproduced and helped to make known the Hill-Adamson portraits in the early 1890s has already been referred to. James Annan was elected a member of The Linked Ring in 1894 and exhibited at their salon for the next fifteen years. Between 1901 and 1914 his pictures were reproduced in five issues of *Camera Work*. In 1904 he became President of the newly-formed International Society of Pictorial Photographers, and was awarded Honorary Fellowship of the R.P.S. in 1924. There are some sixty of his pictures in the Collection, mainly scenes in Spain, Italy and Egypt, but also some of his portraits.

In the formation of The Linked Ring a leading part had been played by *A. Horsley Hinton* (1863–1908). As editor of the *Amateur Photographer*, Hinton exercised wide influence which he made use of to advocate the ideas and ideals of pictorialism. Though he employed 'combination printing' – the use of several negatives to make one picture – within the Ring he was a convinced supporter of 'straight' photography, together with Sutcliffe, F. H. Evans and Frederick Hollyer, as against those who employed manipulative processes, etching of the negative and heavy retouching of both negative and print, to achieve their effects, but he was also a man of moderate views whose influence was on the side of tolerance and cooperation. In his presidential address of November 1923, J. Dudley Johnston, founder of the Collection, paid high tribute to Hinton's work as a photographer. 'Although we must rank Davison as the first of the modern school, I think it was Horsley Hinton who has exercised the most profound influence on British landscape photography and raised it to a higher plane of imaginative vision. . . . It was not only by his work, but by his writings, that he made his influence felt, and during his comparatively brief career – 1889 to 1907 – he was the greatest force operating in the sphere of British photography.'[40] Hinton took extreme care in the production of his exhibition prints, of which there are many fine examples in the Collection.

Another member of The Linked Ring whose chief interest lay in landscape, though on different lines from Hinton's, was *Alexander Keighley* (1861–1947). He was a member of a wealthy manufacturing family coming, oddly enough, from Keighley in Yorkshire, and one of those many photographers whose early hope had been to become an artist. Able to travel as he pleased, and with a knowledge both of photographic processes and artistic techniques, he set himself to produce masterpieces to rank with academy paintings, and for over half a century turned out half-a-dozen 'camera paintings' a year, with titles such as 'My Lady's Garden' or 'Ali Baba's Cave'. In the construction of these he made use of every kind of device,

bringing in foregrounds, adding skies and employing charcoal, chalk and pencil to such an extent that it is often difficult to discern in what his original photograph consisted. Keighley had a long life and in later years, which lie outside the period of this book, made a number of beautiful and impressive landscapes by more truly photographic means. After the dispersal of the Ring, Keighley exhibited regularly at the R.P.S. annual exhibitions, and on occasion served as 'ambassador' abroad for British photographic organisations.

Of the various secession groups set up on the Continent of Europe, those of Paris and Vienna made the main contribution to photographic history. *Robert Demachy* (1859–1938), one of the founders of the Photo Club of Paris, was a banker and amateur artist, who considered that a picture should begin as an idea in the mind and be built up by degrees. The taking of a photograph, therefore, was only one step towards the realisation of an artistic goal – and a step which had at times become lost to sight by the time his goal was reached. While it is often difficult to regard his pictures as photographs, it is impossible to deny their effect, in particular the sullen sensuality of some of his nudes and female portraits. Demachy was a writer and propagandist who produced five books, over 1,000 articles on photographic subjects, and was often featured in *Camera Work*. He was made an Honorary F.R.P.S. in 1905, and the collection contains many examples of his work, an exhibition of which was held as recently as 1973.

The Camera Club of Vienna had been concerned during the 1880s to promote photography as art, and in 1891 held an exhibition confined to photographs judged solely on their artistic merit. By 1895 Austrian photographers had formed their own group, in which the most prominent members were Heinrich Kühn, Professor Hans Watzek, and Dr Hugo Henneberg. Chosen for this book, however, are two delightful gum bichromate prints by lesser-known photographers from the period immediately before the First World War – *Ricco Weber*'s 'Rainy Weather', and the Hungarian couple at a village dance by *Olga von Koncz*.

The collapse of the Ring came almost as dramatically as its original success. *Francis James Mortimer* (1874–1944) had been elected a member in 1907. He was a forceful personality who exercised much influence in the photographic world, based partly on the popularity of his own pictures and partly on his position as editor of a succession of photographic journals from 1906 till his death from enemy action in 1944; in addition, he was editor, from 1912 to 1944, of the prestigious '*Photograms of the Year*'. In 1909 Mortimer organised, in the offices of the *Amateur Photographer* of which he had then lately become editor, a 'Salon des Refusés', for pictures which had not been accepted for The Linked Ring Salon. Mortimer's venture proved successful, and the Ring, which by now had run its course, was dissolved in the following year to be replaced as a centre for the fostering of pictorial photography by the London Salon, which continues to exist.

Mortimer was an ardent yachtsman and his own photography was concerned almost solely with the sea; the technique he employed often combined a Peach Robinson build-up of negatives with the oil pigment and bromoil processes, and his results, at their best, form dramatic compositions. Most famous of all his pictures, however, was not a seascape but his 'Gateway of Goodbye', showing soldiers leaving for the front in the First World War. Mortimer joined the R.P.S. in 1904, and on his death, forty years later, had received most of the honours the Society could confer, having been President from 1940–2, and received its Progress Medal in 1944.

31

VIII THE 'AMERICAN INVASION'

Of all the groups set up in various cities in the early days of the Brotherhood, the most important proved to be that across the Atlantic, out of which before long a movement was born – the Photo-Secession founded by Alfred Stieglitz in 1902 – whose influence in photography is still felt today long after its demise.

Shortly before this happened, at the end of 1900, the work of a number of American photographers had been exhibited in London, where it caused a sensation. Alvin Langdon Coburn, writing in *Photo Era*, reported: 'This year, so say the British photographic magazines, will hereafter be known as the year of the American invasion, for at the London Salon held by the Linked Ring Society at the Dudley Gallery, Piccadilly, seventy-three out of two hundred and thirty nine of the prints, or nearly one-third of the entire exhibition, were of American origin.' [41] He went on to record that, in the pictorial section of the R.P.S. annual exhibition at the New Gallery, Regent Street, forty-four of the exhibits were American, and 'The final climax came in the announcement of an exhibition of nearly four hundred prints . . . by the 'New School of American Photographers' at the rooms of the Royal Photographic Society, 66, Russell Square, W.C.' [42] This exhibition had been organised by F. H. Day, who, incidentally, included over a hundred of his own prints.

The first public appearance of the Photo-Secession was the 1902 exhibition at the National Arts Club in New York; Stieglitz was director of the group and the photographers invited to contribute became its founder members; they included a number whose work had recently been shown in London, among them John G. Bullock, Frank Eugene, Gertrude Käsebier, Joseph T. Keiley, Edward J. Steichen and Clarence H. White. Not only a photographer of great originality and integrity, but an able administrator, editor and critic, Stieglitz was ideally suited to the task he had set himself, which was nothing less than to revitalise American photography, raise it to a new level, and do what so many others had already attempted in various ways – establish it on a par with the other visual arts. Two of the instruments he employed were a gallery, the renowned Little Galleries at 291 Fifth Avenue, later known as '291', at which the sculpture of Rodin and the paintings of Matisse, Picasso and others were exhibited alongside photographs; and the quarterly journal *Camera Work*. This he made into the most influential photographic journal in the world between 1903 and 1917 when it came to an end, having in the meantime set an unassailable standard of reproduction, put the criticism of photography – for a short time – on to a new plane, and published articles by, among others, H. G. Wells, George Bernard Shaw and Gertrude Stein.

As a photographer, *Alfred Stieglitz* (1864–1946) traversed a whole era in his own achievement. His earliest pictures were small, frequently manipulated, and he refused to have them enlarged for exhibitions or for reproduction in magazines; but he lived to become an outstanding exponent of 'straight' photography and to demonstrate its power to combine external reality with inner vision, without making use

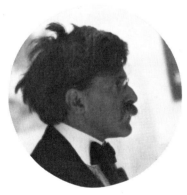

Alfred Stieglitz by Alvin Langdon Coburn

of techniques borrowed from other arts. Stieglitz was given the Progress Medal of the R.P.S. in 1924 for 'services in founding and fostering pictorial photography in America, and initiation and publication of *Camera Work*, the most artistic record of photography ever attempted.' His pictures in the R.P.S. Collection include five examples of some of his best-known works.

Edward J. Steichen (1879–1973) was another who combined artistic talent with entrepreneurial drive. A painter and lithographer in early life, he came under the influence of Stieglitz, whom he joined in the founding of the Photo-Secession and the launching of *Camera Work*, whose layout he designed. In 1922 he burned all his canvases, and in the following year became chief photographer for the American publishers, Condé Nast. He served in both World Wars and in the Second was in charge of all combat photography for the U.S. Navy, after which, from 1947 to 1962, he was Director of Photography for the Museum of Modern Art in New York. The magnificent exhibition, 'The Family of Man', which he organised in the 1950s, was seen by more than nine million people all over the world – and the author can well remember its impact in Johannesburg, the world's focal point in the racial struggle of the twentieth century.

As a photographer, Steichen's work ranged from the banal to the superb over almost every field, fashion and advertising as well as portraiture and impressionism. It is difficult to believe that the same man who took some of his early portraits and sensitive studies also took his later commonplace nudes, fashion pictures and harshly-lit shots of celebrities for *Vogue*. His pictures in the R.P.S. Collection start with platinum prints of the period 1900–4, and it is some of these which have been selected for inclusion.

The career of *Clarence H. White* (1871–1925) touched that of Stieglitz and Steichen through the Photo-Secession, but he was a being of a different, less assertive type. A book-keeper from Ohio who took up photography in 1894, he had achieved an international reputation within five years, and at the Photo-Secession exhibition of 1907 was singled out by the critic of the New York Times as 'perhaps the most gifted of them all'.[43] His pictures, usually taken against sunlight, invest scenes of domestic life with a poetic charm, and even his portraits have the air of figures encountered in a dream. A lecturer in photography at Columbia University from 1907 to 1925, he was made the first President of the Pictorial Photographers of America in 1916. Among the many examples of his work in the R.P.S. Collection is an oddity – a nude posed jointly by himself and Stieglitz.

Gertrude Käsebier (1852–1934) was yet another who had studied art, and moved from painting to photography. She opened a studio in New York in 1897, was the first woman to be elected to The Linked Ring, and one of only two women among the Photo-Secession founders. Her pictures have a romantic quality, and she contrives to blend figures with landscape or setting in a wholly natural and delightful way. Her statement, 'I have longed increasingly . . . to make likenesses that are biographies, to bring out in each photograph the essential personality that is variously called temperament, soul, humanity,' recalls the similar declaration of another great portraitist and romantic, Julia Margaret Cameron.

With *Frederick Holland Day* (1864–1933), we are back among the more-than-lifesize leaders of the 'American invasion', which indeed he organised and spear-headed. A wealthy man, who made friends of negroes and Chinese at a time when the Boston society to which he belonged would hardly admit a white from outside its

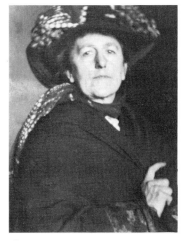

Gertrude Käsebier by Alvin Langdon Coburn

33

own narrow circle, Fred Day managed to pack a number of lives into the normal human span. He had been successful both as artist and publisher before taking up photography. A true eccentric who often wore Arab or Turkish costume, he scandalised Boston by posing men and boys in the nude to illustrate classical myths or Biblical parables. But his most daring fantasy was to reconstruct – with himself, starved and long-haired, as central figure – the last seven days in the Life of Christ, a performance culminating in a series of crucifixion photographs which drew gasps of admiration from critics in Europe and America. A few years later in 1904, Day's vast collection of prints and negatives was destroyed in a disastrous fire, whereupon he gave up photography and applied himself to the collection of antiques and the building of an island mansion. In 1917 he retired to bed, where he remained until his death. An exhibition of his work was given by the R.P.S. in 1972.

Alvin Langdon Coburn (1882–1966) was a giant among giants, a genius of photography whose work, though highly praised almost from its first appearance, has still not received full recognition. Also a Bostonian from a wealthy family, Coburn began taking photographs at the age of eight; by the time he was twenty he had made contact with noted photographers in Europe and America, and assisted F. H. Day, whose relative he was, in organising the famous London exhibition of 1900. Before he was twenty-five, Coburn, a member of the Photo-Secession and The Linked Ring, was invited by the R.P.S. to give a one-man show in London, for which George Bernard Shaw – whose portrait was included – wrote the catalogue preface.

Alvin Langdon Coburn by Frederick H. Evans

Seldom has any photographer set himself to qualify for his life's work so painstakingly as Coburn. In London as a youth he studied developing and printing; in 1903 he worked for a year in the studio of Gertrude Käsebier, before opening his own studios, first in Boston and later in New York. He studied, and was profoundly influenced by, Japanese art. Back in London, between 1906 and 1909, he went twice a week to learn the photogravure process at a School of Photo-engraving off Fleet Street, before buying and setting up printing presses at his home in Hammersmith. Much of Coburn's finest work appeared in books, for which he himself produced the photogravure illustrations. For his *London* (1909) and *New York* (1910), he succeeded in evoking a succession of luminous images of a quiet beauty, which yet remain true to the essential characters, sombre or harsh, of the two cities. In addition, for his *Men of Mark* (1913) and *More Men of Mark* (1922), he made discerning portraits of celebrities in art and literature, for some of whose works – including that of Henry James, H. G. Wells, John Masefield and Maurice Maeterlinck – he created photographic illustrations. Coburn never ceased experimenting. In 1912 he photographed 'New York from its Pinnacles', and in 1916, influenced by the vorticist painter, Wyndham Lewis, and by Ezra Pound, he made a 'vortoscope' of three connected mirrors through which he evolved vortographs, abstract patterns carrying a suggestion of infinity.

Following his marriage in 1912, Coburn left America for London, and later retired to Harlech in North Wales, a small town of steep streets near the sea where – like George Davison some years earlier – he built himself a house. During the last forty years of a long life, Coburn, though he did not abandon photography, applied himself more and more to the study of comparative religion, and then to mysticism. With the R.P.S. his connection was long and close. During his lifetime the Society held three exhibitions of his work, in 1906, 1924, 1957, and a fourth posthumously in 1973. In 1930 he made over to the Society his personal collection of over 500 prints

34

and autochromes, his vortoscope and much other rare equipment. He was made an Hon. F.R.P.S. in 1931, and became a naturalised British citizen in 1932.

Among photographers in Britain during the first twenty years of this century there are few whose work is on a level with that of the great Photo-Secessionists, apart from such as J. Craig Annan, F. H. Evans, George Davison and Frank Sutcliffe who have already been considered. Among that few is *John B. B. Wellington* (1858–1939). Wellington's business interests lay in photography for, like George Davison, he was an employee both of George Eastman in New York and of Kodak, before founding his own firm of Wellington and Ward. Though he was highly knowledgeable on the technical and scientific aspects, his interests as a photographer were pictorial. In the pompous language of a contemporary journal: '. . . not only is his name one well known in our foremost photographic societies where novel methods and niceties of procedure are learnedly discussed, not only is his name essential to the history of photography by reason of certain formulae and methods which he has given to the world, but in addition to these things he has for the last ten or fifteen years been known as a man in the front rank of pictorial workers. A drawer full of medals attest his prowess. . . .'[44] Wellington took some delightful landscapes and seaside pictures, but his most original work consists of scenes – a couple dining by candlelight, raising their glasses in a toast or studying a letter – which suggest not so much incidents from contemporary life as carefully staged tableaux in an Edwardian comedy of manners.

F. Holland Day by Alvin Langdon Coburn

The staging of scenes was carried to its extreme by a figure unique in the history of photography, *Richard Polak* (1870–1957). A Dutchman born in Rotterdam, his photographic preoccupation lay in the effort to reconstruct a particular period from the past by imitating the effects of celebrated painters such as Vermeer and De Hooch. In realising his aim, Polak went to obsessional lengths, buying an old house and filling it with seventeenth-century furniture, mantelpieces, musical instruments, globes, flagons and props of every kind. His models he dressed in clothes carefully copied from paintings or hired from theatrical costumiers. Having started to take pictures in 1912, he gave up three years later when, for reasons of health, he retired to Switzerland, but meantime he had created enough of his delicate platinum prints to compose a series *Photographs from Life in Old Dutch Costume*, which was published as a portfolio in 1923. Though this is nowhere stated in the portfolio, it would seem possible that Polak's pictures were not separate pictorial effects but scenes in some private fantasy, almost a novel in photographs, for which no story has ever come to light.

Lastly, mention should be made of *José Ortiz Echagüe* (b. 1886). A Spaniard, born in Guadalajara, Echagüe has always been associated with the R.P.S., of which he was made an Honorary Fellow, and the Collection contains a large number of his prints, one of which is included in this book. Around the beginning of this century, having trained as an army engineer, he qualified as a balloon pilot, and his earliest photographic work was military. Later in life he maintained his aeronautical and engineering interests and founded both car and aircraft manufacturing concerns. In addition he invented his own photographic printing process, 'carbondir'. As a photographer he concentrated his interest on the Spanish countryside, creating romantic compositions of village life and of sombre religious ceremonials.

IX DOCUMENTARY

So far we have been concerned with the riches of the Collection which, in terms of photographic history, of most aspects of photography and of pictorialism in particular, are unique. But there is one aspect – the documentary – in which the Collection is manifestly lacking. One reason for this is not difficult to find; during the latter part of the period from 1839–1919, British photography as a whole has not a great deal to be proud of in this field. This is surprising, because the beginning had been brave. In the photographing of social conditions, done honestly, without sentimental exaggeration but with a view to drawing public attention to harsh reality, British photographers led the way. In Henry Mayhew's great three-volume pioneering study *London Labour and the London Poor* (1851–64) a number of the illustrations are based on daguerreotypes from the studios of Richard Beard and Son. And it was another British photographer, John Thomson (1837–1921), whose beautiful Woodburytypes were used to illustrate the book *Street Life in London* (1877) which is a landmark both in photography and social history. Shortly before this, Thomas Annan (1829–87), father of James Craig Annan, had made revealing and disturbing pictures of the Glasgow slums; and in the 1870s a Birmingham local photographer named Burgoyne made an impressive record of a slum area known as 'The Gullet' which was then being demolished.

But after these, from 1880 to 1920, at a period when reformers in general were honourably active, British photography has less to offer in the social documentary field. We had no Jacob Riis (1849–1914), so stung by the squalor of immigrants in the New York sweatshops that he set himself to learn photography and, having become famous, refused high office from the President because the work he was already doing was more important. We had no Lewis Hine (1874–1940), a self-taught photographer whose pictures of child labour, taken as record and to bring about changes in the law, are now deservedly renowned for their own sake.

There is no doubt a second reason also which derives from the nature of the Society itself. Roger Fenton, on resigning office as Secretary to the Photographic Society in 1856, made a revealing statement: 'During the three years that I have been Secretary to the Society, it has grown in a manner which surpassed my utmost expectations. When we proposed to meet together as a Society, I never thought we should be more than a little comfortable body of gentlemen, meeting together to ride what I may call our hobby.'[45]

If, with this in mind, one makes a list of the themes and subjects which are strongly, indeed magnificently represented in the Permanent Collection, it would read something like this: country scenes and rustic life; the sea and seaside; architecture, particularly that of cathedrals, colleges and great cities; foreign travel, and the 'wonders of the world'; portraiture, usually of artists, men of letters or country landowners; womanly beauty and sexual charm; children at play . . . in short, the interests of a cultured and humane gentleman of leisure. And if one makes another

36

list of those which are slightly or scarcely at all represented, it would read: political life and politicians; industry, engineering, commerce; popular sport; the theatre and music-hall; news and the recording of great events; social comment and awareness of the conditions in which the overwhelming majority of the population spent their lives. John Thomson's work, for example, is represented at the R.P.S. by the copies of his books and Thomas Annan and Burgoyne are not represented at all.

When we examine the documentation of manners and customs, the cupboard is slightly less bare. Sir Benjamin Stone (1836–1914), the Member of Parliament who founded the National Photographic Record Association in 1897 and travelled all over the country photographing local worthies, traditional ceremonies, and indeed almost every vanishing aspect of town or country life, was a member of the R.P.S., which gave an exhibition of his work in 1900. But his 25,000 prints are almost all in either the British Museum or the Birmingham Public Library, not in the Collection.

Oxley Grabham (1865–1939), who was Curator of York Museum from 1905 onwards, did for his own locality much what Stone, with his far greater resources, was doing for the country as a whole. Grabham's pictures of local craftsmen posed with the tools of their trades; of public servants such as postmen, firemen and police in their uniforms; of rural activities such as rook-shooting or descending the cliffs on ropes for gulls' eggs; or of what served for entertainment, the visit of a dancing bear, afford us precious glimpses of village life as it was just within living memory.

Much better known, and a far more talented photographer, was *Paul Martin* (1864–1942), who, after training as a wood engraver, realised that with the invention of the half-tone block in 1880, his profession was doomed and four years later turned to photography.[46] Later, while depending for his livelihood on a portrait studio in Bayswater, he spent his spare time wandering around London on weekdays and Southern England at weekends with his 'Facile' camera disguised as a brown paper parcel, through which he could operate unnoticed. Paul Martin had an artist's eye and a warm sympathy for his fellowmen; he scorned posing, and has often been called 'the first candid cameraman'. Free from any sense of mission, he recorded with equal affection the mudlarking street arabs, lovers' flirtations on the beach, weekends camping on the Thames or officers preening at a military review; but his range of activity was wide enough also to take in historical events, such as the Great Frost of 1895 and the Diamond Jubilee in 1897. In addition, he made notable improvements in equipment from which he was too modest and retiring to benefit, so that he died forgotten and in poverty. The R.P.S. held an exhibition in 1896 of his 'London by Gaslight' photographs, and the Collection possesses many of his own prints and has recently been given a large collection of his negatives.

Though in general the Society was not greatly interested in news photography, and the Collection has therefore little to show in what is now known as photo-journalism, there is one splendid exception, a news photographer whose pictures are full of the drama of his time. *Horace W. Nicholls* (1867–1941) is mentioned in few standard works of reference, and it is only in recent years that his name has become familiar even to students of photography – and that chiefly for his 'Women at War' taken between 1917–1918 when he was working for the Department of Information – which, excellent as they are, form by no means the most impressive aspect of his work.

The son of an artist, trained as a young man in photography, Horace Nicholls took a post in 1892 in a Johannesburg studio, came home to marry, then returned to make

a unique coverage of the South African War from 1899 to 1901, when he returned to England.[47] The cameras of 1900 did not allow of battlefield photography, but his shots of columns winding over the dusty veldt, sailors handling guns, weary troopers resting beside their horses, or cavalry crowding into Ladysmith's main street among cattle, foot passengers and carts, give unforgettable impressions of a war in which heat and distance were two of the main hazards.

Yet more striking is his photographic reporting, completely modern in style, of great social and sporting occasions in the years just before the First World War. This was a time when class distinctions were accepted as natural, and visibly expressed both in manners and costume. These ladies in white dresses and flowered hats, sauntering with parasols or waving excitedly at the racing; top-hatted gentlemen consulting gipsy fortune-tellers, or ignoring the crowds as they settle down to a champagne luncheon in the open, summon up Ascot, Derby Day, Henley as no one again will ever see them. Nicholls was a working journalist; he wanted to sell his pictures to the *Daily Mirror*, to the *Bystander*, *Tatler* or the *Illustrated London News*, and he knew just what would appeal to each, and what might be built up into a whole page in one or other. Here and there, among the many hundreds of his photographs in the Collection, can be found 'join-ups' or montages in which he has tried out the same elements in varying combinations to suit whatever paper he had in mind.

There are two others in this field who deserve mention. *James Jarché* (1891–1965) was the chief cameraman of the *Daily Herald* in the early 1930s, and the first Fleet Street photographer to take up the miniature camera (35mm) with enthusiasm. He became chief cameraman to the magazine *Weekly Illustrated* from 1934–8, when it was absorbed into *Illustrated*, on which he held the same position till its collapse in 1957. Jarché had a talent for turning up at the critical moment and if his pictures of Winston Churchill at the 'Siege of Sydney Street', and of Blèriot just after his first Channel Crossing, lack photographic quality, they make up for it in historical interest. The clumsy retouching to be seen on his prints was generally held to be necessary in every newspaper office at that time, being carried through as a matter of course and often regardless of effect. Jarché always wished to be regarded as more than a 'mere' news photographer, and the present writer well remembers his delight on being made an F.R.P.S. In 1934 he published an autobiography under the title *People I Have Shot*.

Of the work of *William J. Day* (1854–1939) there is enough in the Collection to make it evident that his work deserves to be better known. He was the son of another photographer, Robert Day (1822–73), operating in the same area of the South Coast, where their joint work spans the best part of a century. William Day produced many fine prints of country and seaside scenes, sheepshearers, wheelwrights, holiday makers, workers repairing a damaged quay. It would seem to have been almost by accident that he also took photographs of the Titanic sailing on her first and only voyage, and of the first hydroplane to appear on a Bournemouth beach.

X THE SOCIETY AND ITS COLLECTION

Men with a strong common interest tend to form a society or club to promote that interest, and in Victorian England they did not wait for some government-sponsored agency or wealthy foundation to provide funds, but got together and launched their own organisation. Reputedly the first group inspired by interest in photography to come together in London, was the Photographic, also called the Calotype, Club started in 1847 by a dozen amateurs – most of whom later became founder members of the Photographic Society – the best-remembered today being Roger Fenton, Frederick Scott Archer, Robert Hunt, Dr Hugh W. Diamond, Peter Le Neve Foster and the club's founder P. W. Fry. Four years later, when interest in photography had much increased following the Great Exhibition of 1851 and Scott Archer's publication of the wet collodion process in the same year, the possibility opened of setting up a society of a more formal character, aiming at a wider membership. Roger Fenton, a prime mover in this, went over to Paris to study the constitution and method of operation of the Société Héliographique, the world's first photographic society, which had been founded in January 1851; and in March 1852 outlined in *The Chemist* his 'Proposal for the Formation of a Photographical Society'.[48]

Nothing could be done, however, to encourage the widespread practice of photography while Fox Talbot asserted a right to patents in other photographic processes in addition to the calotype process which was his invention, and it was not until July 1852 that, after various attempts to induce him to loosen his grip had failed, the Presidents of the Royal Academy and of the Royal Society, to which Fox Talbot belonged, applied pressure jointly and Fox Talbot consented . . . 'so far as was possible consistently with existing arrangements,'[49] which meant in effect with the exception of professional portraiture, at that time by far the most lucrative outlet.

In December of 1852, a successful exhibition was held in London, one of the first in Britain solely devoted to photography, at which the large number of 774 photographs were shown. Finally, on Thursday, 20 January 1853, a meeting took place at the Society of Arts in the Adelphi – with Sir Charles Eastlake, President of the Royal Academy as Chairman and Roger Fenton as Honorary Secretary – at which it was proposed by Sir William J. Newton, R.A., the miniature painter, and agreed after a discussion, 'That a Society be now established to be called 'The Photographic Society'.[50] Only six weeks later the first number of the *Journal of the Photographic Society* appeared with the record of the society's foundation, its rules, a report of the first Ordinary Meeting and an account of the paper read by Sir William Newton, 'Upon Photography in an Artistic View, and in its relations to the Arts'.

The members were evidently gluttons for work since they listened to two other papers on the same day. At the second meeting on 3 March, 1853, it was clearly indicated that the idea of a Permanent Collection had already been discussed, though it would prove to be another seventy years before much was done to realise it: 'The Honorary Secretary stated that a letter had been sent as a circular to all the gentlemen

who exhibited photographs at the late Exhibition of the Society of Arts, and he believed to all the Members of the Society, requesting them to contribute specimens of their art for the purpose of forming a circulating gallery, to be sent round the country, so as to diffuse the photographic information as widely as possible. No mode seemed better calculated to advance the progress of the art than that those Members who had negatives, and were able to print them, should send choice specimens to assist in the formation of a Collection for the Society of Arts.'[51]

Progress in the early years was rapid – in the first year three to four hundred members joined – and enthusiasm must have been high since an arduous programme of meetings was successfully carried through. Classes in photography were started at King's College, Strand, and a number of provincial societies sprang up. In January, 1854, only a year after its foundation, the society organised its own first exhibition of nearly 1,500 photographs at the Society of British Artists in Suffolk Street, which was visited by Queen Victoria and Prince Albert who had both already agreed to become patrons of the Society. In 1856, when Roger Fenton gave up his post, it was decided to appoint a full-time secretary – who would also be editor of the *Journal* which had now a circulation of nearly 3,000 – for a salary of £250 a year, and though over the years there were recurrent financial difficulties, the *Journal* was maintained in continuous publication.

For us today, to whom photography is an aspect of everyday life as familiar as the motorcar, it is difficult to appreciate the fervour it aroused in the pioneers; in attending meetings and taking part in the Society's discussions, members felt they were participating in a development which would go far to transform the nature of life and of society itself. At the Annual General Meeting on 7 February, 1856, the President, Sir Frederick Pollock, declared in his address: 'The uses to which photography may be applied are really as large, as extensive, as any purpose for which a society can be gathered together. The object of it is to present a perfect record of whatever is visible – of whatever light illumines and conveys to the human understanding – visible truth in any form – this you have the aid of photography to give permanence to, and to enable (we may almost say) all the world to see. . . . Whatever a photographer observes – whether in private he is viewing a specimen connected with the research of the microscope . . . whether he is beholding the monuments of art or surveying the grandest features of nature – whatever can be observed by any one, the photographer can make observable by all the world, and not merely now, but for ever. Copies can be multiplied, and whatever is discovered in one place can be diffused for the purpose of instruction over the whole world. . . . Gentlemen, I own I cannot help thinking that it will have a tendency to diffuse among all orders and classes of the community the habit of attentive and accurate observation, and I know nothing that is calculated so much to improve the mind for all purposes, and especially for all useful and practical purposes, as the habit of close, minute and accurate observation.'[52]

Four years later, at the A.G.M. of 1860 it was announced that 'A photographic library is also in progress of formation and is becoming more and more important', and in the following year that: 'Photographers accompanied the brilliant campaign in Italy by Imperial command; and the choicest and rarest works of ancient art in the Museums of this country and abroad are now, under Government orders, produced and made known to thousands by the aid of photography.'[53]

Throughout the first few decades of the Society's existence its concern with

scientific and technological development was paramount, but from about 1880 onwards this dominance was increasingly challenged by the pictorialists. And with good reason, since the entry into the field of photographic companies such as Eastman of Rochester, N.Y. had made research and development more and more a matter for big corporations and less for the private enthusiast, so that anyone seeking to make a reputation through photography found that the way must lie through the pictures he took rather than the discoveries he made. In the 1890s came the 'great secession' and the launching of The Linked Ring, whose salons for a time attracted major interest; by degrees, however, most of the seceders either came back or continued to exhibit with the Society as well as at the Salons. In 1894, the society, which had changed its name twenty years earlier to The Photographic Society of Great Britain, was incorporated to become The Royal Photographic Society of Great Britain.

At the beginning of the twentieth century, meetings – which at first had been monthly – were being held every week, and after the First World War, 'Groups' were founded to cater for special interests, the first being the Scientific and Technical founded in 1919, followed soon after by the Pictorial, and others to the number at the present time of twelve. Membership, which was around 1,000 seventy years ago, is approaching 7,000 today, and the Society has a fuller programme of activities than it has ever had, both in London, overseas, and through its nine Regional organisations. A most important achievement in the past few years has been the setting up of The National Photographic Record with the task, already achieved, of compiling a Directory listing virtually all photographic collections in Britain.

Throughout its long life, the home of the R.P.S. has always been in London, indeed in Central London. After a number of temporary arrangements, the Society established itself in No. 66 Russell Square, Bloomsbury from 1899–1909, moving to No. 35 from 1909–39. After this for many years the Society occupied an imposing mansion overlooking Hyde Park, at 16 Princes Gate. Since 1970 its home has been in 14 South Audley Street, another fine house in a central position but with serious drawbacks both from a financial and functional point of view, and it has now been decided that the Society will move its headquarters to the quieter atmosphere of Bath, where arrangements have been made to establish a National Photographic Centre in a historic building, and to embark on a programme of development, in association with the University of Bath, which will allow exhibitions and research on a scale hitherto impossible.

The Collection itself, as a vital part of the Society's activities, is a product only of the last fifty years. For though, as we have seen earlier, the idea of a Permanent Collection goes back to the 1850s, very little was done for seventy years to translate that idea into fact. The first proposal seems to have come from the Prince Consort who, in 1857, presented the Society with a number of pictures. 'The announcement was received with loud cheers, and a vote of thanks passed to his Royal Highness.' No action followed, however, and the pictures would seem to have disappeared without trace. But the Prince Consort was a persistent man, and on his visit to the Society's Exhibition at Suffolk Street in January, 1859, he suggested to the President, the Lord Chief Baron Pollock, the formation of a collection of photographs, not only pictorial but covering all the achievements of photography.

When the Prince brought the matter up yet again on a further visit, the Society at last felt obliged to take action, but shelved the problem after the usual manner of

Societies, by setting up a committee. The committee in its turn followed precedent in such cases, and did nothing. In 1861 the Prince died, and there the question of a collection seems to have rested until 1890. In that year Dr G. Lindsay Johnston read a paper in which he proposed 'A Scheme for the Formation and Establishment of a Central Institute of Photography in Connection with the Photographic Society of Great Britain.' His suggestion was to establish 'a permanent Institution like the Society of Arts, where not only could the trophies of our art be exhibited to an admiring public, but where daily instruction in every department of photography including the mechanical processes, could be given under suitable instructors, and where, moreover, as in the Royal Institution, a complete laboratory could be at the disposal of members who were desirous of pursuing original research.'

As for the necessary money, he had already 'interviewed several prominent men in the City of London, and with scarcely an exception I have had a most favourable and encouraging ear lent to me, and have received promises from several that if they saw that others would fall in with the idea they themselves would be only too willing to help.' Surely also, if the Council and Members were to make an energetic appeal to the public, they could count on the support of the press. '. . . who are depending more and more every day upon photography to illustrate their sheets.'[54] His enthusiasm led to much discussion but no result, at least as regards establishing a collection, though shortly afterwards, when the Society moved for a time into 50 Gt Russell Street in Bloomsbury, the idea of a library and museum was revived, and Dr Lindsay Johnson appointed first curator and librarian. Over the next few years it was twice suggested that medal-winning or 'representative' photographs from the annual exhibitions should be acquired to form a historic record, and in 1892 some were actually obtained and arrangements made to circulate them round affiliated photographic societies throughout the country. After four years, however, so many of the photographs were missing or damaged that the arrangements had to be wound up.

Such then was the situation in 1923 when Mr J. Dudley Johnston, the Society's newly-elected President, decided that the subject of his presidential address should be Pictorial Photography, and looked around to see what pictures were available. He found to his dismay that 'The Permanent Collection at that date consisted of about one hundred framed pictures, a few of which were hung about the house, but the majority reposed in the lumber room on the top floor.'[55]

Seven years later, now President for the second time, Dudley Johnston reported on what had been accomplished since his earlier address: 'I got the Council to appoint me Curator of Prints and, armed with this official status, I set myself to beg, borrow, and, if necessary, annex whatever I could find that ought to be included in the collection, and with so much success that in the past seven years there have been added nearly a thousand pictures . . . ranging over the whole period from the work of Niépce in 1826 to the present time, and the whole of this has not cost the Society a penny beyond some trifling amounts for railway carriage, etc.'[56]

As for what sort of pictures he acquired, those in this book offer some part of the evidence, but a few facts will also show. In 1924 when he embarked on his self-chosen task the Society possessed a single portrait by Mrs Cameron, but by 1930 when he delivered his second address, it owned 170. It had also been given the renowned collection of over two hundred prints built up by Harold Holcroft in his house at Wolverhampton, and the whole of the collection of more than 400 prints and 112 autochromes compiled by Alvin Langdon Coburn. Both of these, it is evident, were

J. Dudley Johnston by Alvin Langdon Coburn

42

handed over primarily as acts of friendship to Dudley Johnston himself and in response to his enthusiasm.

In 1953, when the R.P.S. celebrated its centenary, the Permanent Collection had increased from something over a thousand to 'upwards of 3,000 items'[57] and between 1953 and the present day that total has been multiplied five times. But it is evident that Dudley Johnston, who died in 1955 and whose widow continued to add to and care for the collection almost up to the present day, was given no more than his due in the early fifties when it was stated: 'Had there been no Dudley Johnston, there would have been no permanent collection.'[58]

NOTES

I. **The R.P.S. Collection and the Founding Fathers**
1. Beaumont Newhall, *The History of Photography from 1839 to the Present Day* (The Museum of Modern Art, 1949), p. 134.
2. *Phot. J*, 15 Jan. 1864, p. 430.
3. Ian Jeffrey. *The Real Thing. An Anthology of British Photographs 1840–1950* (Arts Council of Great Britain 1975), p. 7.
4. *Ibid.*
5. *J. Phot. Soc.*, 3 March 1853, p. 2.
6. *Ibid.* 22 Dec. 1856, p. 171.
7. *Ibid.* 15 Feb. 1861, p. 99.
8. *J. Phot. Soc.*, 21 Feb. 1856, p. 301.
9. Memoires of Thereza (Llewellyn) Maskelyn, 1923; in Llewellyn family papers. Recorded in *Dillwyn Llewellyn* by Richard Morris. Catalogue to the Fox Talbot Centenary Special Exhibition at the Fox Talbot Museum, Lacock, p. 15.
10. *Bull. de la Soc. Française de Photo.*, vol. i. 1 Jan. 1855. Quoted by Aaron Scharf, *Art and Photography* (Allen Lane The Penguin Press 1968), pp. 342–3.

II: **Portraiture**
11. *Photographic News* 18 Oct. 1861, p. 500. Quoted in H. Gernsheim, *The History of Photography* (O.U.P. 1955), p. 171.
12. Aaron Scharf, *Art and Photography*, as above, p. 52. describes it as ". . . a farrago of faces compressed into an impossible space, with confused lighting from several sources, hopelessly contradictory in scale and meagre in execution."
13. *Photographic Notes* vol. ix, (London, 1864), p. 171.
14. J. Dudley Johnston, Pres. Address to the R.P.S. (*Phot. J.*, Dec. 1923), p. 568.
15. For an account of G.B.S. acting as photographic model on his ninetieth birthday, cf. Merlyn Severn *Double Exposure* (Faber & Faber 1956), pp. 99–100.

16. Obituary in the *Richmond and Twickenham Times*, 26 June 1886, p. 3.

III: **Travel Photography**
17. Francis Frith Album *Upper Egypt and Ethiopia*. On unnumbered page foll. phot. "The Approach to Philae."
18. Cecil Beaton with Gail Buckland *The Magic Image*, (Weidenfeld and Nicolson, 1975), p. 73.
19. Information about Linnaeus Tripe comes from the notes by Miss Usha Desai to an exhibition of his work at the R.P.S., London, Feb–March 1977.

IV: **Architecture**
20. *The Photographic Quarterly*, vol. ii, 1891, p. 157.
21. George Bernard Shaw: "Evans–An Appreciation". *Camera Work*, Issue 4. October 1903, pp. 12–16.
22. *Ibid.*

V: **'High Art' Photography**
23. *J. Phot. Soc.*, 21 Feb. 1856, p. 303.
24. *Ibid.* 15 Feb. 1860, p. 146.
25. Harry Cooper *The Centenary of The R.P.S. of Great Britain* (R.P.S. London, 1953), p. 9.
26. *Photo. J.* 25 Nov. 1892, pp. 27 and 29.
27. H. P. Robinson *Pictorial Effect in Photography* (London 1869), pp. 51 and 109.
28. Derek Clifford *Collecting English Watercolours* (John Baker, London, 1970), p. 103.
29. *Photographic Notes* 28 April 1857, p. 202.

VI: **Naturalistic and Impressionist Photography**
30. P. H. Emerson *Naturalistic Photography*, 2nd ed. (London 1890), p. 74.
31. *The Photographic News*, 19 March 1886, p. 188. Report of Emerson's lecture to the Camera Club on 'Photographing, A Pictorial Art'.

32. *Ibid.* p. 187.
33. Emerson, *op. cit.*, pp. 277–8.
34. Emerson, *op. cit*, p. 150.
35. P. H. Emerson *The Death of Naturalistic Photography* (1890), p. 2.
36. P. H. Emerson, *The Death of Naturalistic Photography*, pp. 5–6.
37. *Ibid.* p. 1 footnote.
38. The complicated story is told in full in Professor Margaret Harker's *The Linked Ring*, (Heinemann, and the R.P.S., London 1979).

VII: **Pictorialism**
39. Michael Hiley *Frank Sutcliffe, Photographer of Whitby*, (Gordon Fraser, London 1974), p. 116.
40. J. Dudley Johnston, Presidential Address to The R.P.S. 6 Nov. 1923. See *Phot. J.* Dec. 1923, p. 575.

VIII: **The 'American Invasion'**
41. *Photo Era*, The American Journal of Photography, vol. vi, No. 1. Jan. 1901, p. 209.
42. *Ibid.*, p. 210.
43. Quoted by Prof. Margaret Harker in *Masterpiece*, Catalogue to Arts Council Exhibition of Treasures from the Collection of The R.P.S. 1971–2.
44. Library Series, No. 14., *The Pictorial Work of J. B. B. Wellington*, by the Editor. Included in *The Practical Photographer*, Nov. 1904.

IX: **Documentary**
45. *J. Phot. Soc.*, 21 Feb. 1856, p. 301.
46. Paul Martin *Victorian Snapshots* (Country Life, London, 1939), p. 10.
47. For facts about the life of Horace Nicholls, I am indebted to Gail Buckland, *The Magic Image*, p. 126.

X: **The Society and its Collection**
48. *The Chemist*, March 1852
49. *J. Phot. Soc.*, 3 March 1853, p. 3.
50. In 1874 became The Photographic Society of London became The Photographic Society of Great Britain. In 1894 it was changed again to The Royal Photographic Society of Great Britain.
51. *J. Phot. Soc.*, 1 April 1853, p. 13.
52. *Ibid.*, 21 Feb. 1856, p. 303.
53. *Ibid.*, 15 Feb. 1861, p. 19. The 'brilliant campaign' was France's war against Austria in 1859, which led to the end of Austrian control and the unification of Italy under the monarchy.
54. *Phot. J.*, 21 Feb. 1890, p. 100–101.
55. *Ibid.*, Dec. 1930, p. 514.
56. *Ibid.*, p. 511.
57. Harry Cooper *The Centenary of The R.P.S. of Great Britain* (R.P.S., London, 1953), p. 17.
58. Will Lynch *Permanent Collections at The Royal Photographic Society* from *Photogram of the Year, 1955.* (Iliffe, London) p. 27.

THE PHOTOGRAPHS

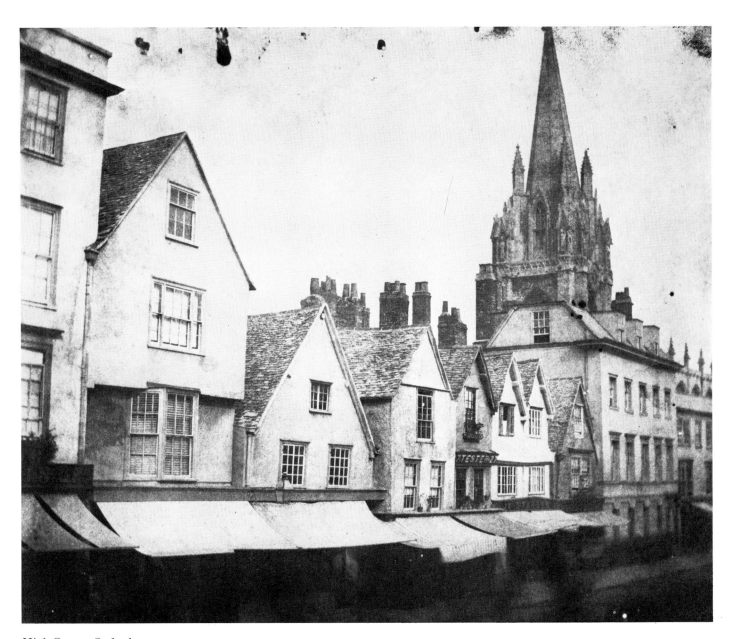

High Street, Oxford
by W. H. Fox Talbot, 1846
18.5 × 21.5cm ($7\frac{3}{8}'' \times 8\frac{1}{2}''$)

*The R.P.S. Collection contains
many of his original prints as well
as* The Pencil of Nature, *the first
book ever to be illustrated with
photographs.*

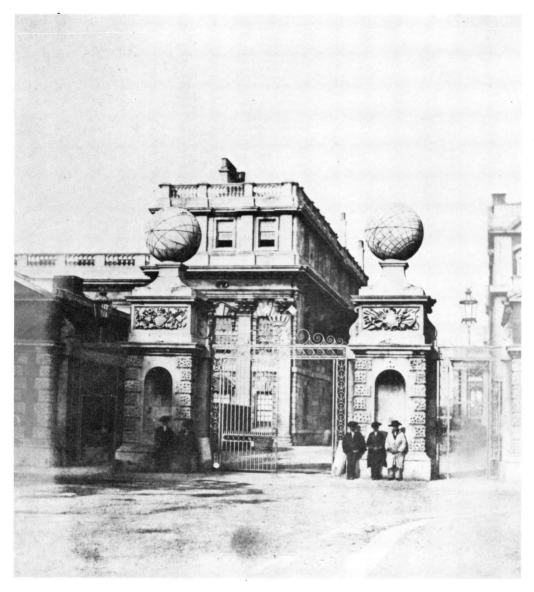

*Entrance to Greenwich
Hospital*
by W. H. Fox Talbot, 1843
18.7×17.3cm ($7\frac{3}{8}'' \times 6\frac{3}{4}''$)

*As an ardent amateur artist, Fox
Talbot had developed a strong
sense of composition, apparent
from his earliest photographs.*

Bishop's Hall Palace,
Heigham, Norwich
by W. H. Fox Talbot, 1843
16.5 × 14.5cm (6½″ × 5¾″)

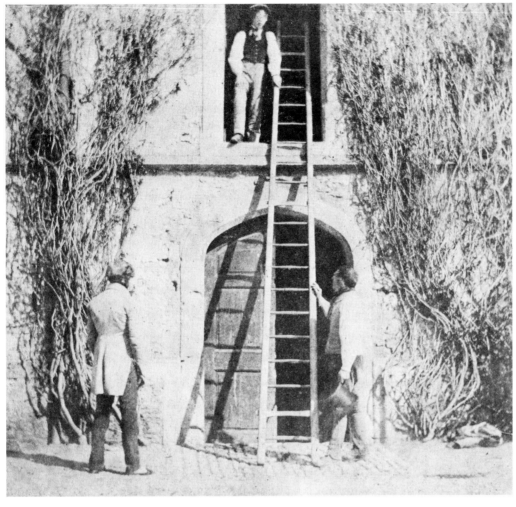

The Ladder
by W. H. Fox Talbot
17 × 14.5cm ($6\frac{3}{4}'' \times 7\frac{1}{4}''$)

Plate XIV from The Pencil of
Nature. *Nicolaas Henneman,
Talbot's assistant, is on the left.*

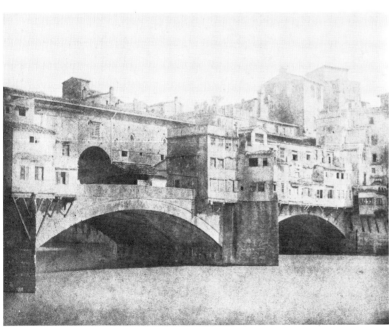

Ponte Vecchio, Florence
by W. H. Fox Talbot, 1846
16.7 × 21cm ($16\frac{3}{4}'' \times 8\frac{1}{4}''$)

49

The Chess Players
by W. H. Fox Talbot, 1846
20 × 15cm (7¾″ × 5¾″)

*Thought to have been
photographed, with other similar
studies, in the studio of Antoine
Claudet, the figure on the right.*

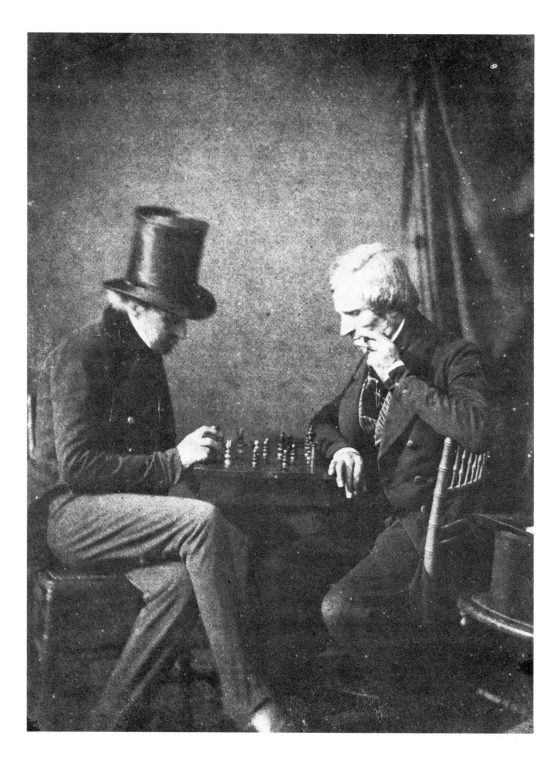

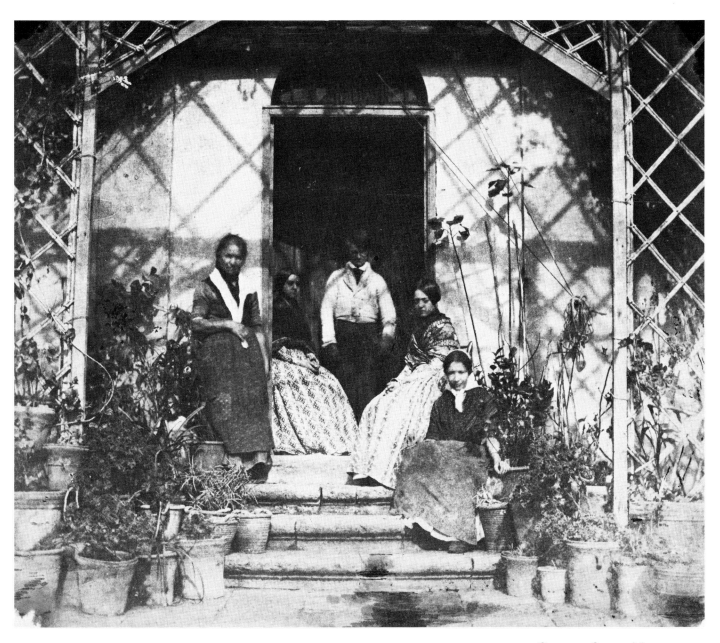

*Group on Steps with
Flowerpots*
by the Rev. G. W. Bridges,
1847
17.3 × 20.3cm (4¾″ × 7¾″)

*A pioneer of photography, he owed
much to Fox Talbot's advice and
help.*

Highland Gillies at Balmoral
by Roger Fenton
29.7 × 49cm ($11\frac{3}{4}''$ × $19\frac{1}{4}''$)

*A magnificent study of character,
made on one of Fenton's visits to
the royal home in Scotland. He
was also frequently a guest at
Buckingham Palace and Windsor
Castle.*

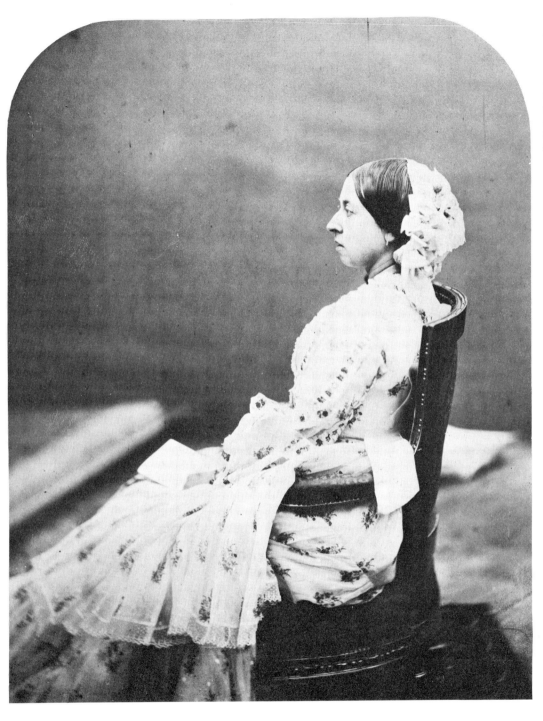

Queen Victoria in 1854
by Roger Fenton
17.3 × 13.6cm (6¾″ × 5¼″)

*Fenton established a friendly
relationship with Queen Victoria
as well as with the Prince Consort,
and it was under her patronage
that he went out to the Crimea
in 1855.*

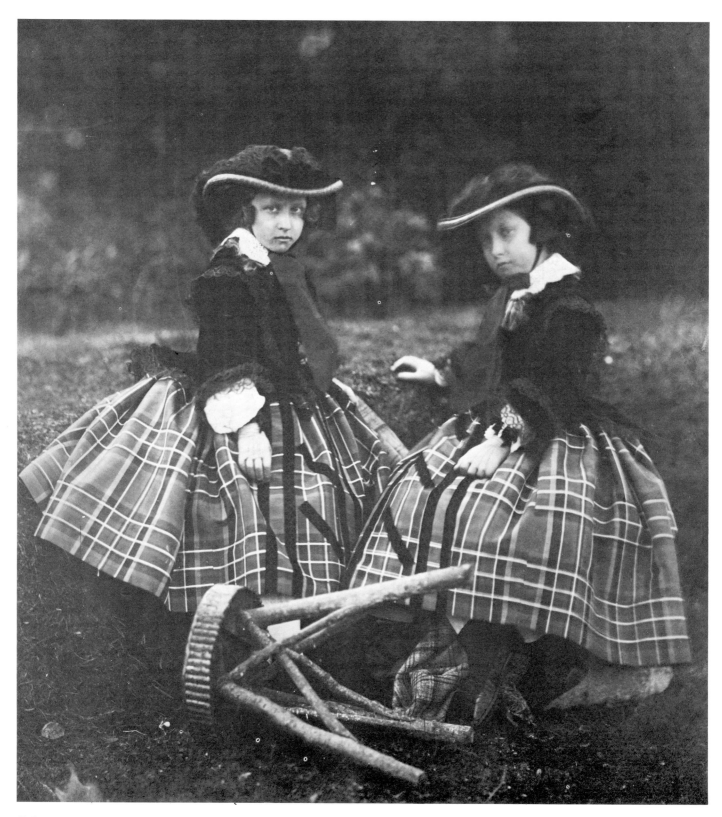

Princesses Helena and Louise
by Roger Fenton, *c.* 1854
32 × 29.2cm (12½″ × 11½″)

Portrait groups such as those
Fenton made of the royal children
were unusually natural and
informal for this period.

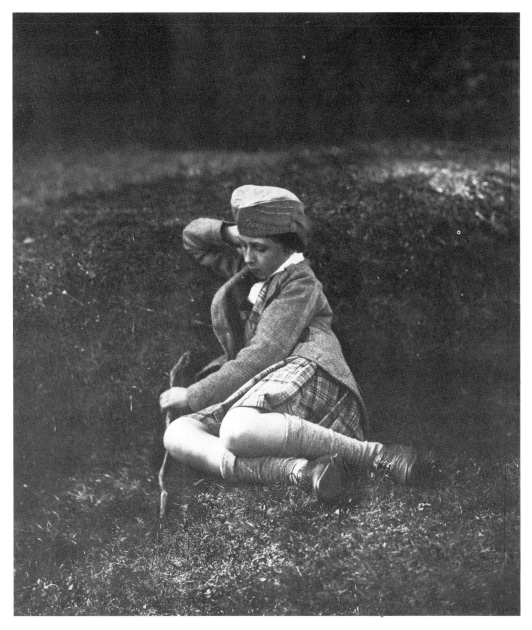

Prince Alfred, Duke of Edinburgh
by Roger Fenton, 1857
32 × 28cm (12½″ × 11″)

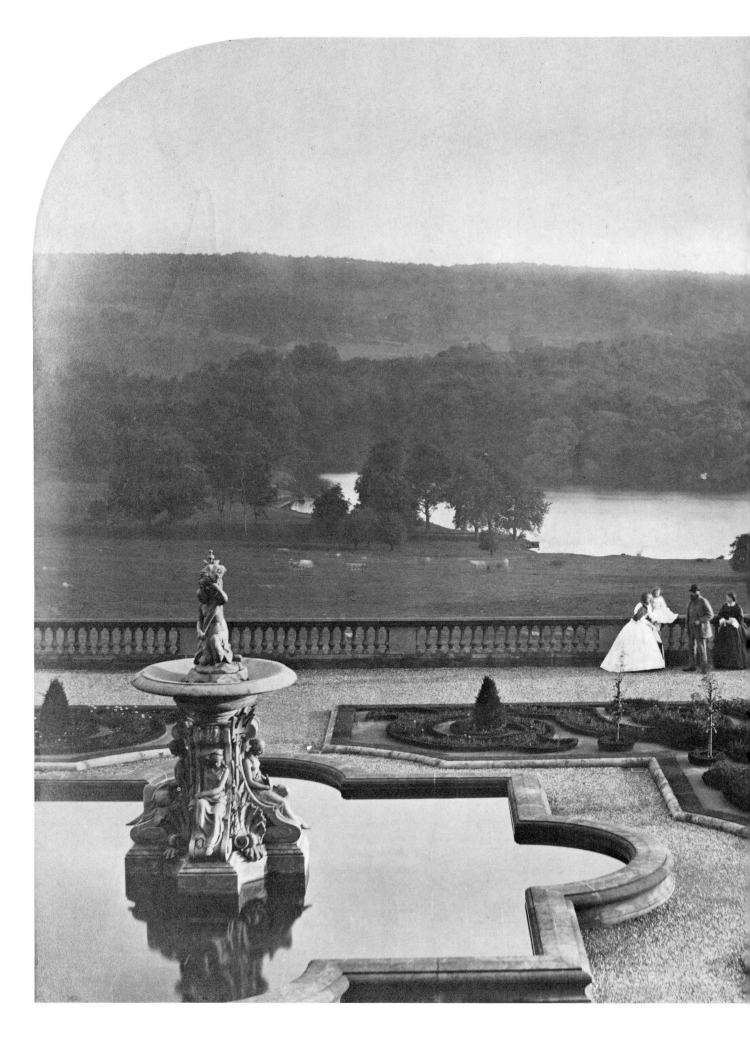

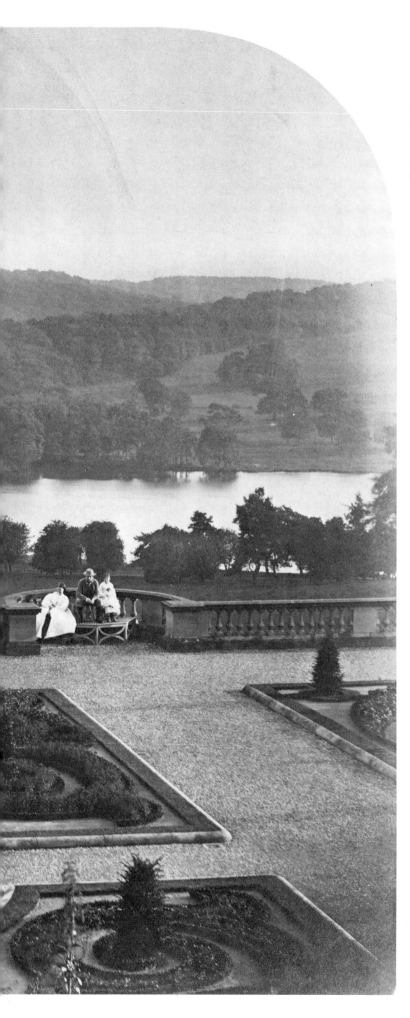

Terrace and Park, Harewood
by Roger Fenton, 1860
34 × 42.5cm (13¼″ × 16½″)

*A wonderful prospect with a
most skilful disposition of figures.
Fenton was the first secretary of
the Photographic Society (later to
become The R.P.S.), and
remained an active member till he
gave up photography altogether in
1862.*

57

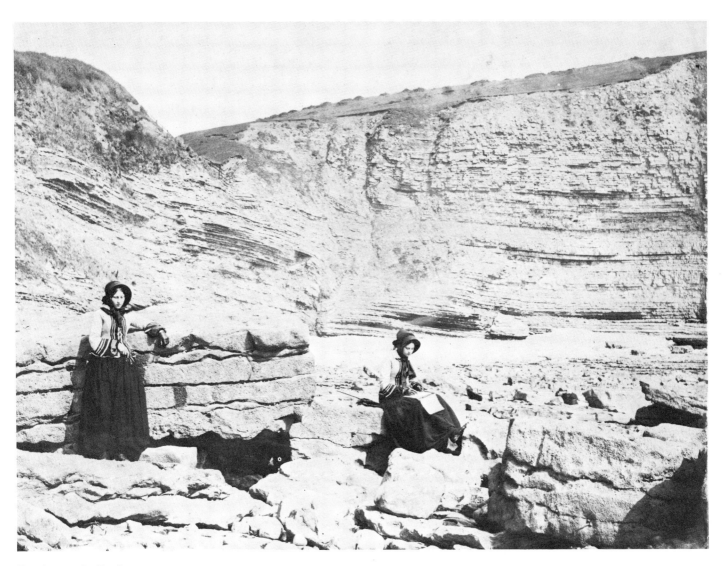

Resting on the Rocks
by John Dillwyn Llewellyn, *c.* 1852
16 × 21.5cm (6¼″ × 8½″)

This is among the earliest of seaside holiday
photographs taken on the South Wales coast by
J. D. Llewellyn, an associate and cousin by
marriage of Fox Talbot.

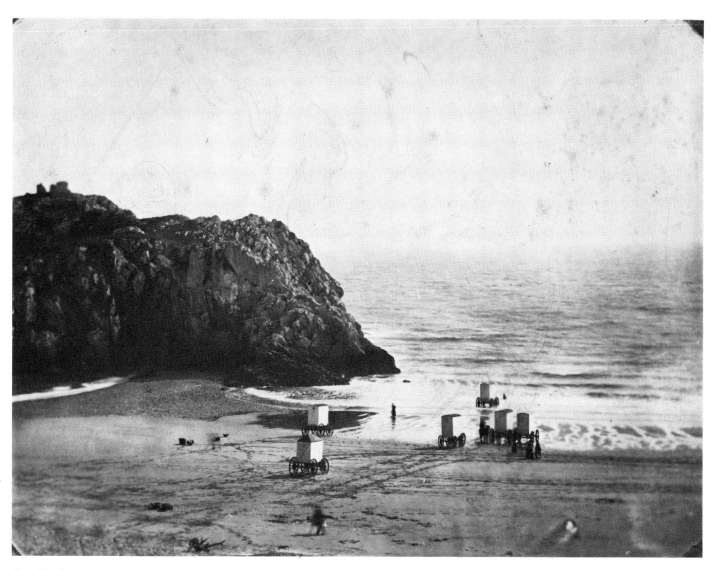

Seaside Scene
by John Dillwyn Llewellyn, 1852
16 × 21cm (6¼″ × 8¼″)

*The work of Llewellyn has become better known in
recent years since a number of his photographs
came to light in Welsh collections.*

Woman and Wreath
by John Dillwyn Llewellyn,
1852
20.5 × 15.6cm (8″ × 6″)

*Llewellyn was on the first Council
of the Photographic Society,
elected in January, 1853.*

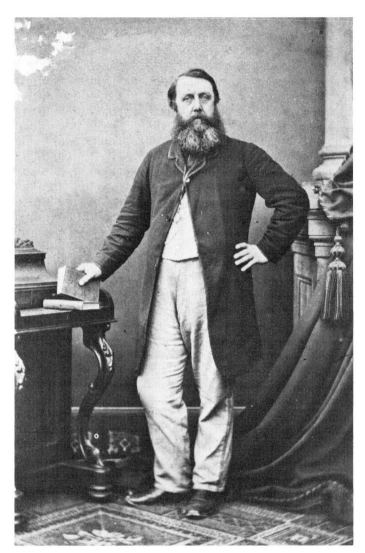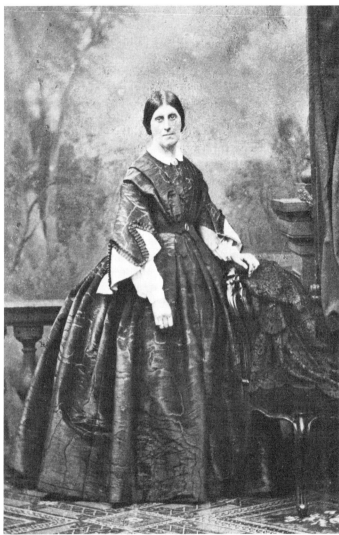

Peter le Neve Foster and Georgiana
Elizabeth le Neve Foster
by Antoine Claudet
8.4 × 5.6cm (3¼″ × 2¼″)
8.9 × 5.7cm (3½″ × 2¼″)

Two of the carte de visite *pictures made by*
Claudet at his 'temple to photography' in Regent
Street, London. Peter le Neve Foster was one of
the founder members of the Photographic Society in
1853.

Trees
by John Morgan, *c.* 1852
2.55 × 20.2cm (10″ × 8″)

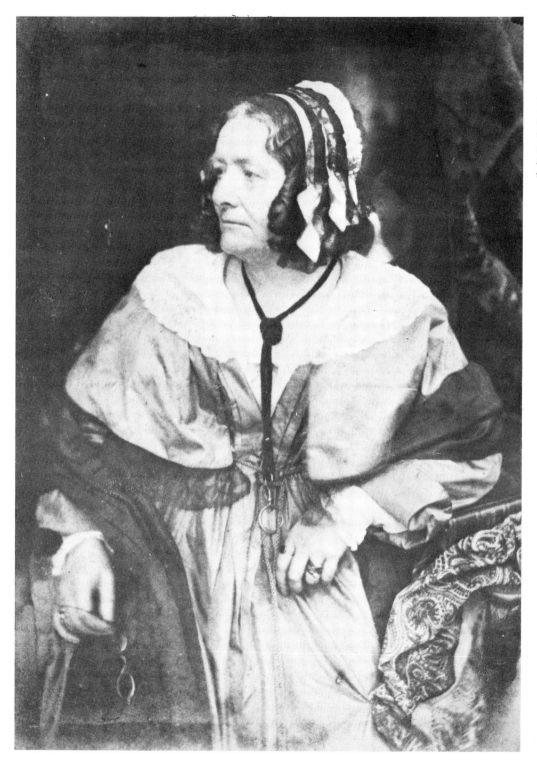

Mrs Jamieson
by D. O. Hill
19.5 × 14cm (7½″ × 5½″)

*With his colleague Robert
Adamson, Hill made more than
1,500 calotypes in four years,
before Adamson's premature death
in 1847. As studies of character
their portraits have never been
surpassed. Mrs Jamieson was a
writer and art critic.*

John Henning and Handyside Ritchie
by D. O. Hill
21 × 15.5cm (8¼″ × 6″)

Henning, who had been a carpenter, studied art and later became famous for his sculptural work based on the Parthenon frieze. Ritchie was also a sculptor, doing mainly architectural work.

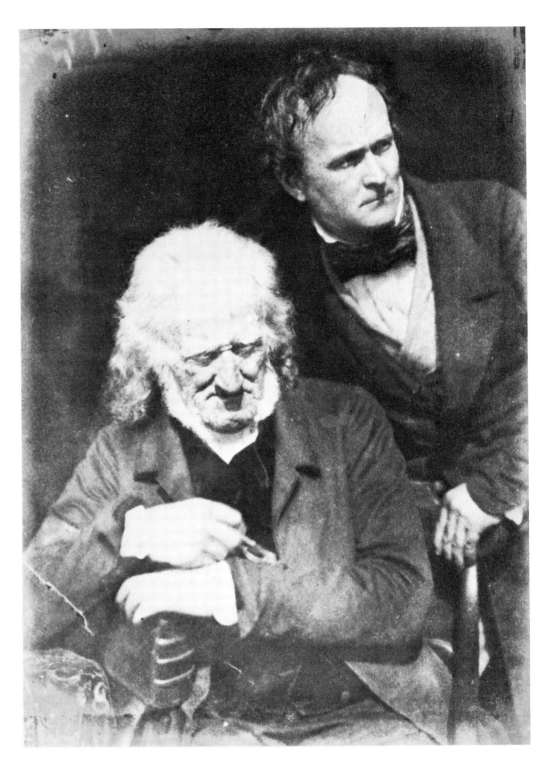

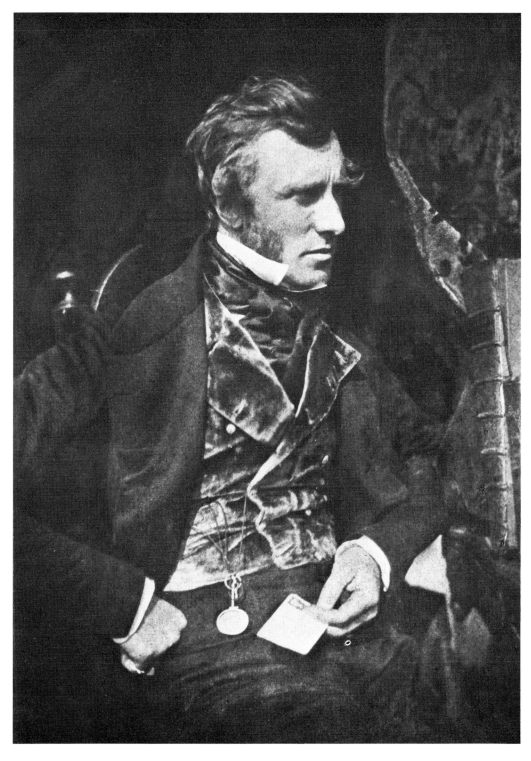

Mark Napier
by D. O. Hill
19.7 × 14.3cm (7½″ × 5½″)

Napier was a Scottish historical biographer and the author of various legal books.

Rev. T. Henshaw-Jones
by D. O. Hill
19.8 × 15.6cm (7¾″ × 6″)

This may have been intended for inclusion in Hill's vast multi-portrait 'Signing of the Deed of Demission', but it has not been identified in the painting.

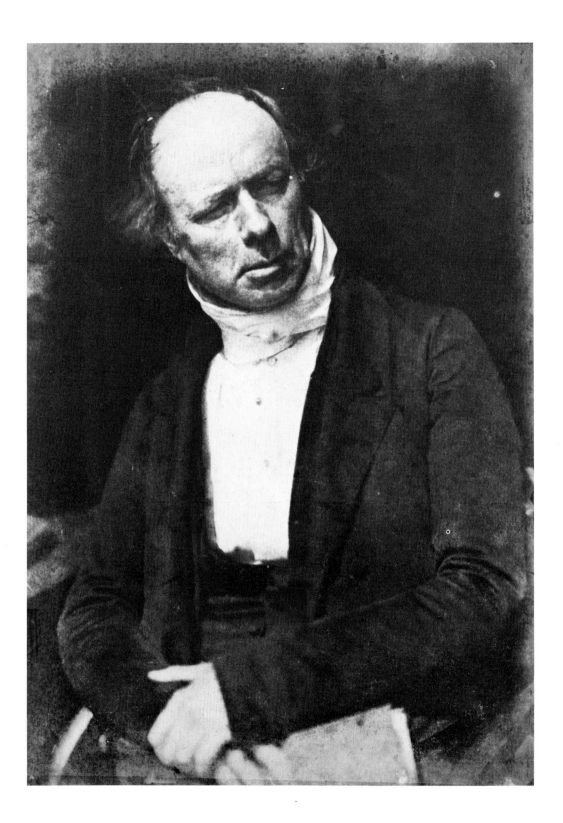

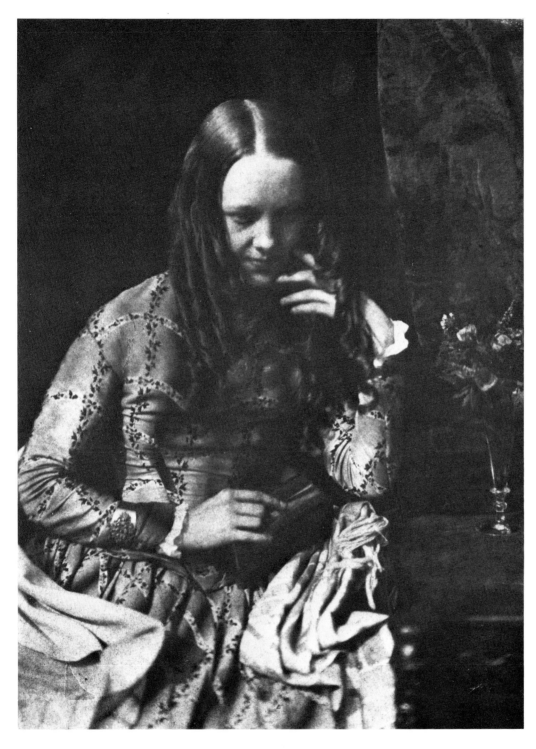

Miss Justine Monro
by D. O. Hill
19.8 × 14.7cm (7¾″ × 5½″)

One of a number of charmingly natural portraits of women and children made by Hill and Adamson during their collaboration.

At Bonaly
by D. O. Hill
15 × 20.8cm (6″ × 8¼″)

Household staff on the steps of Bonaly Tower, home of Lord Cockburn, a judge and a friend and patron of Hill.

'Edinburgh Ale'
by D. O. Hill
14.5 × 19.5cm (5¾″ × 7½″)

James Ballantyne, author and artist, Dr George William Bell, and Hill himself.

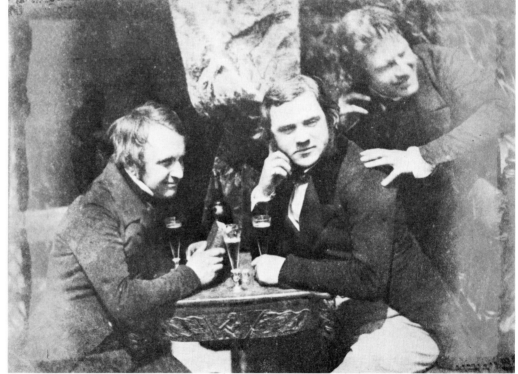

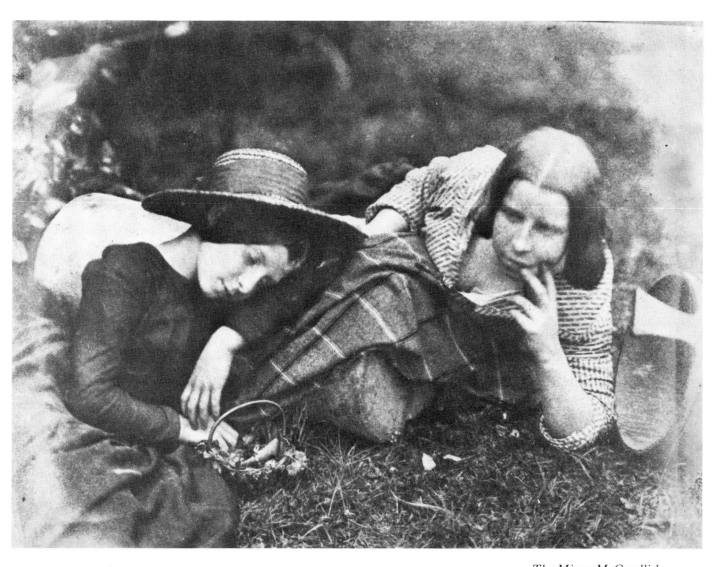

The Misses McCandlish
by D. O. Hill
15.2 × 20.7cm (6″ × 8″)

The three McCandlish sisters lived in the fashionable New Town district of Edinburgh, where Hill himself had lived when he first married.

Highlanders
by Joseph Cundall, 1856
23.7 × 19.7cm (9¼″ × 7½″)

*The Highlanders were celebrated
for their action in the Crimea. This
photograph was taken the year
after their return.*

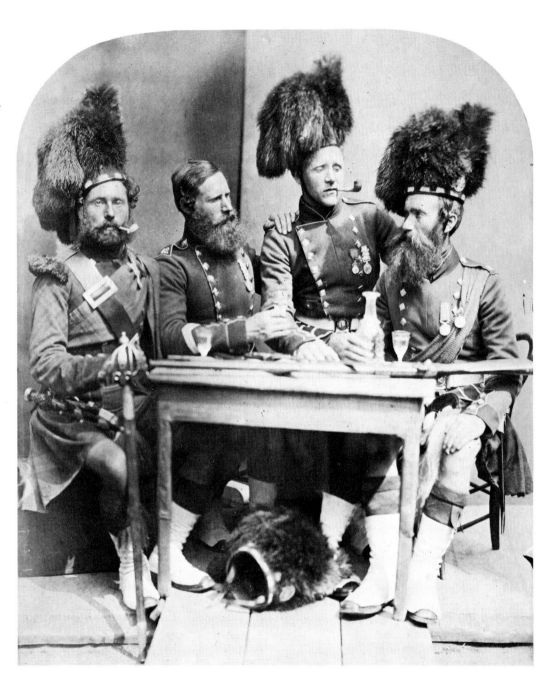

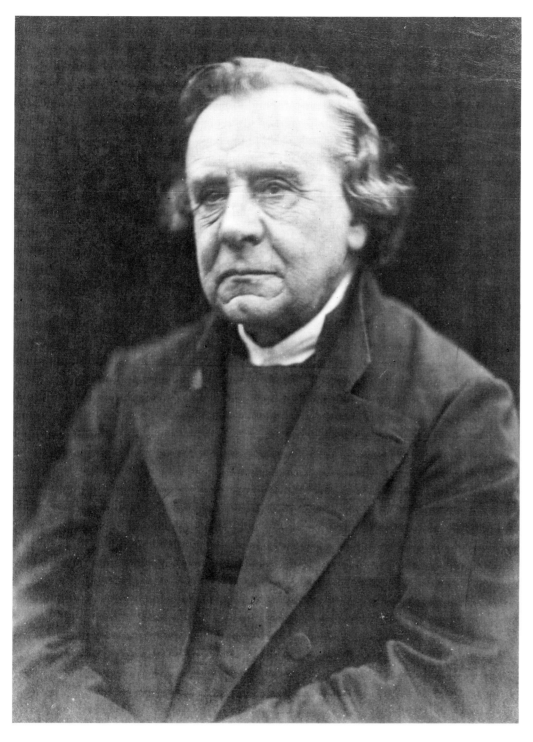

The Bishop of Winchester
by Julia Margaret Cameron,
1872
35 × 16.2cm ($13\frac{1}{2}''$ × $6\frac{1}{4}''$)

One of many portraits of eminent
Victorians by the most renowned of
all nineteenth-century portraitists.
The R.P.S. Collection includes
over 400 of her prints.

G. F. Watts with Children
by Julia Margaret Cameron,
1867
25 × 19.3cm (9¾″ × 7½″)

Watts, the most admired portrait
painter of his day and the husband
of Ellen Terry, painted
Mrs Cameron in the early 1850s
and was later often photographed
by her.

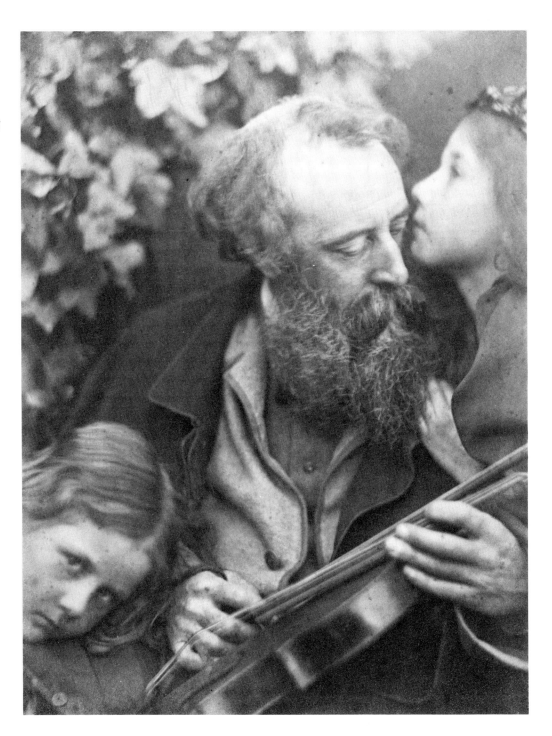

72

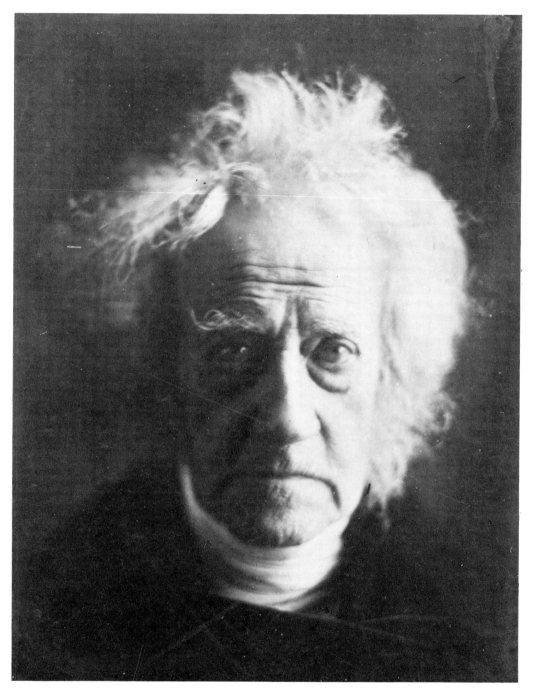

Sir John Herschel
by Julia Margaret Cameron,
1867
34.7 × 27.5cm ($13\frac{1}{2}''$ × $10\frac{3}{4}''$)

*Herschel, one of the greatest
scientists and astronomers of the
nineteenth century, made notable
contributions to photographic
knowledge.*

Peasant Group, Ceylon
by Julia Margaret Cameron,
1878
33.7 × 27.2cm ($13\frac{1}{4}''$ × $10\frac{1}{2}''$)

*Mrs Cameron's husband, Charles
Hay Cameron, owned coffee estates
in Ceylon to which, after nearly
thirty years in England, they
retired in 1875. Here she continued
to take pictures till her death four
years later.*

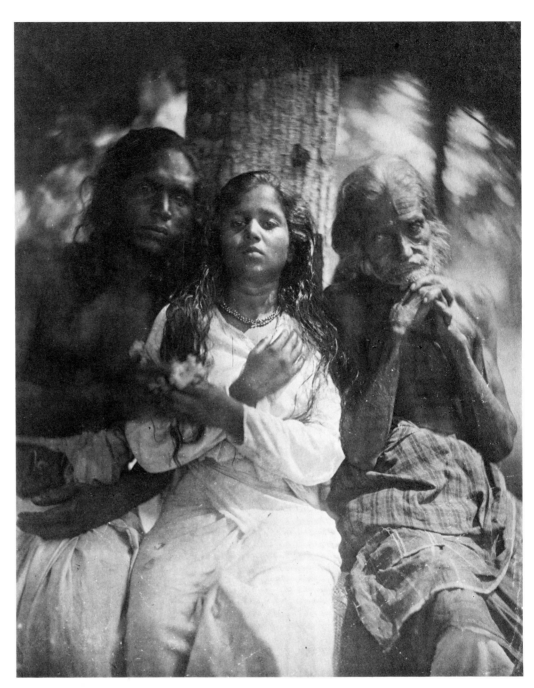

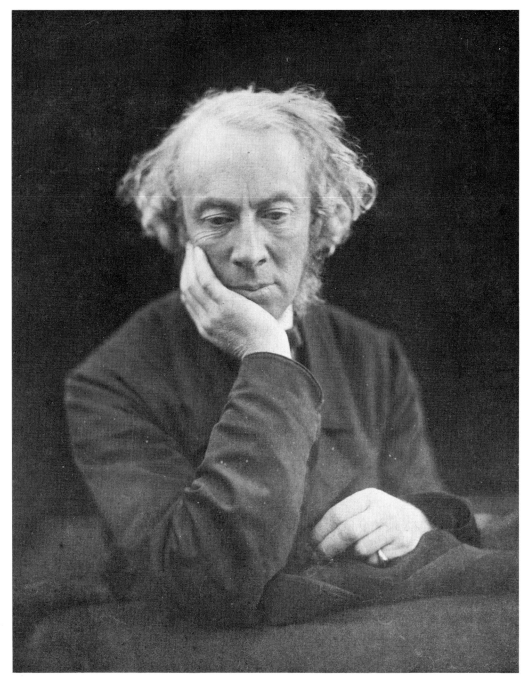

Aubrey de Vere
by Julia Margaret Cameron,
1868
25.3 × 20.3cm (10″ × 8″)

*Aubrey Thomas de Vere was an
Irish poet and critic, a member of a
circle which included Tennyson,
Watts, Browning and Carlyle – all
of whom were photographed by
Mrs Cameron.*

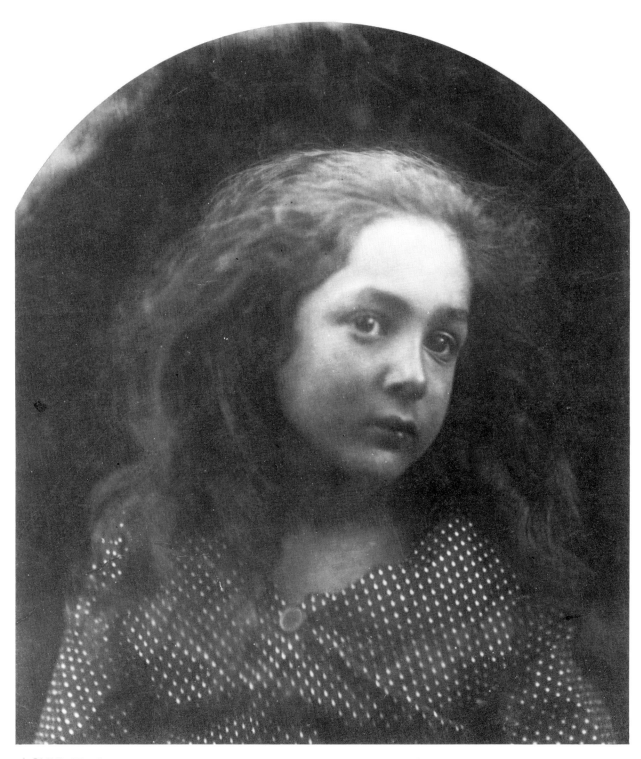

A Child's Head
by Julia Margaret Cameron,
1874
26×22.9cm ($10\frac{1}{4}'' \times 9''$)

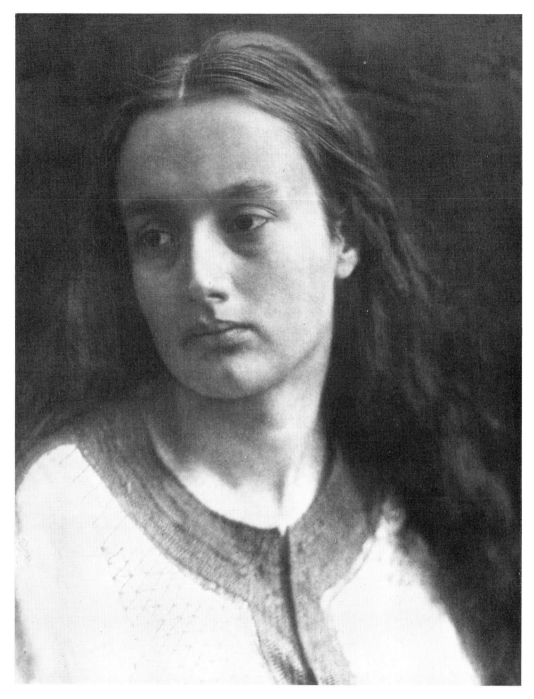

Mrs Ewen Cameron
by Julia Margaret Cameron,
1870
34.2 × 27cm ($13\frac{1}{2}''$ × $10\frac{1}{2}''$)

*Ewen, Mrs Cameron's son,
married eighteen-year-old Annie
Chinery, daughter of a doctor
living near the Camerons' home in
the Isle of Wight. 'Never,' wrote
Mrs Cameron, 'was one's own
offspring dearer . . . than this
darling Daughter is to me.'*

Mary Hillier
by Julia Margaret Cameron,
1867
34.7 × 27cm (13½″ × 10½″)

This handsome portrait was
extravagantly captioned by
Mrs Cameron 'Call I follow,
I follow – let me die.'

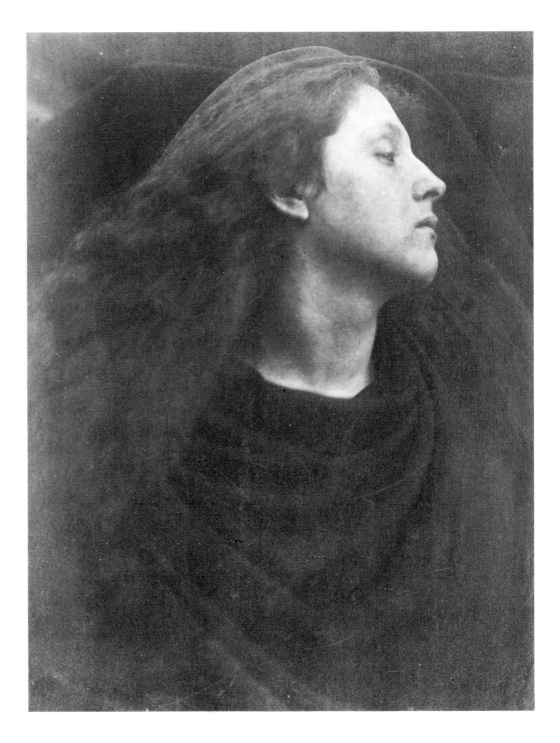

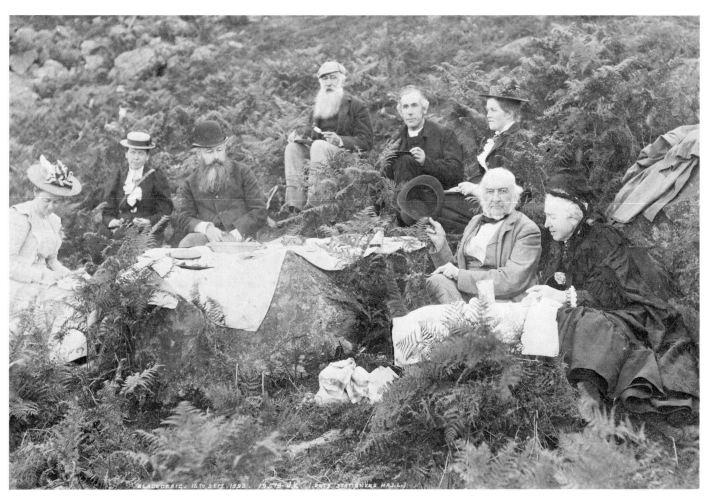

*Gladstone Picnicking at
Blackcraig Castle*
by J. Valentine, 1893
19 × 29cm ($7\frac{1}{2}'' \times 11\frac{1}{2}''$)

*One of the few photographs in the
Collection to show contemporary
political leaders. By the last
decades of the century a number of
commercial firms, such as
Valentine, were producing
excellent portraits, as well as
landscapes for postcards.*

William Morris
by Frederick Hollyer, 1873
37.5 × 30cm ($14\frac{1}{2}'' \times 11\frac{3}{4}''$)

William Morris, poet, artist and
social reformer, was one of many
leading figures in literature and art
who were photographed by
Hollyer.

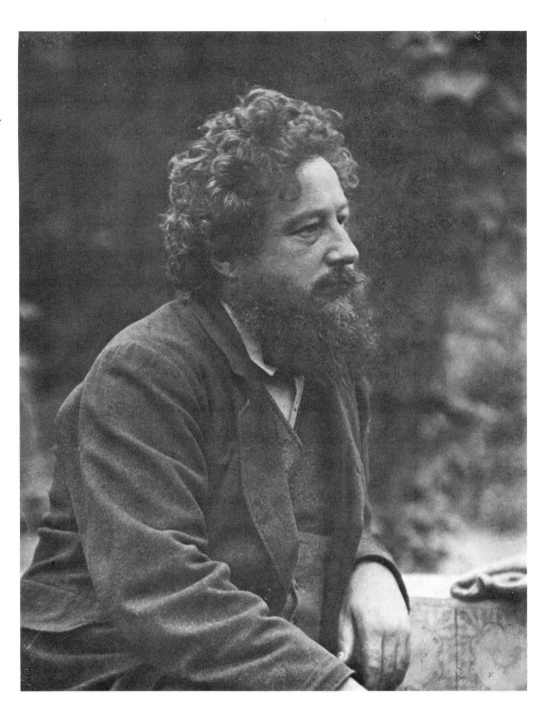

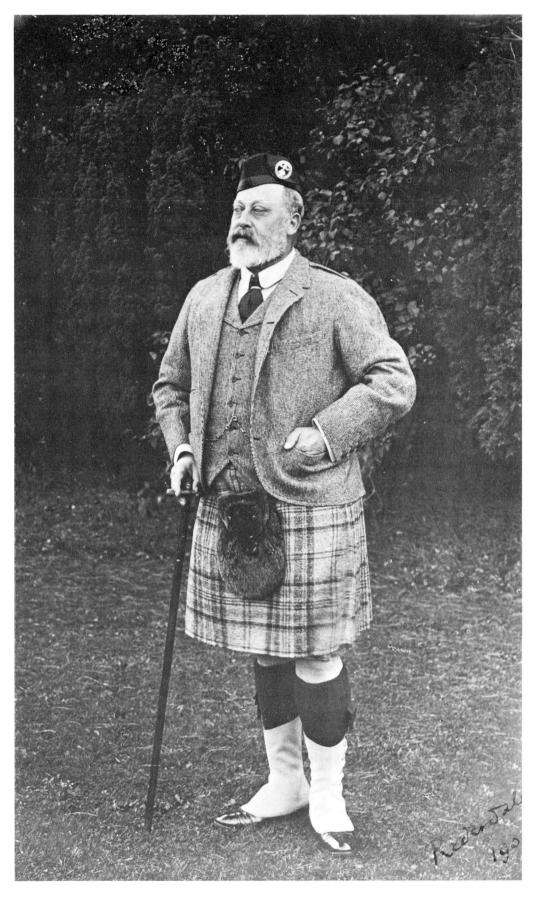

King Edward VII
by Lord Redesdale, 1904
28.3 × 17.4cm (11″ × 6¾″)

*Lord Redesdale, who was
President of The R.P.S., has
caught the mixture of authority
with urbanity in his royal 'sitter'.*

The Rt. Hon. J. A. Roebuck
M.P.
by Maull and Polyblank,
c. 1860–70
20 × 14.6cm (7¾″ × 5½″)

*As M.P. for Sheffield, he called in
the House of Commons for a
committee of enquiry into the early
conduct of the Crimean War, thus
leading indirectly to Roger
Fenton's photographic mission of
1855.*

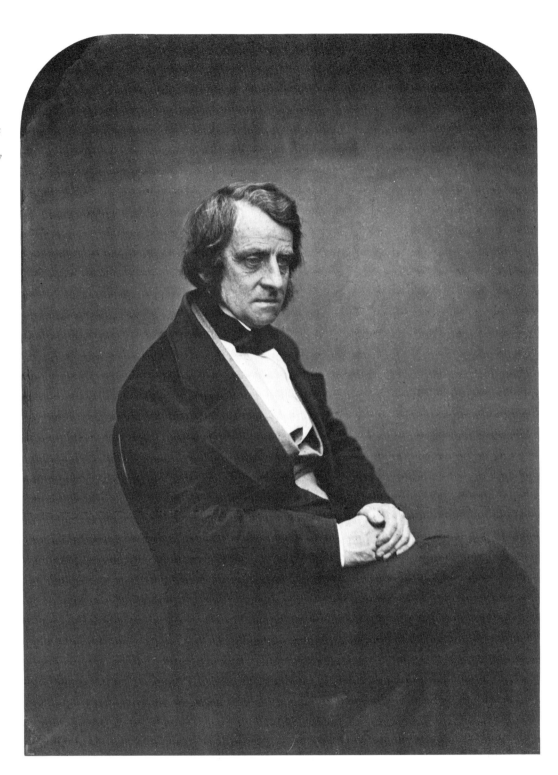

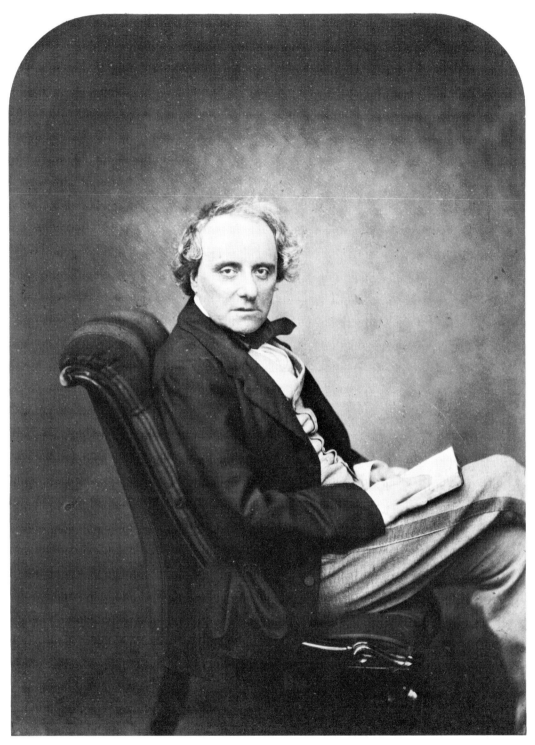

Charles Kean
by Maull and Polyblank,
c. 1860–70
20 × 14.6cm (7¾″ × 5½″)

The renowned actor at the height of his career.

Sir Edwin Landseer
by Maull and Polyblank,
c. 1860–70
20 × 14.6cm (7¾″ × 5½″)

*This firm took portraits, mainly of
artistic, theatrical and legal
figures, first in the City and later
in Piccadilly.*

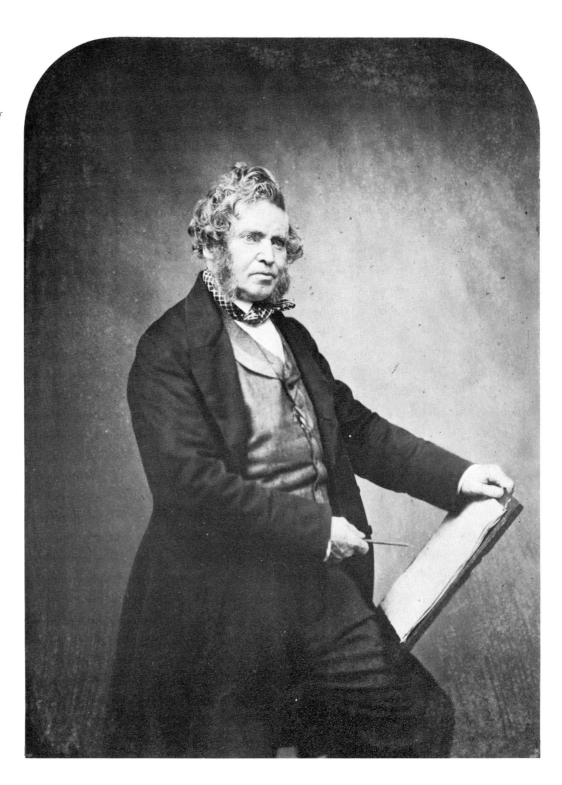

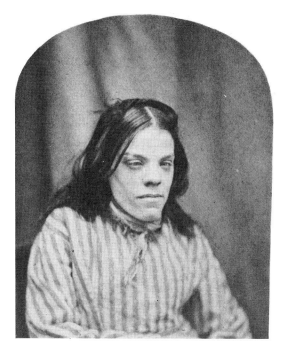

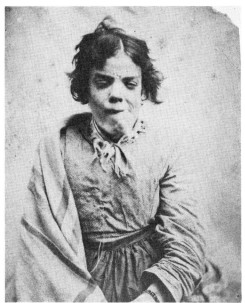

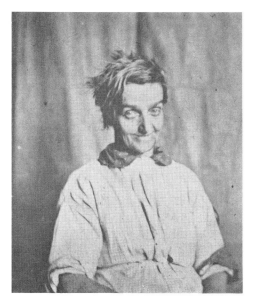

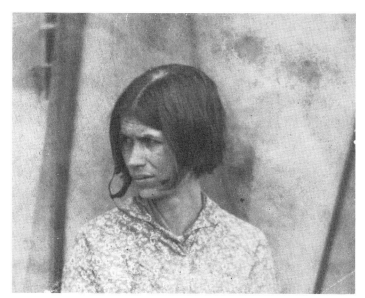

Untitled
by Dr Hugh W. Diamond
6–8 × 5–6.5cm
($2\frac{1}{4}''$–$3''$ × $2''$–$2\frac{1}{2}''$)

*A record which is unique for its
period, some of the patients of
Dr Hugh Welch Diamond,
superintendent in the Surrey
County Asylum, photographed
about 1852. Dr Diamond, one
of the founders of the
Photographic Society, hoped
that the use of photography
might help other medical
workers in recognising
symptoms or stages of mental
illness.*

*'Pharaoh's Bed' Temple,
Philae*
by Francis Frith, *c.* 1857
15.5 × 22.5cm (6″ × 8¾″)

*This massive temple had
nothing to do with Pharaoh's
bed. The island of Philae was
regarded as having been the
scene of the burial and
resurrection of Osiris, and was
therefore sacred.*

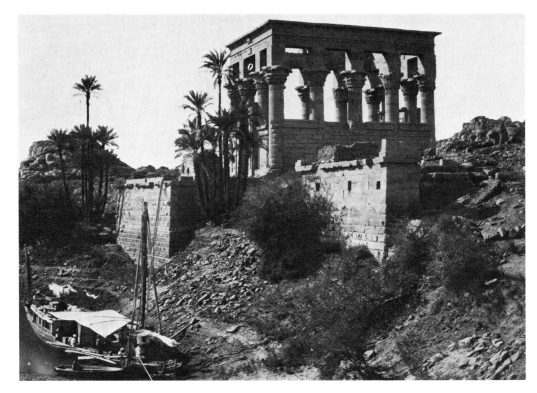

*The Temple of Wady
Kardassy, Nubia*
by Francis Frith, *c.* 1857
15.5 × 22.5cm (6″ × 8¾″)

*In the course of three visits to
Egypt, Frith travelled further up
the Nile than any photographer
had ever been.*

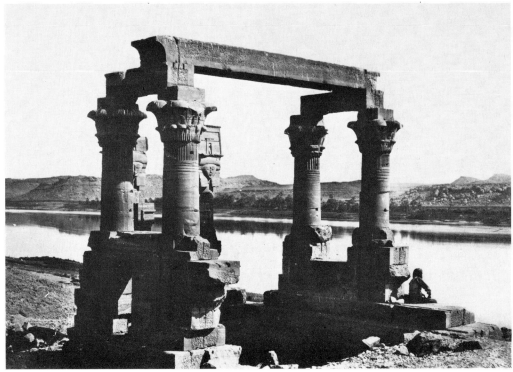

*The Street called Straight,
Damascus*
by Francis Frith *c.* 1857
14.5 × 11.5cm (5½″ × 4½″)

*This is the frontispiece to one of
the bound volumes of Frith's
photographs which are among
the Collection's most interesting
treasures.*

The Approach to Philae
by Francis Frith, *c.* 1857
15.5 × 22.5cm (6″ × 8¾″)

Frith worked with wet collodion
plates under almost insuperable
difficulties from heat and dust, and
was also continually pressed for
time. But the best of his pictures
have a dignity and grandeur
worthy of their subjects.

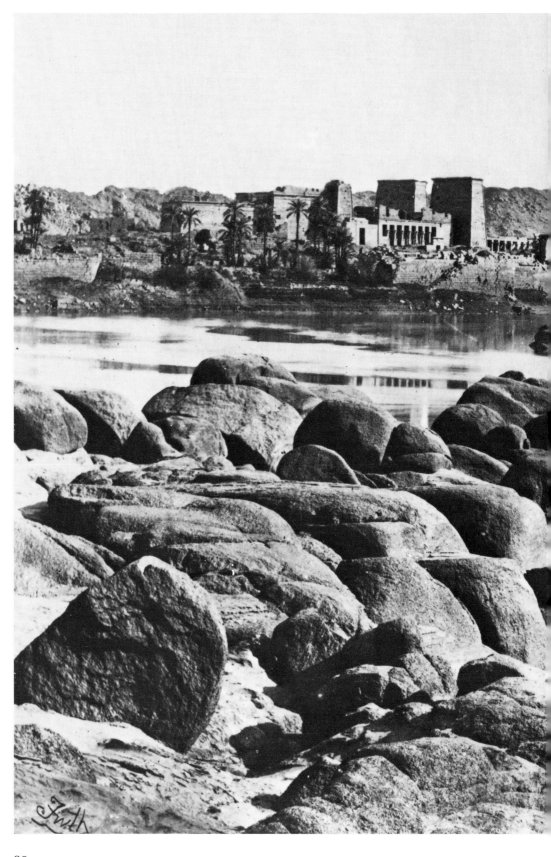

Portion of the Great Temple of
Luxor
by Francis Frith, *c.* 1857
15.5 × 22.5cm (6″ × 8¾″)

One of the southerly courts of the
temple, which was being used at
this period as a grain store.

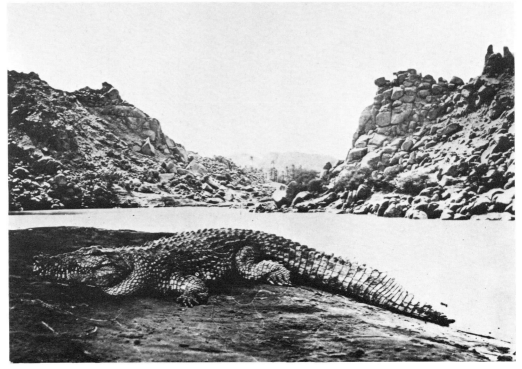

Crocodile on a Sandbank
by Francis Frith, *c.* 1857
15 × 22cm (6″ × 8½″)

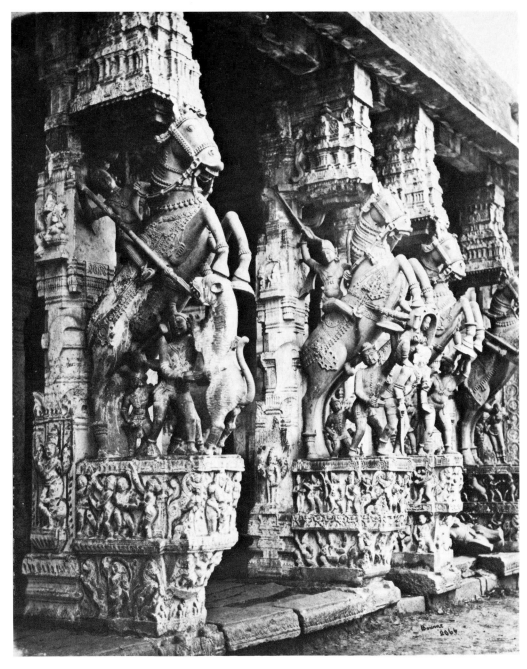

Carved Horse Pillars,
Mundapum
by Samuel Bourne
29.6 × 24.3cm ($11\frac{1}{2}'' \times 9\frac{1}{2}''$)

Bourne set up a photographic
business in Simla in 1861, from
which centre during the 1860s he
made three great photographic
journeys to the Himalayas.

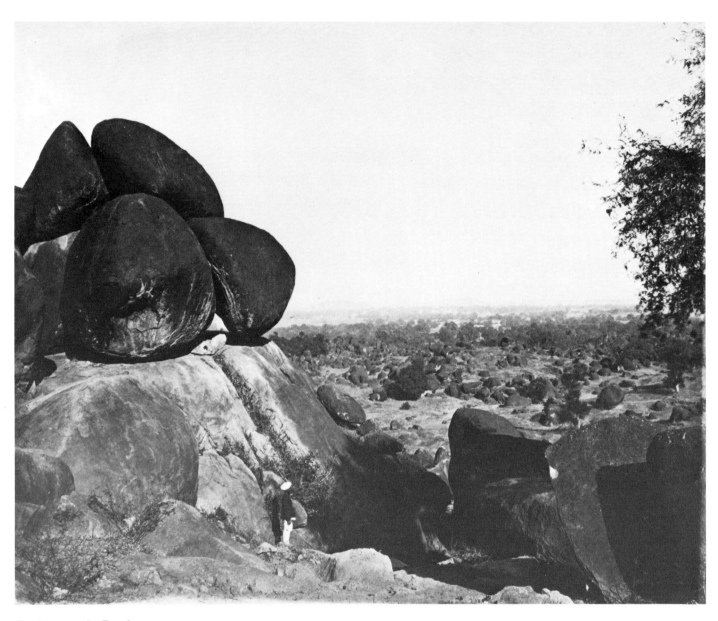

Boulders on the Road to
Muddun Mahal
by Samuel Bourne
23.8 × 29.1 cm (9¼″ × 11½″)

The enormous boulders, their scale
shown by the man standing below,
frame a distant view of Jubbulpore.

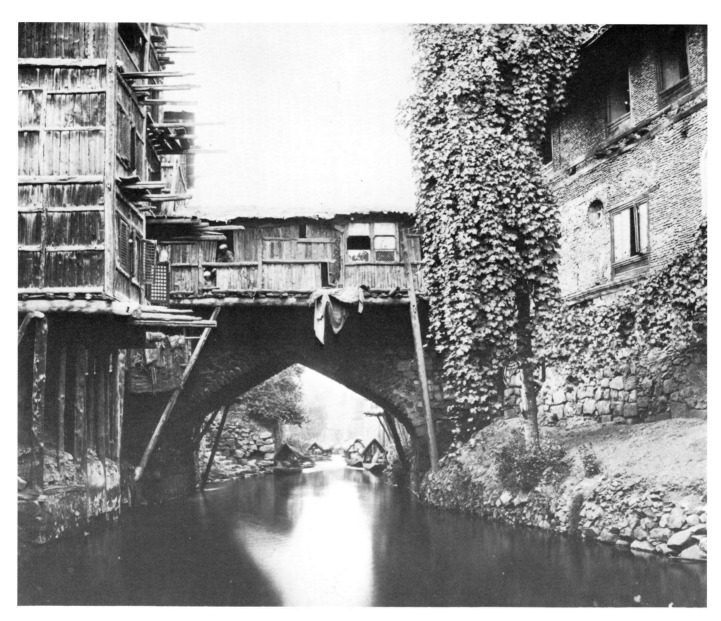

*Old Stone Bridge on the
Marqual Canal, Kashmir*
by Samuel Bourne
23.7 × 29.4cm (9¼″ × 11½″)

*Bourne's photographic forays into
Northern India, with the supplies
he had to carry with him, were
made on the scale of small military
expeditions.*

The Maharajah of Rewar
by Samuel Bourne
30.9 × 25.9cm ($12'' \times 10\frac{1}{4}''$)

Among Bourne's many portraits of Indian notables, none is more startling than this Maharajah in his cloak, black silk gloves, and strings of pearls and jewels.

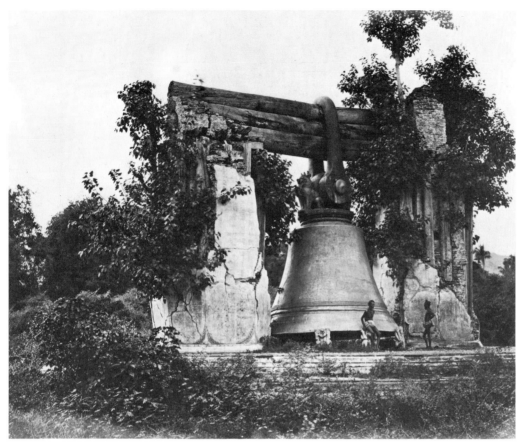

The Great Bell at Mengoon
by Samuel Bourne
23.3 × 29cm (9″ × 11½″)

The enormous bell was reputed to weigh ninety tons.

View on the Salween River near the Rope Station
by Samuel Bourne
24.1 × 29.6cm (9½″ × 11½″)

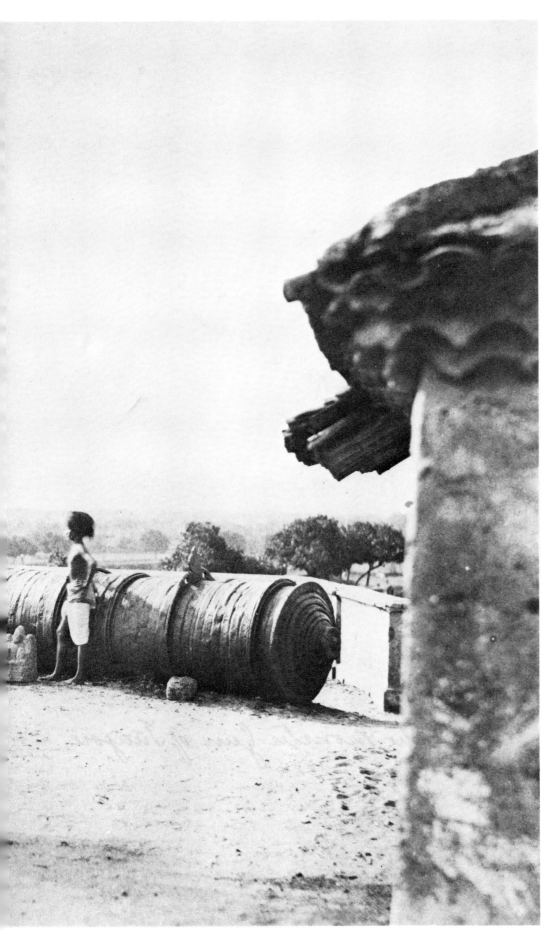

The Monster Gun of Tanjore
by Capt. Linnaeus Tripe,
c. 1856–60
28 × 36.2cm (11″ × 14¼″)

As official photographer to the
Madras Presidency under the East
India Company, Tripe travelled
widely throughout Southern India.
His albums, 500 of his waxed
paper negatives and many of his
prints now form part of The
R.P.S. Collection.

Bridge over the Kaveri,
Trichinopoly
by Capt. Linnaeus Tripe
30.2 × 37.4cm (11¾″ × 14½″)

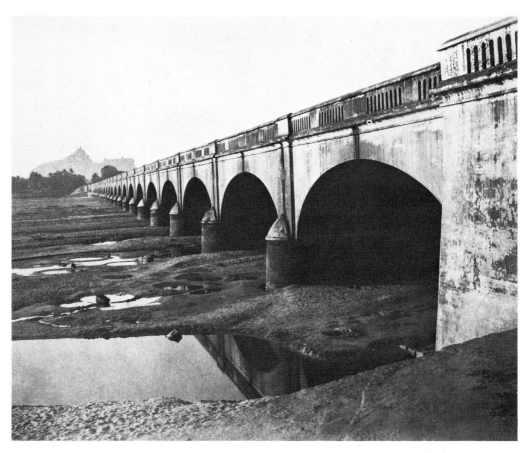

Four Figures on a Shrine
by Capt. Linnaeus Tripe
26 × 34.4cm (10¼″ × 14¼″)

Approach to the Pagoda on the Rock,
Trichinopoly
by Capt. Linnaeus Tripe
28.5×36.7cm $(11\frac{1}{4}'' \times 14\frac{1}{2}'')$

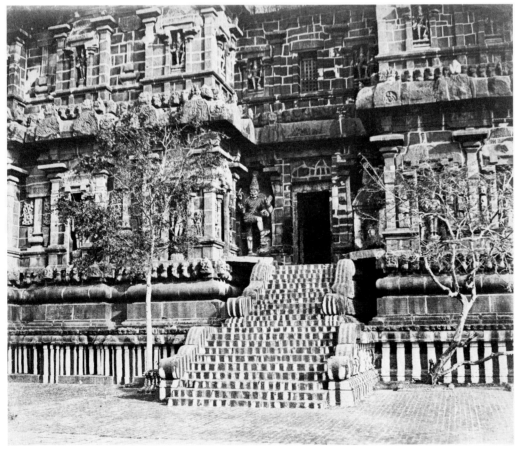

Side Entrance to the Temple of
the Great Bull, Tanjore
by Capt. Linnaeus Tripe
24.7×37.2cm $(9\frac{1}{2}'' \times 14\frac{1}{2}'')$

99

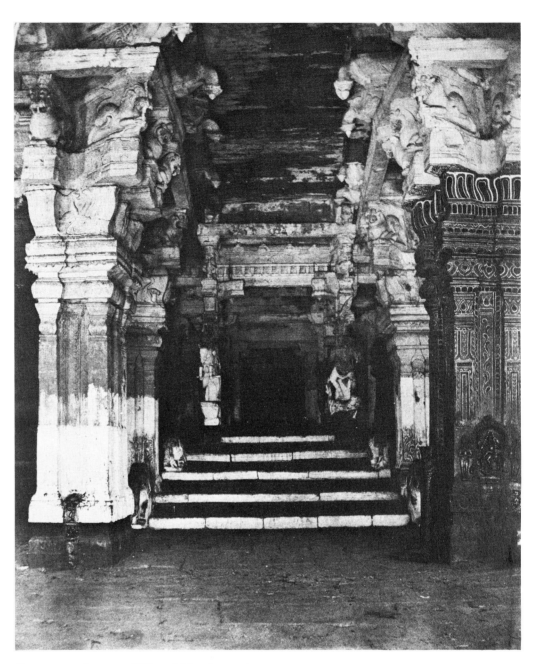

Entrance to the 1,000 Pillared Mundapam in
the Great Pagoda, Madura
by Capt. Linnaeus Tripe
36.5 × 30.8cm (14¼″ × 12″)

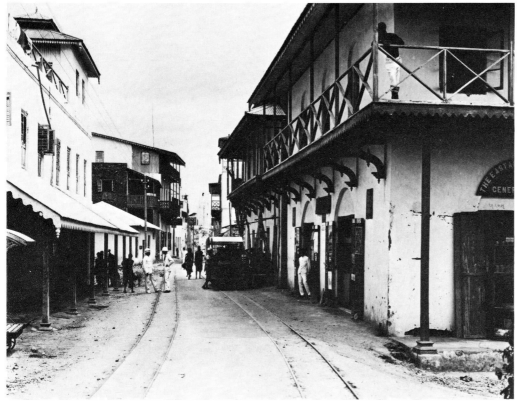

Vasco de Gama Street,
Mombasa
by William D. Young
15.2 × 20.7cm (6″ × 8″)

During the years 1900–10, Young
established studios in Mombasa
and also in the newly developing
settlement of Nairobi. Little, if
any, of his work has ever been
published.

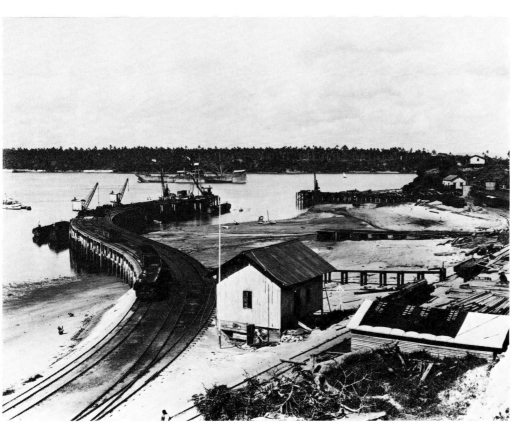

Kilindini Harbour
by William D. Young
15.2 × 20.2cm (6″ × 8″)

Young was employed as a freelance
photographer for the Uganda,
later the East African, Railway,
as it worked its way inland.

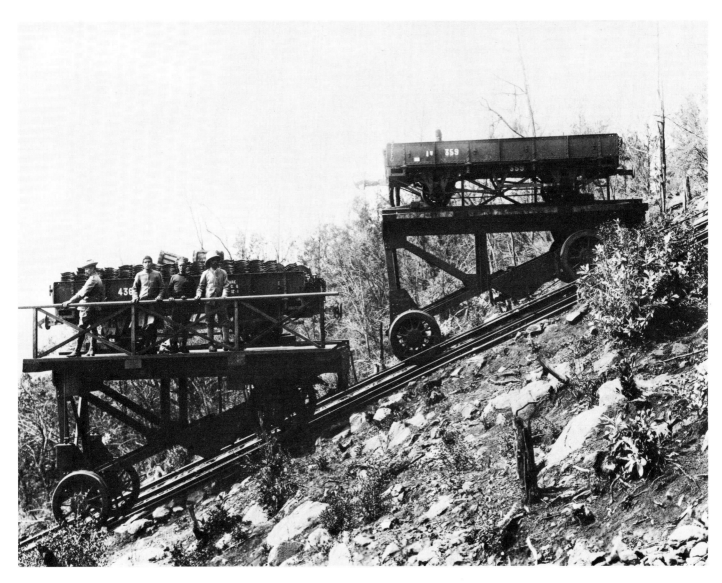

Carriers on Temporary Rope
Incline, Kikuyu Escarpment
by William D. Young
15.2 × 20.2cm (6″ × 8″)

Traces of these temporary
ropeways can still be seen on one or
two Kenyan hillside slopes.

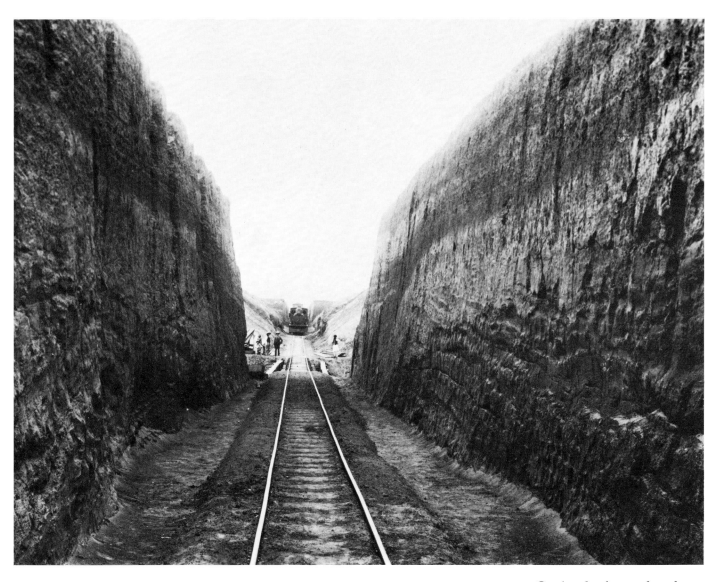

*Cutting the Approach to the
Morandot River*
by William D. Young
15.2 × 20.2cm (6″ × 8″)

*Construction of the Uganda
Railway opened up the territories
of East Africa to the outside world.*

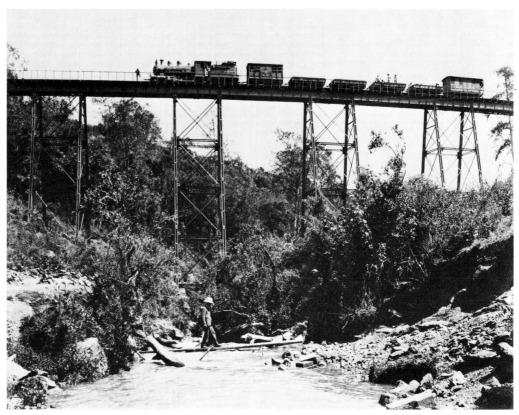

A Viaduct on the Mau Escarpment
by William D. Young
15.2 × 20.2cm (6″ × 8″)

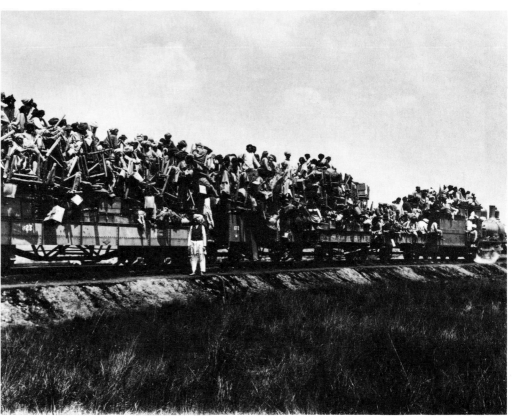

Platelayers Shifting Camp
by William D. Young
15.2 × 20.2cm (6″ × 8″)

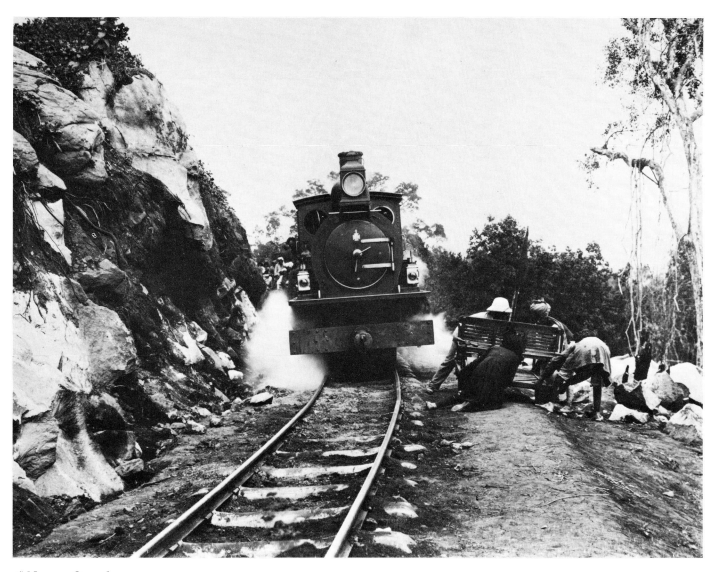

A Narrow Squeak
by William D. Young
15.2 × 20.2cm (6″ × 8″)

*Platelayers shifting their trolley out of the way of
an approaching train. One of the remarkable
pictures from the album of this almost unknown
photographer of the early twentieth century.*

At the Tomb of Tutankhamun
by Lord Carnarvon, 1916
34.5 × 27.4cm ($13\frac{1}{2}''$ × $10\frac{1}{2}''$)

*These photographs, by the
discoverer of the famous tomb,
convey something of the
atmosphere and the scale of the
work involved.*

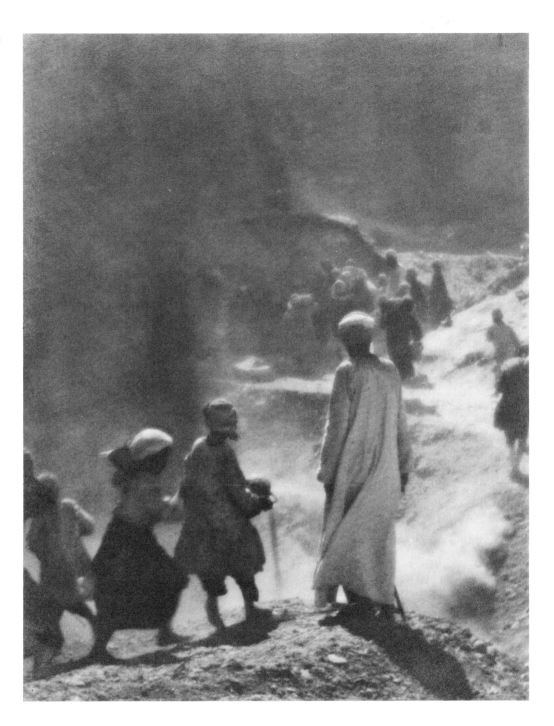

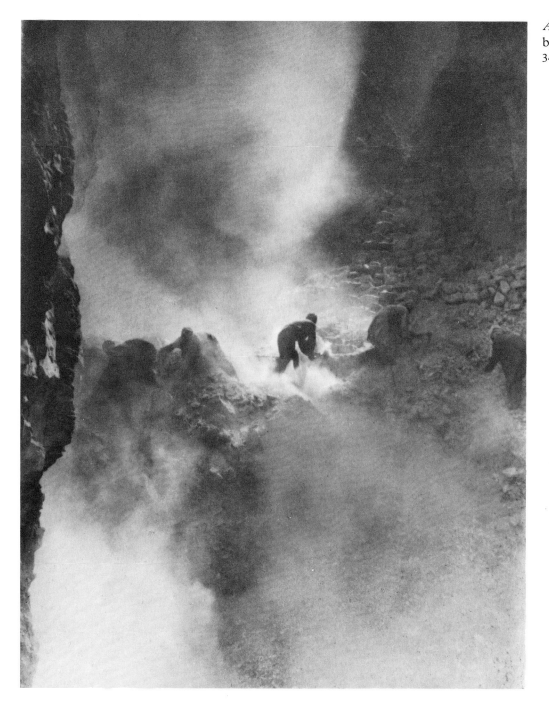

At the Tomb of Tutankhamun
by Lord Carnarvon, 1916
34.5 × 27.4cm ($13\frac{1}{2}''$ × $10\frac{1}{2}''$)

The Castle Berg, Antarctic
by Herbert G. Ponting,
1910–12
68.3 × 57.2cm (26¾″ × 22½″)

*As official photographer to
Captain Scott's ill-fated second
expedition, Ponting made a unique
collection of photographs, both of
the expedition and of the Antarctic
scenery.*

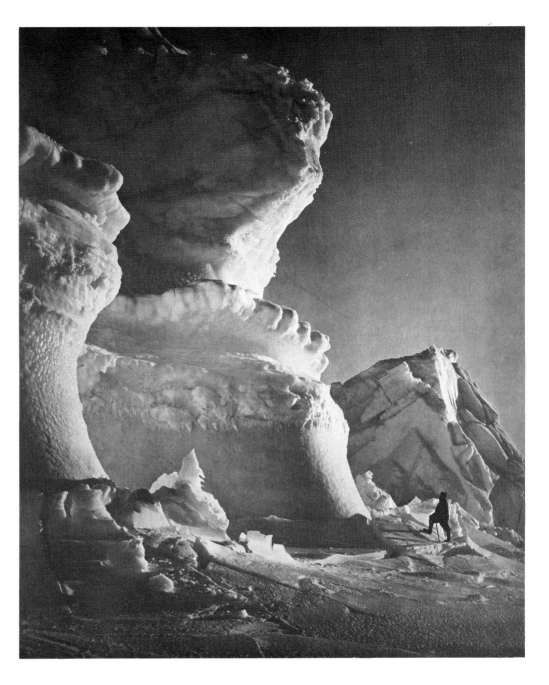

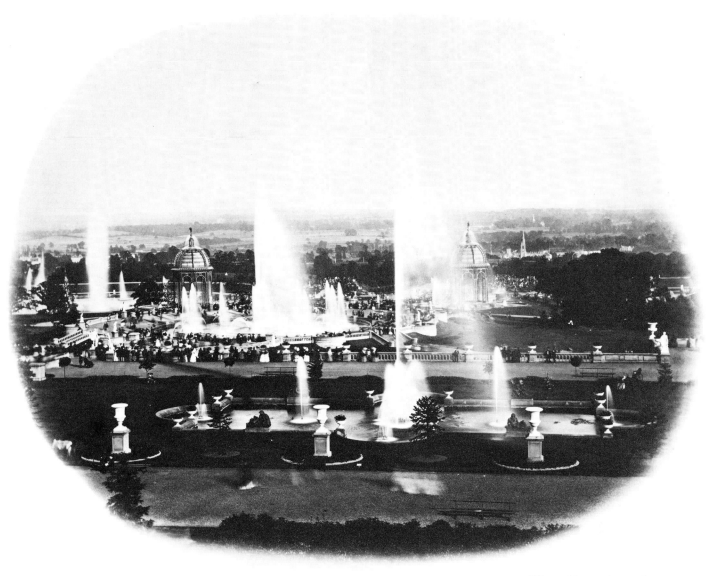

Water Fountains at the Crystal Palace
by Philip H. Delamotte
22.2 × 29cm (8½″ × 11½″)

Delamotte had been commissioned by the Directors to make a record of the building of the Crystal Palace from 1851 to the opening ceremony on its new site in 1854.

Regent Street, London
by Valentine Blanchard,
1856–65
7.2 × 8.1cm (3½″ × 3¼″)

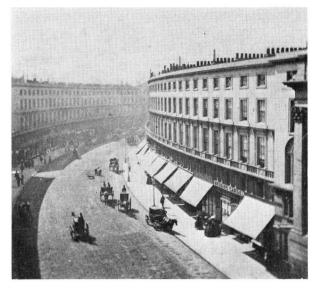

Houses of Parliament with Tug
by Valentine Blanchard,
1856–65
7.2 × 8.1cm (2¾″ × 3¼″)

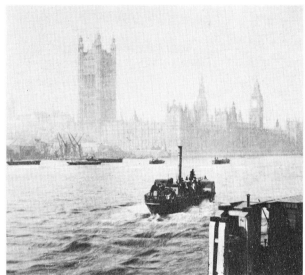

View over the Estuary
by Valentine Blanchard,
1856–65
7.2 × 8.1cm (2¾″ × 3¼″)

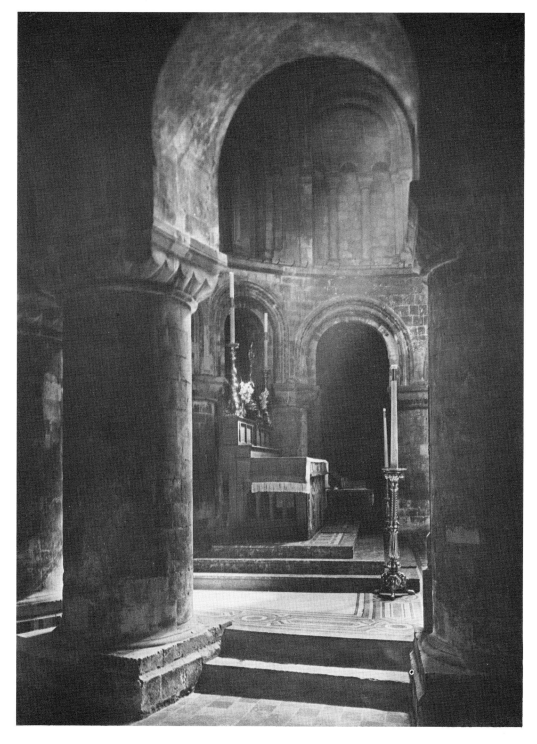

*St Bartholomew the Great,
Smithfield*
by Frederick H. Evans,
c. 1904
24.5 × 18.2cm (9½″ × 7″)

*A bookseller turned photographer,
Evans specialised in the cathedrals
of England and Europe. He was
also a friend of Aubrey Beardsley,
William Morris and George
Bernard Shaw.*

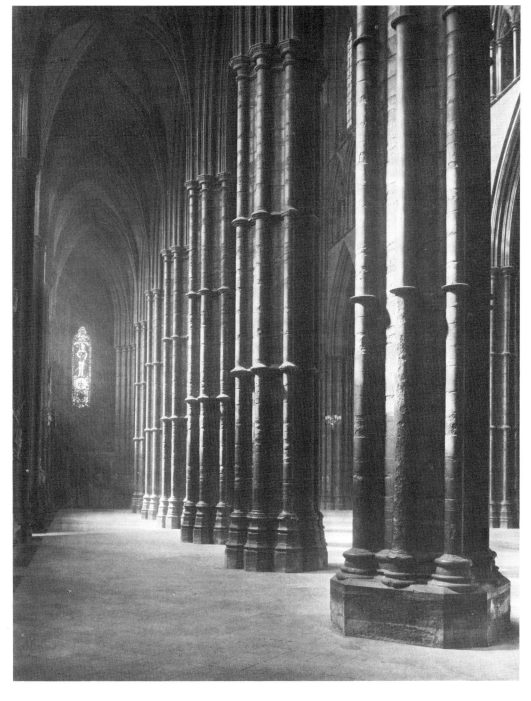

*Westminster Abbey, South
Nave Aisle*
by Frederick H. Evans, 1912
24 × 18.5cm ($9\frac{1}{2}''$ × $7\frac{1}{4}''$)

A Utrecht Pastoral
by J. Craig Annan
21.7 × 28.7cm ($8\frac{1}{2}'' \times 11\frac{1}{4}''$)

*James Craig Annan, son of
Thomas Annan, a professional
photographer and friend of D. O.
Hill, was the leading exponent in
Britain of the photogravure
process.*

A Mountain Road in Spain
by J. Craig Annan, *c.* 1913
11.5 × 18cm (4½″ × 7″)

The Quay, Genoa
by J. Craig Annan
21 × 28.8cm (8¼″ × 11¼″)

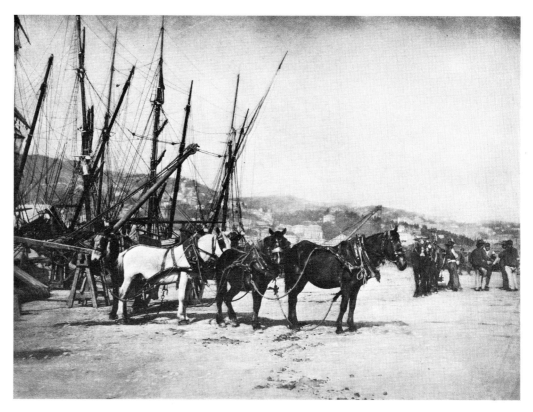

St Martin's Bridge, Toledo
by J. Craig Annan, *c.* 1913
12.8 × 18cm (5″ × 7″)

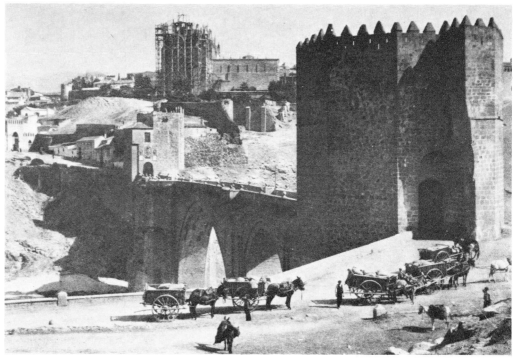

116

Scarboro'
by James McKissack, *c.* 1911
27.5 × 21cm (10¾″ × 8¼″)

A Dusty Day
by Arthur Marshall,
c. 1900–5
35 × 27.5cm (13½″ × 10¾″)

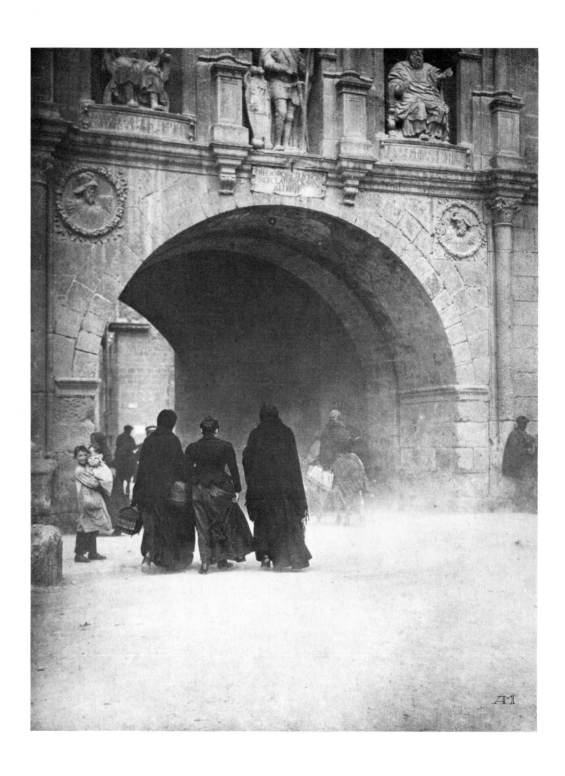

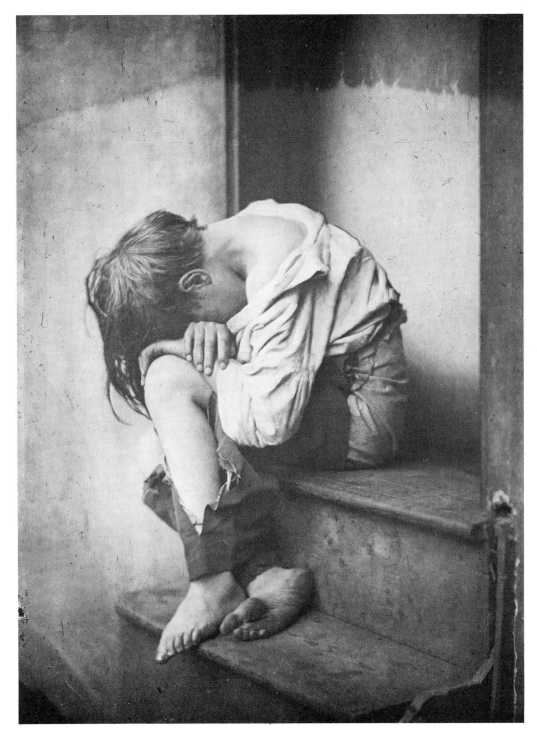

Rejlander, a Swede who lived and worked in Britain, was one of the many photographers who had originally trained and studied to become painters. Much of his work shows the influence of contemporary and earlier painting.

Gustave Doré
by O. G. Rejlander, 1860
17.6 × 22.5cm (7″ × 8¾″)

*Though somewhat unnaturally
posed, Rejlander's portrait of
Gustave Doré suggests the
romantic extravagance which
distinguished his sitter's work as
artist and engraver.*

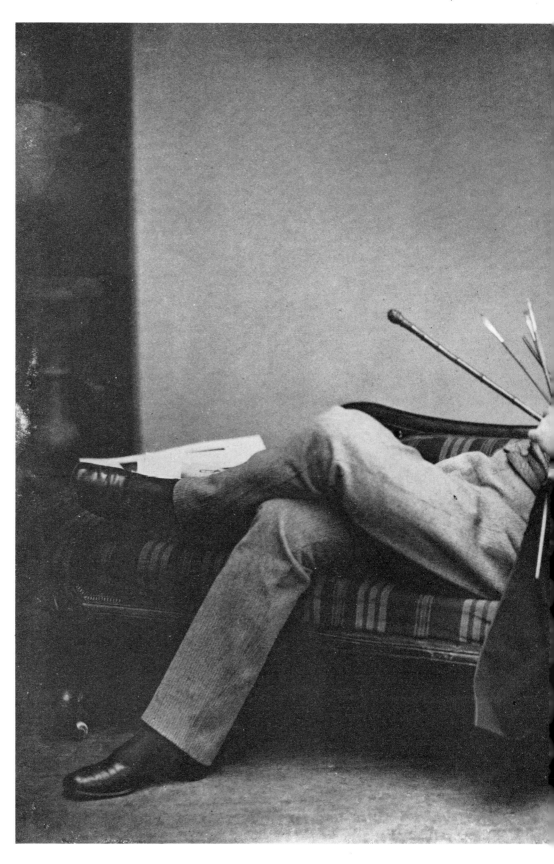

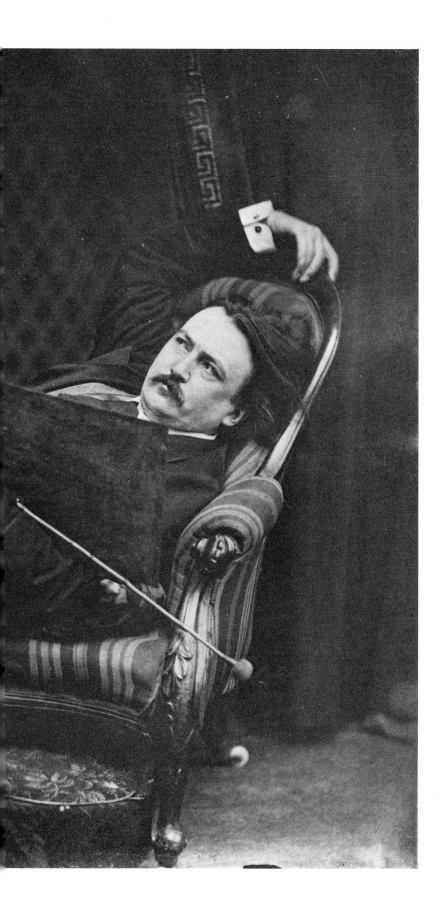

Do It Again!
by O. G. Rejlander, *c.* 1857
14 × 11cm (5½″ × 4¼″)

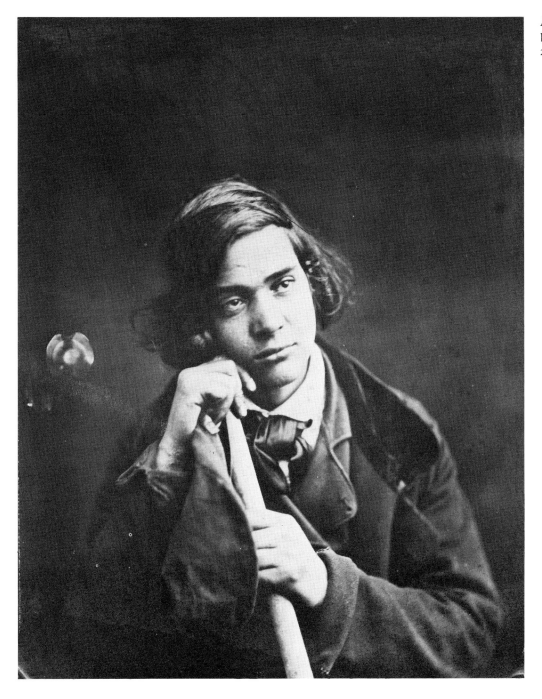

Longing for Home
by O. G. Rejlander
21 × 16.7cm (8¼″ × 6½″)

*The Shortest Way in
Summertime*
by Henry Peach Robinson,
1884
28 × 37cm (11″ × 14½″)

*Like Rejlander, Robinson had been
a painter, and became the most
eminent 'High Art' photographer
of his day. He was also a prolific
writer on photography.*

Confidences
by Henry Peach Robinson
28.7 × 36cm (11¼″ × 14″)

*His work combines great technical
skill with easy sentiment and an
eye for composition.*

On the Way to Market
by Henry Peach Robinson,
c. 1866
36 × 28.2cm (14″ × 11″)

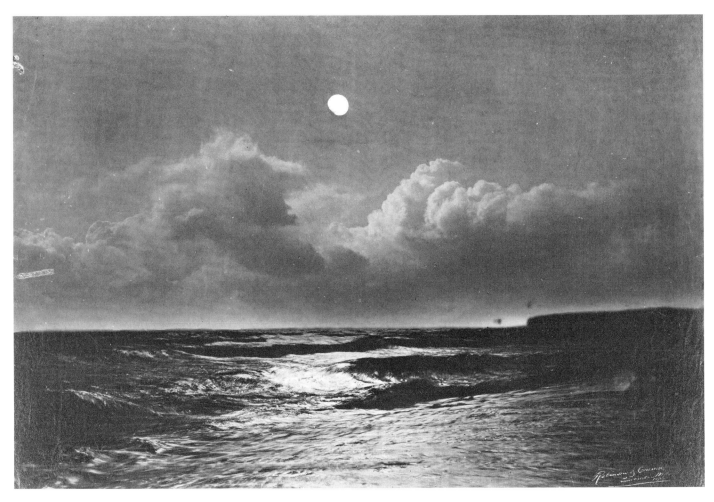

Seascape at Night
by Henry Peach Robinson
(with Cherrill), 1870
27.5×39.4cm ($10\frac{3}{4}'' \times 15\frac{1}{2}''$)

The Woods in Autumn
by Henry Peach Robinson
25.7×39cm ($10'' \times 15\frac{1}{4}''$)

Those who only know Robinson's work from his elaborate compositions, such as 'Fading Away', may be surprised by the freshness of his woodland scenes.

Dying Day
by Ralph W. Robinson, 1891
18.7 × 32cm (7¼″ × 12½″)

Ralph was the son of Henry Peach Robinson. A noted photographer in his own right, he also presented a large quantity of his father's prints and negatives to The R.P.S.

A Primrose by the River's Brim
by Ralph W. Robinson, 1891
23.5 × 33cm (9¼″ × 13″)

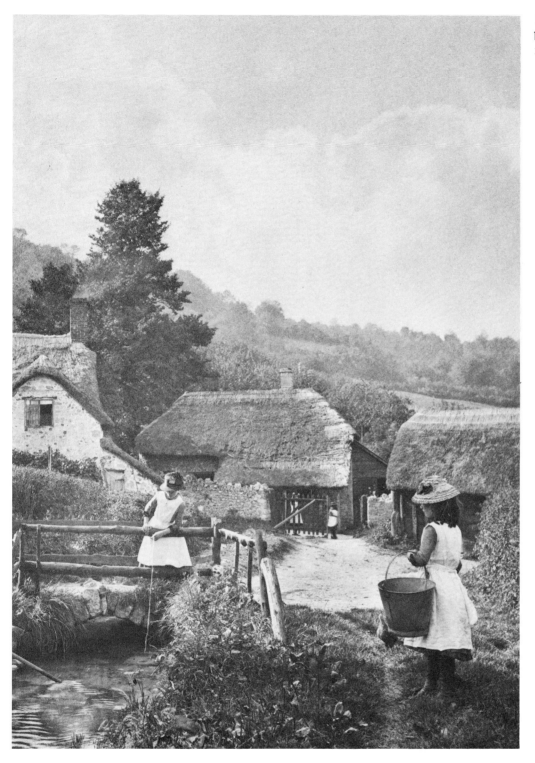

The Brook by the Farm
by F. P. Cembrano, *c.* 1891
16 × 11.5cm (6¼″ × 4½″)

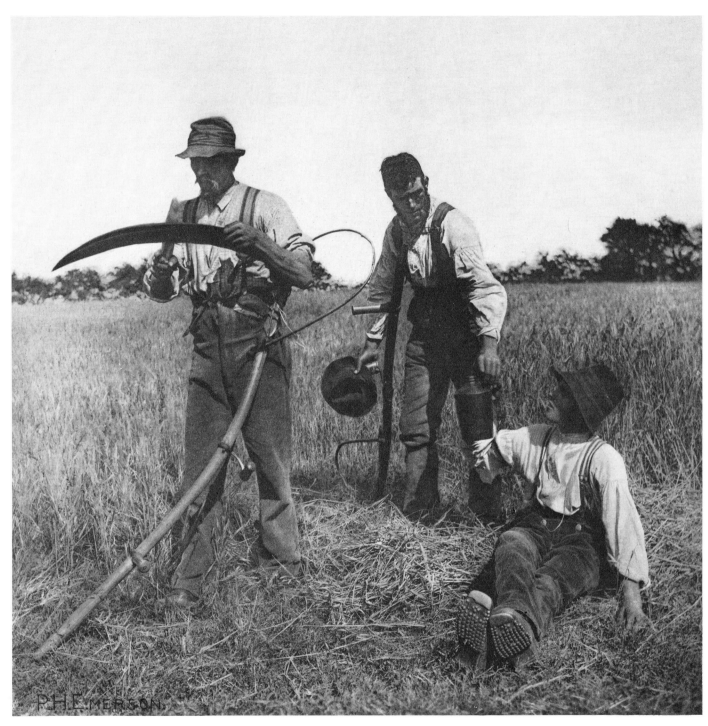

In the Barley Harvest
by P. H. Emerson, 1888
23.5 × 24.2cm (9¼″ × 9½″)

Emerson photographed mainly in East Anglia and on the Norfolk Broads. Both through his photographs and his writings, he opposed the current fashion for 'High Art' and advocated a return to naturalism.

NATURALISTIC AND IMPRESSIONIST 130–140

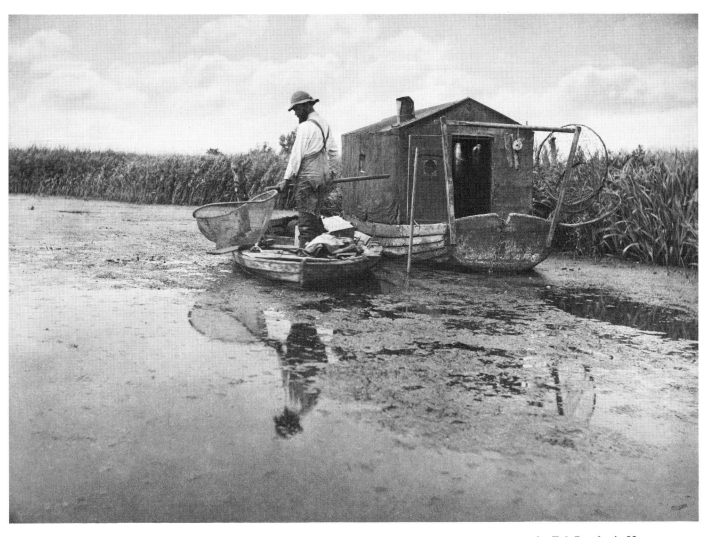

An Eel Catcher's Home
by T. F. Goodall
20.5 × 29cm (8″ × 11½″)

Goodall and Emerson collaborated
over several photographic books, in
which the rural life of East Anglia
is memorably recorded.

Poling the Marsh Hay
by T. F. Goodall, 1886
23 × 29cm (9″ × 11½″)

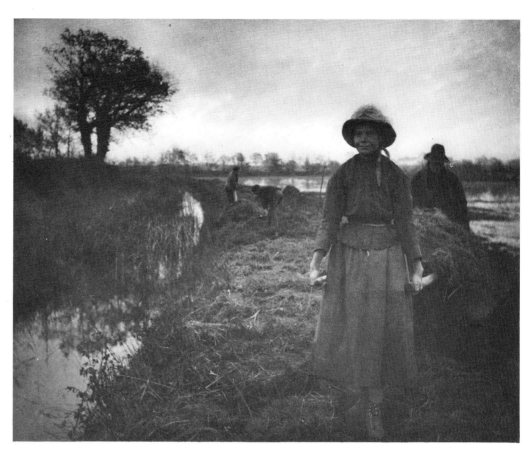

Rowing Home the Schoof Stuff
by T. F. Goodall
13.7 × 27.6cm (5½″ × 10¾″)

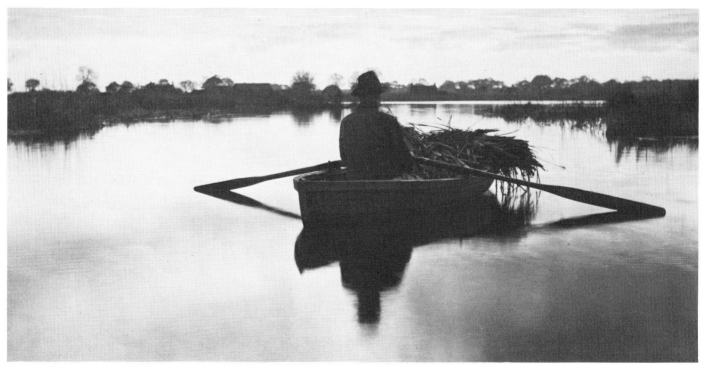

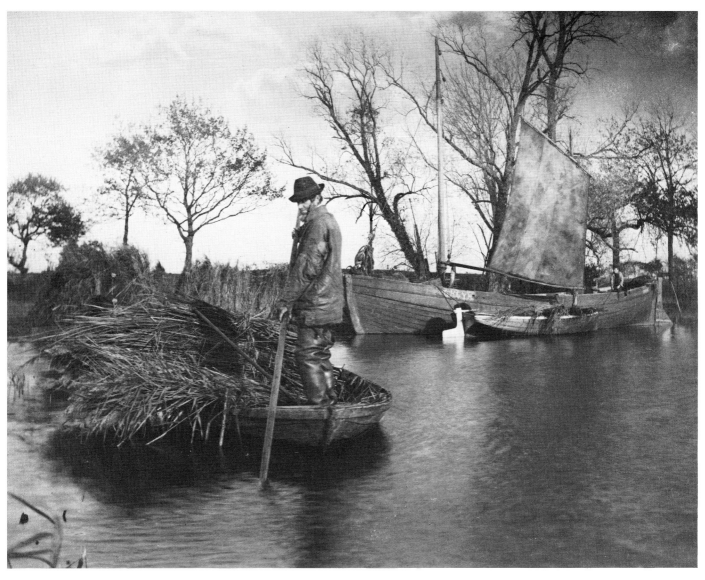

The Gladdon-Cutter's Return
by P. H. Emerson, 1886
22.5 × 29cm ($8\frac{3}{4}'' \times 11\frac{1}{2}''$)

*Emerson and Goodall's
photographs convey a moving
impression of the arduous life led
by reed-cutters, fishermen and
punt-gunners a century ago, when
the Norfolk Broads still had little
contact with the outside world.*

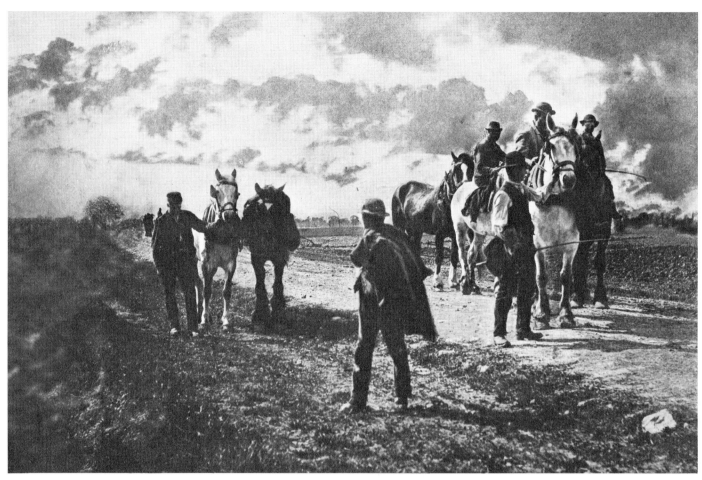

*Berkshire Teams and
Teamsters*
by George Davison, *c.* 1888
10.8 × 16.8cm (4¼″ × 6½″)

Harlech from the Golf Links
by George Davison
18 × 24cm (7″ × 9¼″)

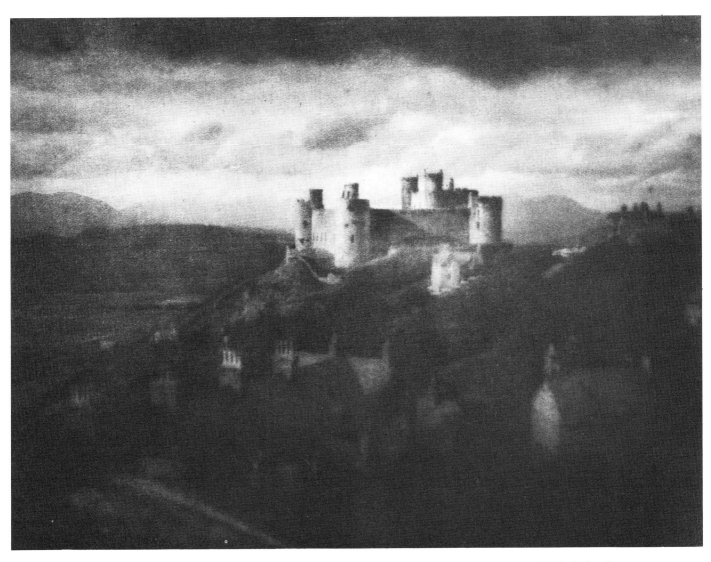

Harlech Castle
by George Davison, 1907
15.5 × 21cm (6″ × 8¼″)

*Davison had been much influenced
by the work of French
Impressionist painters, some of
whose effects he sought to reproduce
by photographic means.*

Potato Harvest
by H. Y. Sümmons, 1906
20 × 14.5cm (7¾″ × 5½″)

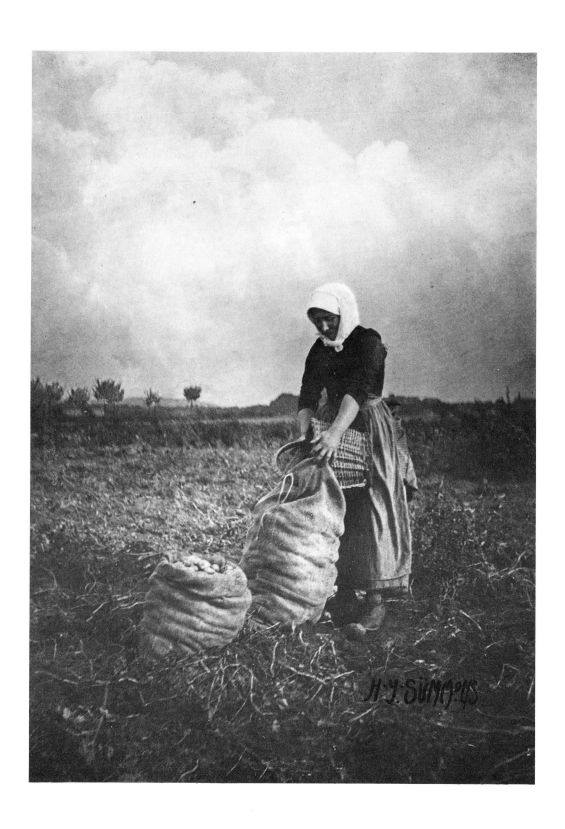

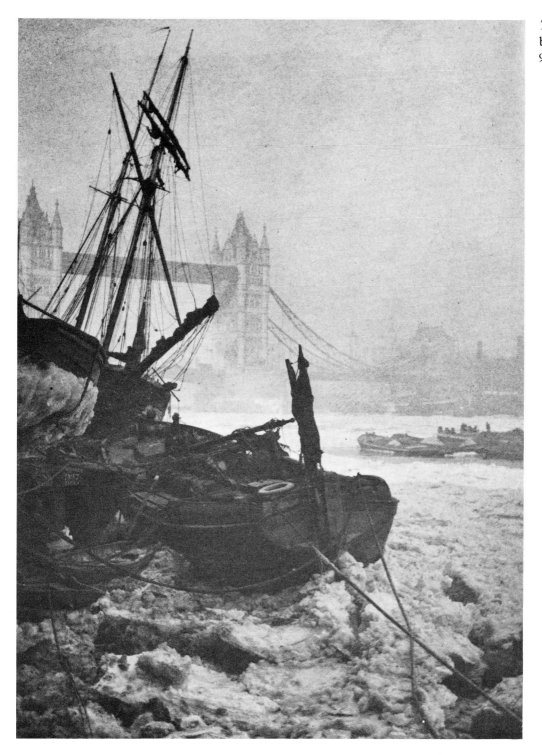

The Frozen River
by A. J. Ransome, 1895
9.5 × 7cm (3½″ × 2½″)

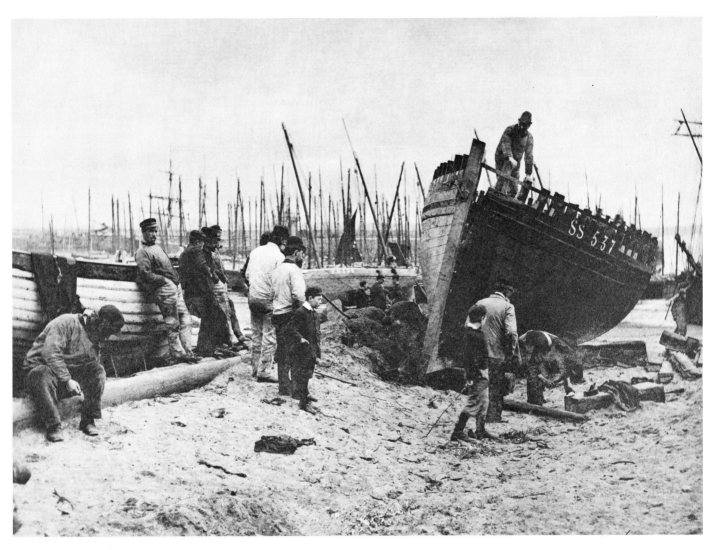

Beached for Repairs
by Graystone Bird, 1901
27×37.5cm ($10\frac{1}{2}'' \times 14\frac{1}{2}''$)

Woodcutters
by C. F. Grindrod, 1902
37.5 × 29.3cm (14½″ × 11½″)

Low Tide
by C. F. Inston, *c.* 1900
11 × 15.2cm (4¼″ × 6″)

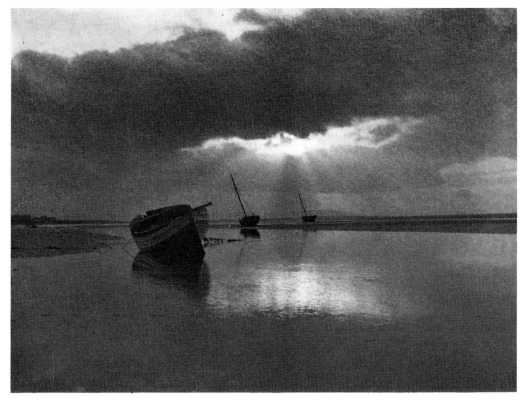

End of a Stormy Day
by C. F. Inston, 1901
10.7 × 15.6cm (4¼″ × 6″)

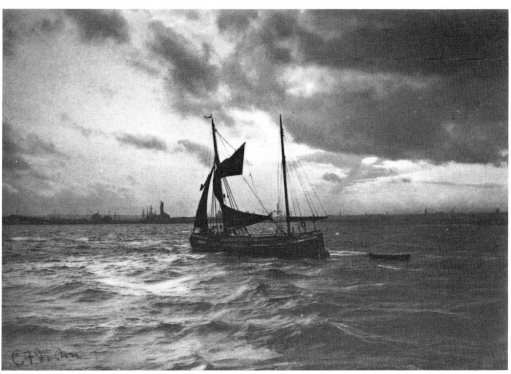

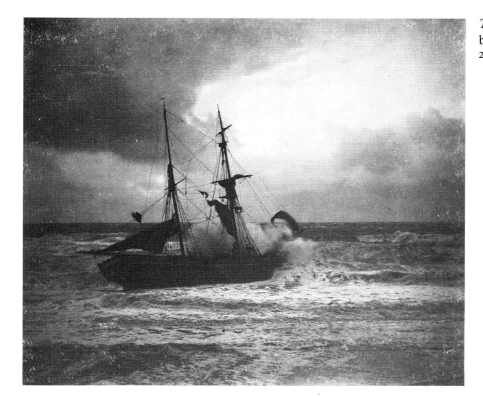

The Flag of Distress
by Frank M. Sutcliffe, 1885
22.5 × 28.5cm (8¾″ × 11¼″)

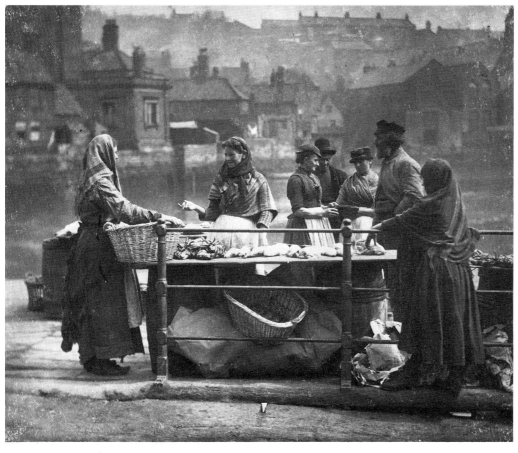

A Fish Stall
by Frank M. Sutcliffe,
c. 1882–90
23.7 × 28.7cm (9¼″ × 11¼″)

While still a young man, Sutcliffe established himself at Whitby on the Yorkshire coast, and his life's work centred round the activities of the port, the fishermen and their families.

The Dock End, Whitby
by Frank M. Sutcliffe, 1880
23.2 × 30.2cm (9″ × 11¾″)

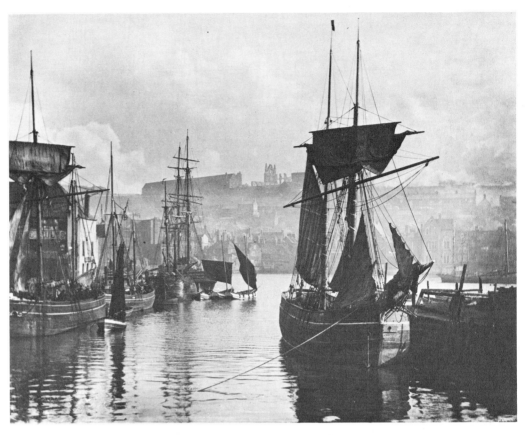

Selling Fish
by Frank M. Sutcliffe
15.3 × 20.7cm (6″ × 8″)

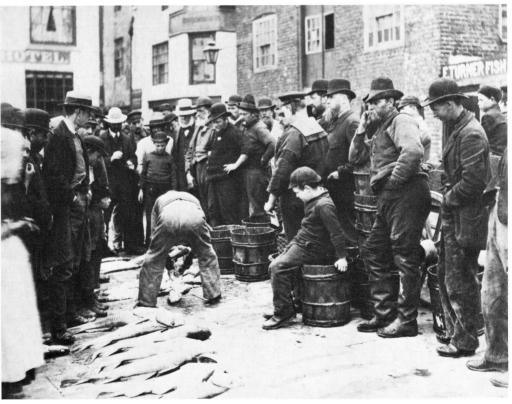

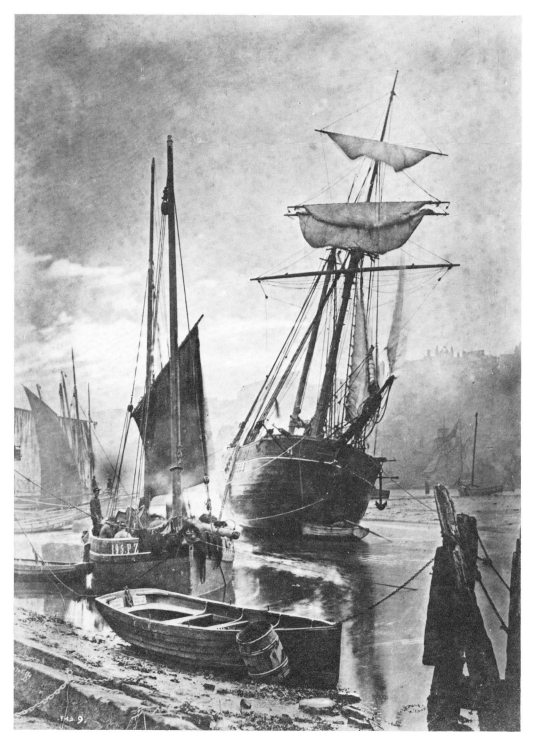

Boats at Moorings
by Frank M. Sutcliffe
20.5 × 15cm (8″ × 6″)

Effects of light on sky, water and the sides of vessels attracted Sutcliffe, who made many of his pictures in the early morning and late evening.

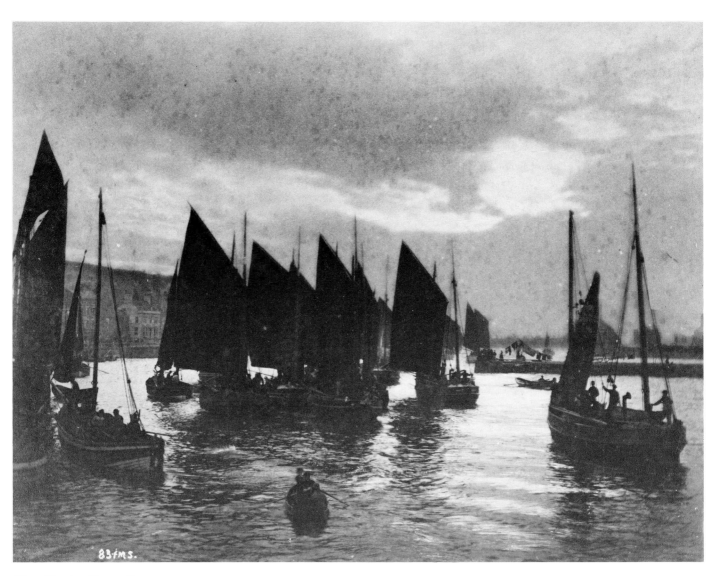

Fleet Putting Out to Sea
by Frank M. Sutcliffe
15.2 × 20.5cm (6″ × 8″)

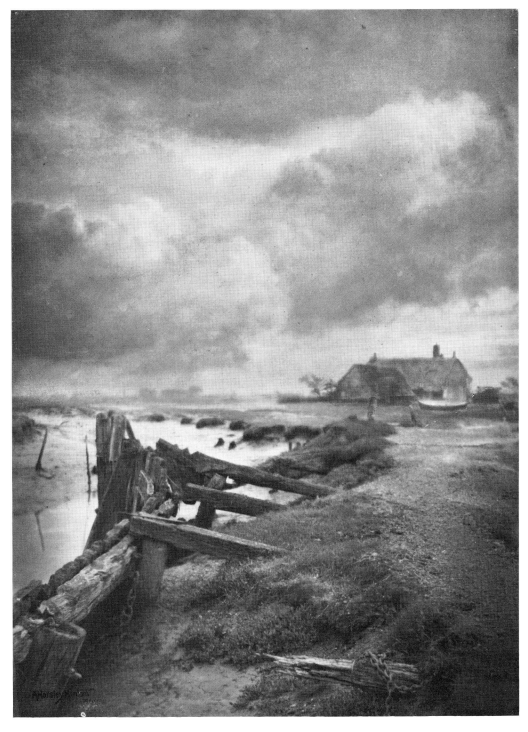

Summer Clouds
by A. Horsley Hinton, *c.* 1898
49 × 36.5cm (20″ × 14¼″)

As editor of The Art Journal,
*Hinton used his influence to
advocate the ideals of 'pictorialism'
– concentration on the artistic and
creative aspects of photography.*

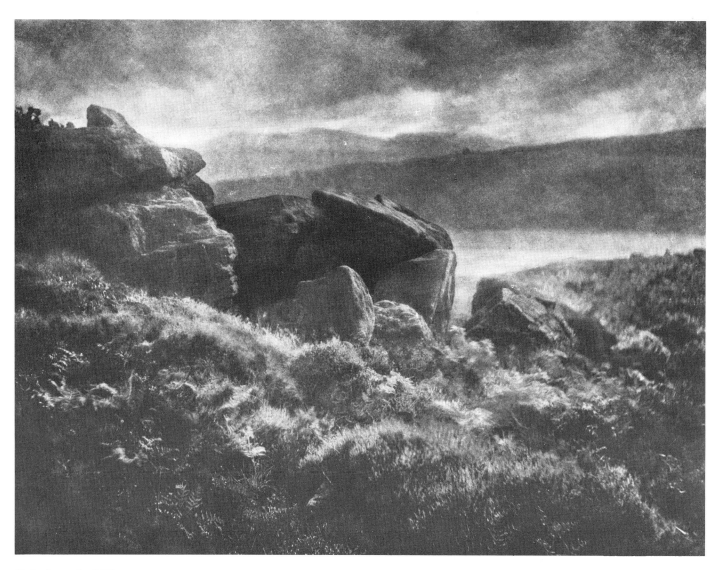

Rain from the Hills
by A. Horsley Hinton, 1904
14.5 × 19.5cm ($5\frac{1}{2}'' \times 7\frac{1}{2}''$)

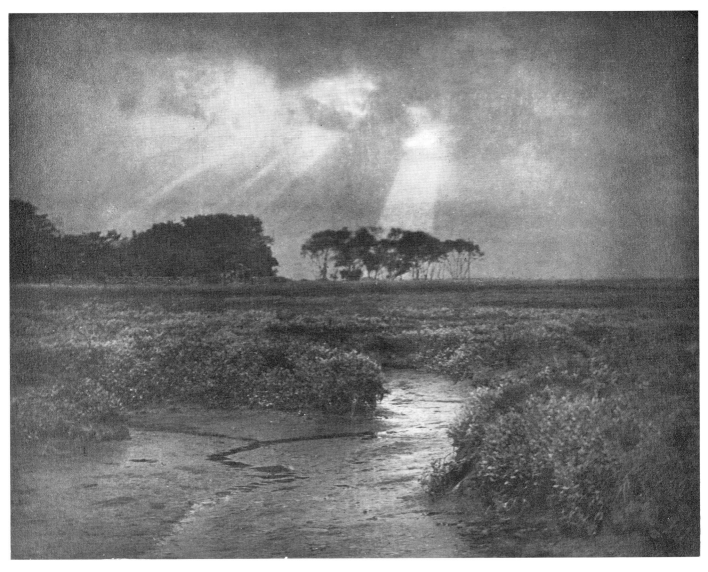

A Rift in the Clouds
by Alexander Keighley, 1898
34.5 × 45.3cm (13½″ × 17¾″)

The Passing Bell
by Alexander Keighley, 1900
58.8 × 45.5cm (23″ × 18″)

*A wealthy man, with some
knowledge of painting and much of
photographic processes, Keighley
set himself to produce
'masterpieces' that would rank
with Academy paintings.*

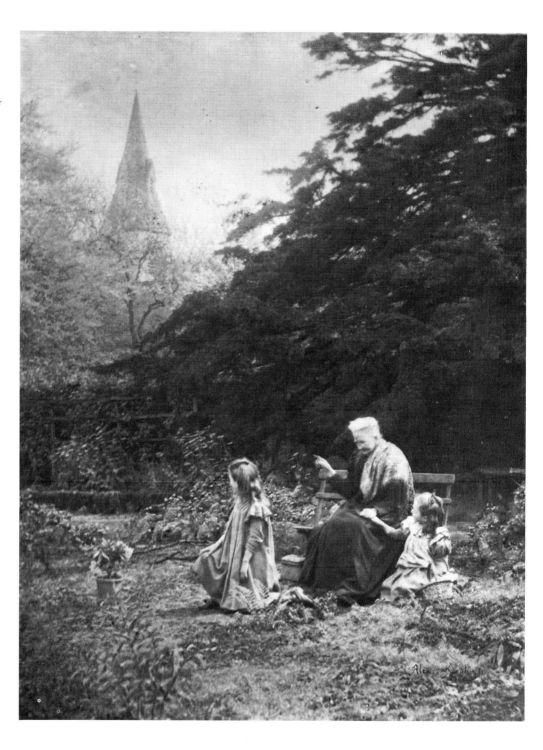

148

(Facing) *Sunflowers*
by Alexander Keighley,
c. 1900
36.1 × 24cm (14¼″ × 9½″)

*Keighley frequently brought in
foregrounds, added skies, and
touched up his photographs with
charcoal, chalk or pencil. Note
that the church towers and trees
in the background have been
reversed.*

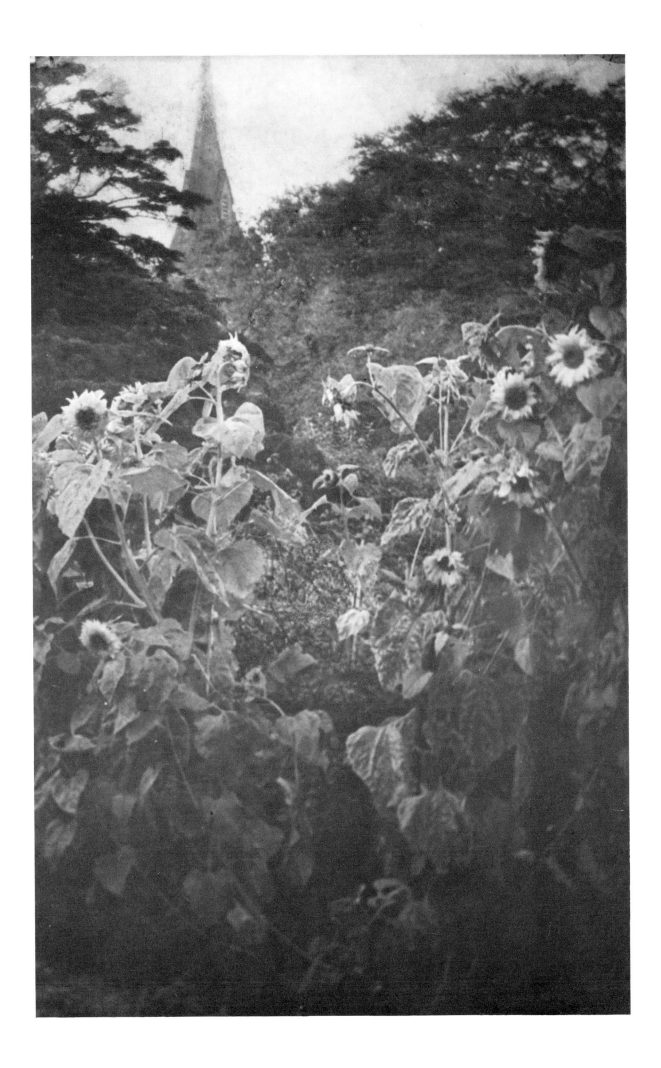

Der Tanz
by Olga von Koncz, 1914
21.6 × 16.8cm (8½" × 6½")

Rainy Weather
by Ricco Weber, 1913
22 × 15.5cm (8½″ × 6″)

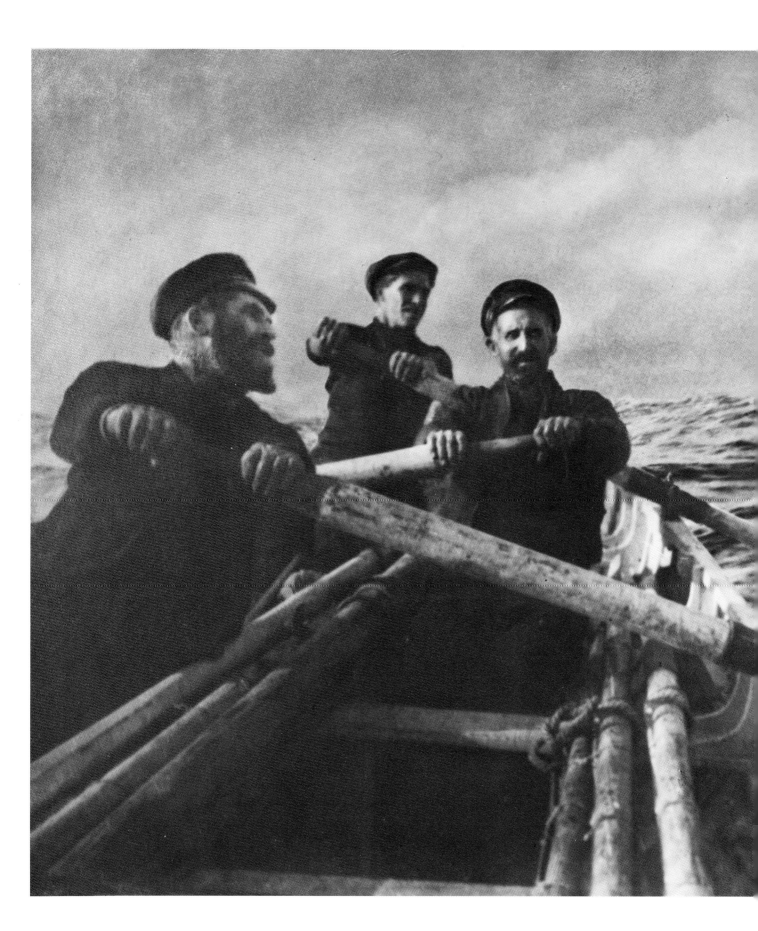

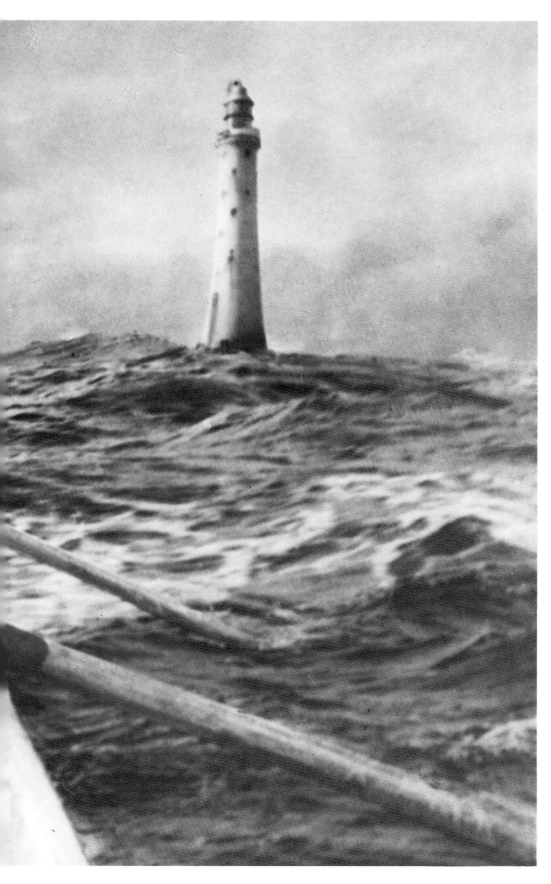

The Relief Boat
by F. J. Mortimer, 1911
29.6 × 47.6cm (11½″ × 18½″)

An ardent yachtsman, Mortimer concentrated all his photographic interest on the sea, and would build his compositions up from several negatives. He became President of The R.P.S. from 1940–2, and was killed in the bombing of London in 1944.

The Wreck
by F. J. Mortimer, 1911
36.5 × 38cm (14¼″ × 15″)

*Mortimer was present at the wreck
of the* Arden Craig *off the Scilly
Isles in 1911.*

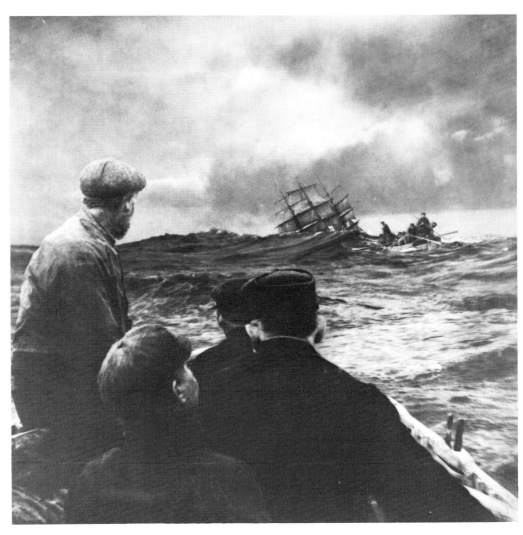

Shipwrecked
by F. J. Mortimer, 1918
32 × 47.5cm (12½″ × 18½″)

*Mortimer and his wife and
daughter in this re-creation of
survivors of the wreck of the*
Arden Craig.

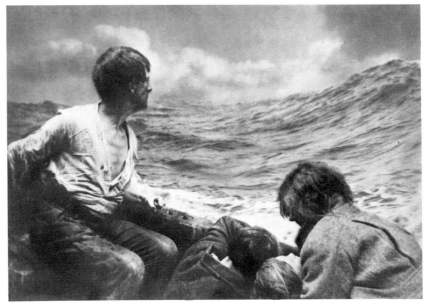

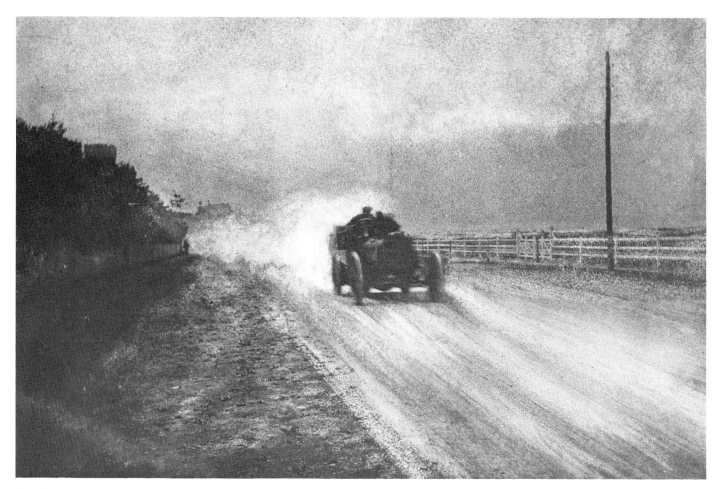

Speed
by Robert Demachy, 1906
15.3 × 23.7cm (6″ × 9¼″)

*One of the founders of the Photo
Club of Paris, Demachy was an
amateur artist who considered that
a picture should begin as an idea,
and be worked up by a variety of
techniques and processes to achieve
its complete effect.*

Deux Jeunes Filles
by Robert Demachy, 1906
Nude 16.3 × 10.5cm (6½″ × 4″)
Head 15.9 × 11.5cm (6¼″ × 4½″)

The two pictures on these pages, mounted and captioned together by Demachy, were a gift from him to The R.P.S. together with many other photographs. Demachy was a prolific writer, who produced five books and over 1,000 articles on photographic subjects.

En Bretagne
by Robert Demachy, *c.* 1904
19.9 × 27cm (7¾″ × 10½″)

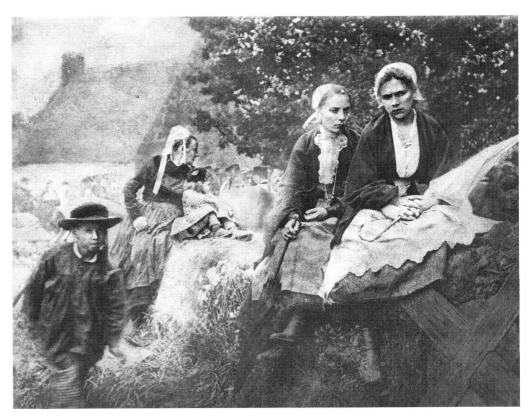

Lecture Interrompue
by Robert Demachy
17 × 20cm (6½″ × 7¾″)

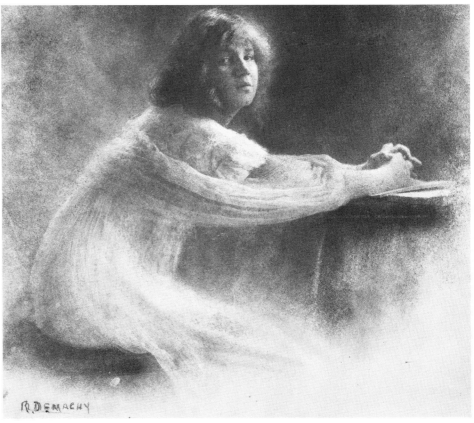

158

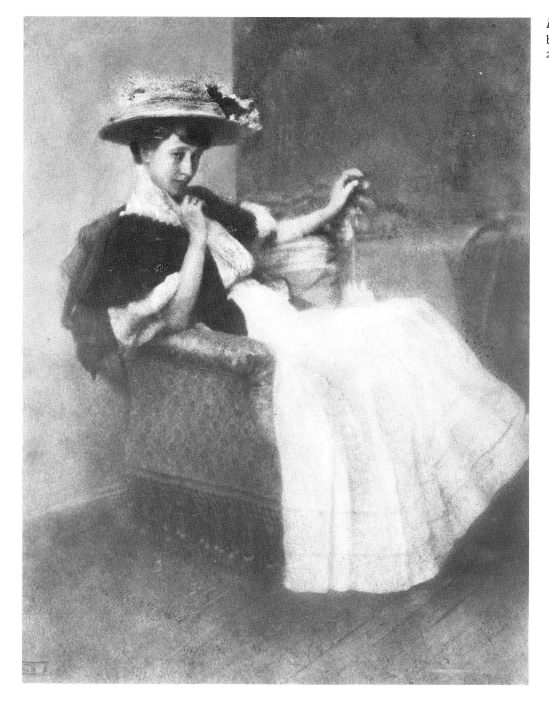

En Visite
by Robert Demachy
22.2 × 17.5cm ($8\frac{1}{2}''$ × $6\frac{3}{4}''$)

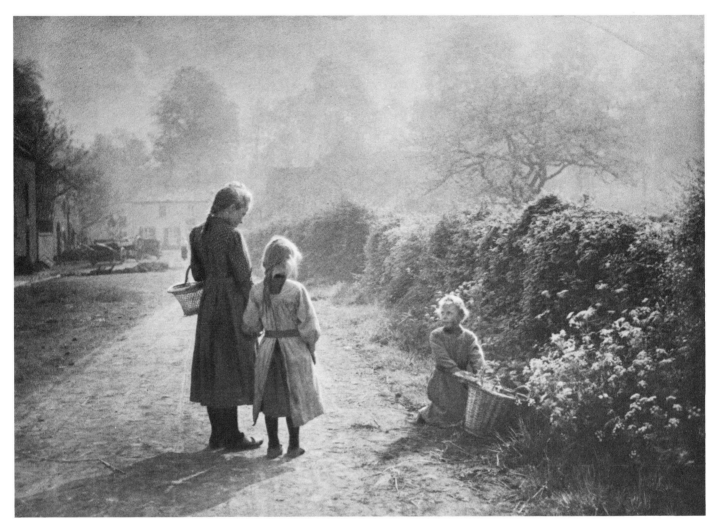

En Passant
by Léonard Misonne, 1907
26.5 × 30.9cm (10½″ × 12″)

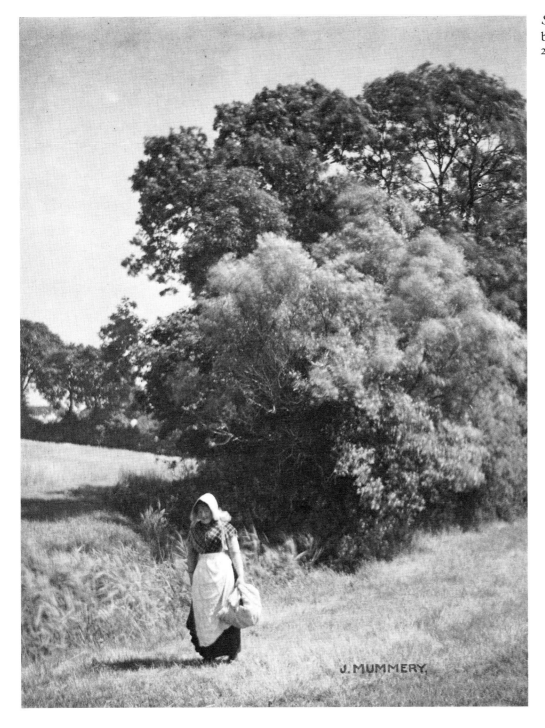

Summer Noontide
by J. C. S. Mummery, *c.* 1900
29.2 × 22.5cm (11½″ × 8¾″)

New York Central Yards
by Alfred Stieglitz, 1904
30.7 × 26cm (12″ × 10¼″)

*The work of Stieglitz soon became
almost as well-known in Britain as
in the US. In 1924 he was
awarded the Progress Medal of
The R.P.S. for services in
founding and fostering pictorial
photography in America, and for
the initiation and publication of
Camera Work, 'the most artistic
record of photography ever
published'.*

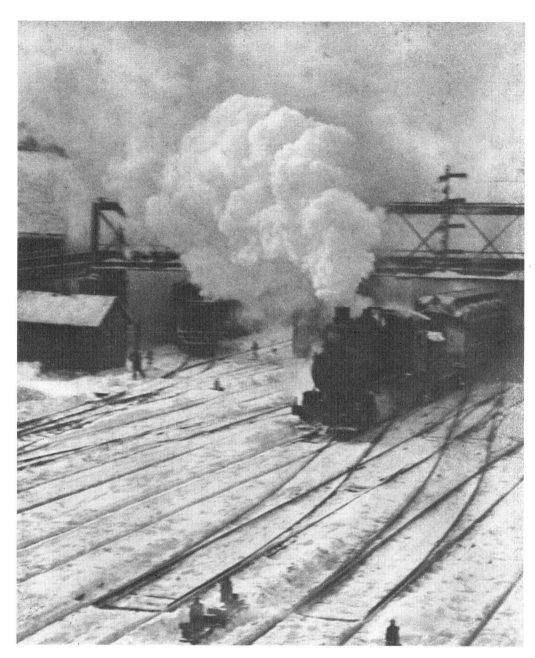

Going to the Post
by Alfred Stieglitz, 1904
30.5 × 26.5cm (12″ × 10½″)

Paris
by Alfred Stieglitz, 1911
13.5 × 17cm (5¼″ × 6½″)

A Snapshot; Paris
by Alfred Stieglitz, 1911
13.5 × 17cm (5¼″ × 6½″)

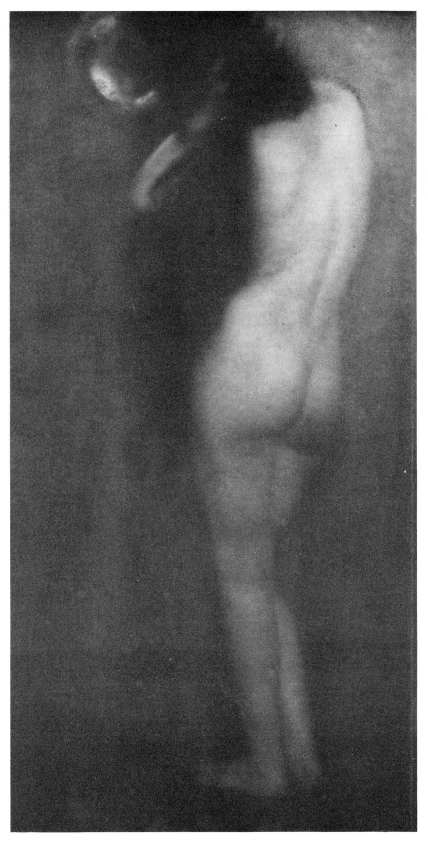

The Little Round Mirror
by Edward J. Steichen, 1904
40.5 × 21 cm (16″ × 8¼″)

*A painter and lithographer,
Steichen's early work shows the
influence of this training. His later
photography was largely
commercial and journalistic.
He devoted much time to
organisational activities, and
became Director of the Department
of Photography for the Museum of
Modern Art, New York,
1947–62.*

At the Piano
by Edward J. Steichen,
1900–3
15 × 17.5cm (6″ × 6¾″)

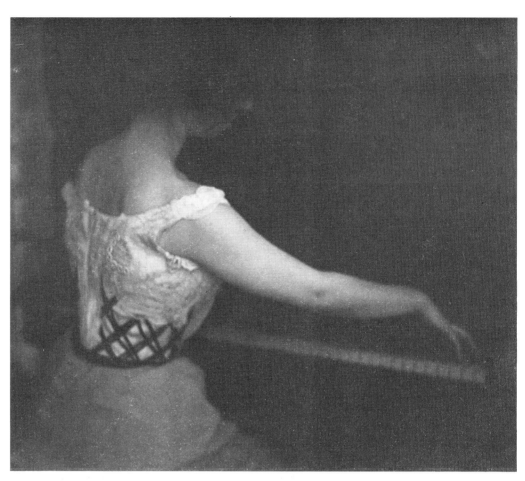

La Rose
by Edward J. Steichen
14.7 × 13.2cm (5½″ × 5″)

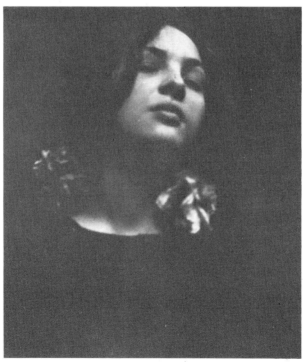

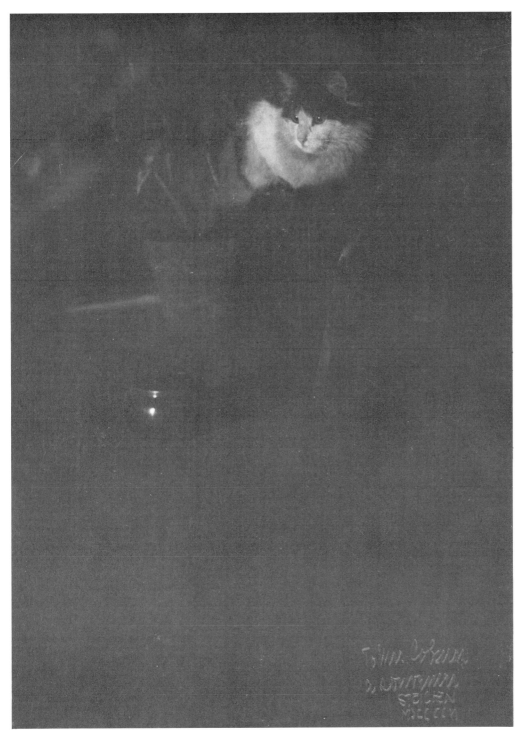

The Cat
by Edward J. Steichen, 1902
20.2 × 15cm (8″ × 6″)

*A number of Steichen's early
pictures were presented to The
R.P.S. by F. H. Evans, and others
by A. L. Coburn. This print is
inscribed in pencil 'To
Mrs Coburn, a souvenir, Steichen,
1902'.*

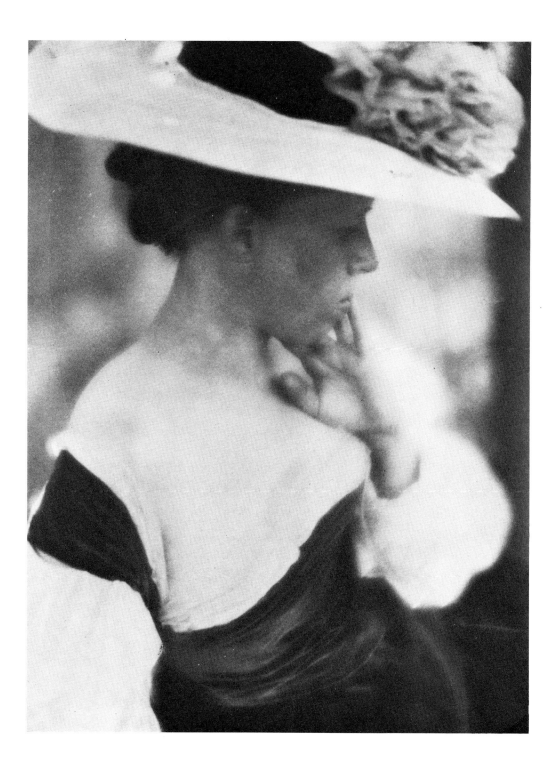

168

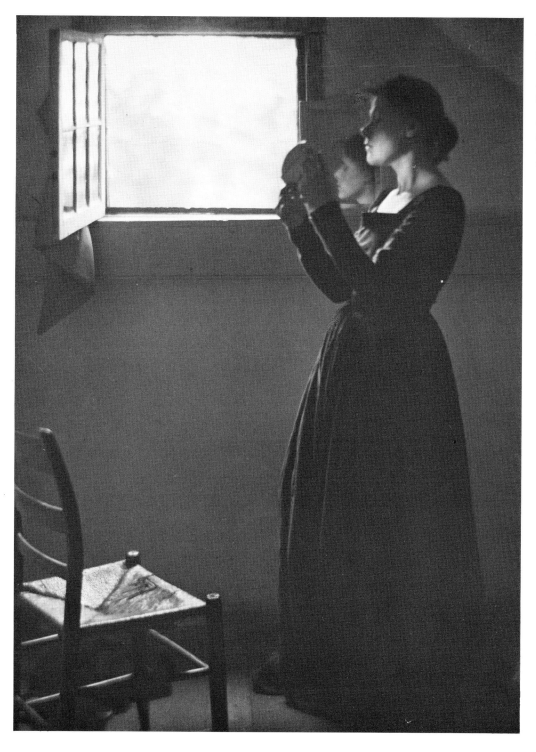

The Mirror
by Clarence H. White, 1912
24.3 × 18cm ($9\frac{1}{2}'' \times 7''$)

*A book-keeper who took up
photography in his early twenties,
White had achieved international
recognition within five years. He
later became first President of the
Pictorial Photographers of
America.*

Semi-nude Figure
by Clarence H. White, 1910
23 × 16.5cm (9″ × 6½″)

*His pictures, often taken against
the light, invest everyday
surroundings with a poetic charm
and sense of mystery.*

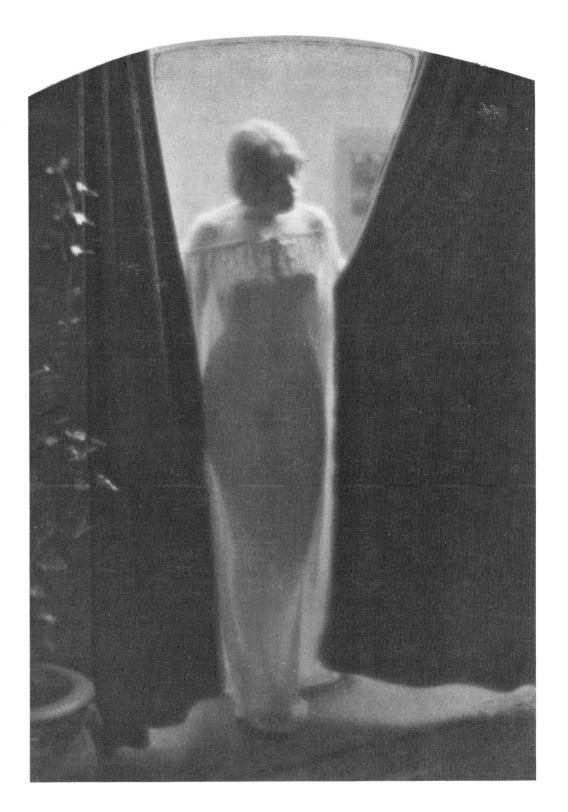

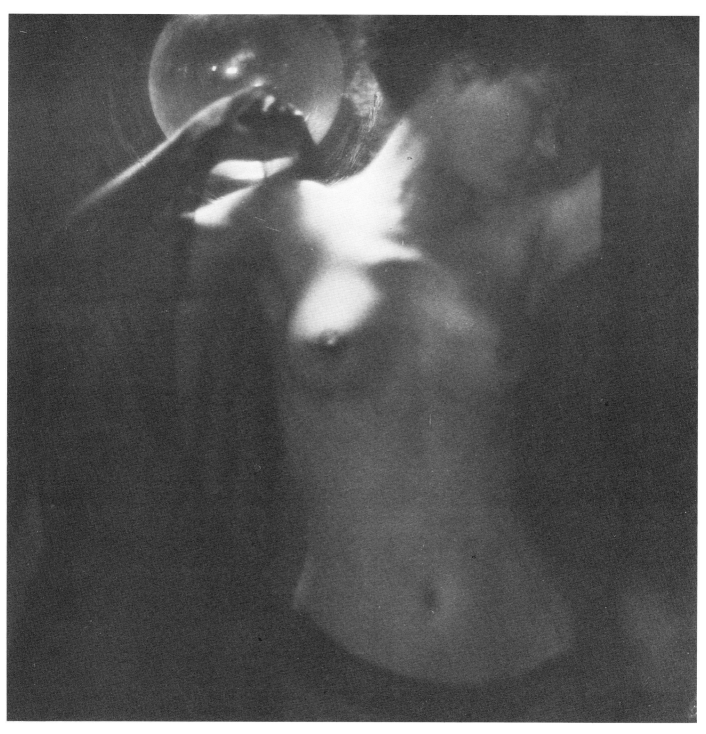

Torso
by Clarence H. White, 1906
17.5 × 18cm (6¾″ × 7″)

Girl in a Flowered Dress
by Clarence H. White, *c.* 1910
19.5 × 11.7cm (7½″ × 4½″)

The Letter
by Gertrude Käsebier, *c.* 1905
20.6 × 15.5cm (8″ × 6″)

*Gertrude Käsebier was another of
those who transferred their artistic
interest from painting to
photography. She was the first
woman elected to The Linked
Ring, and one of only two women
among the founders of the Photo-
Secession.*

A Girl's Head
by Gertrude Käsebier
20.5 × 15.5cm (8″ × 6″)

One of 'The Seven Last Words'
by F. Holland Day, 1898
24.2 × 19.8cm ($9\frac{1}{2}'' \times 7\frac{1}{2}''$)

Holland Day's re-staging of the crucifixion, with a large caste, himself as central figure and every detail meticulously researched, was the most sensational episode in the life of this wealthy eccentric.

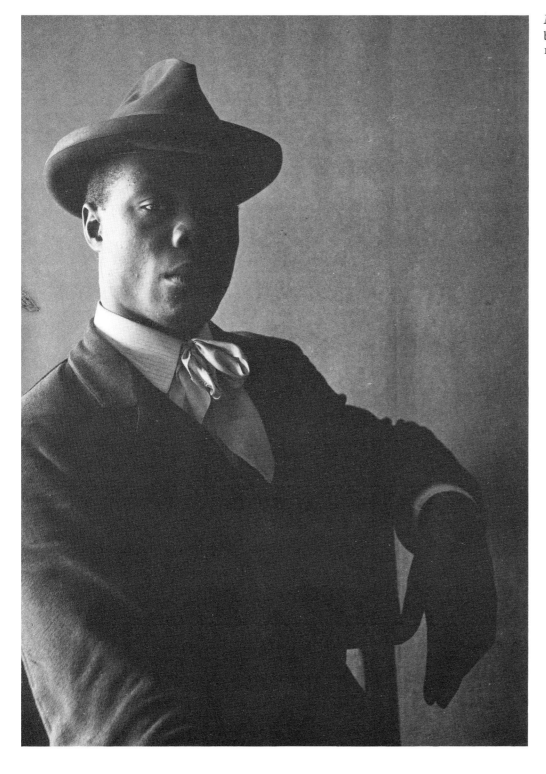

Negro with Hat
by F. Holland Day, *c.* 1900
15.2 × 11cm (6″ × 4¼″)

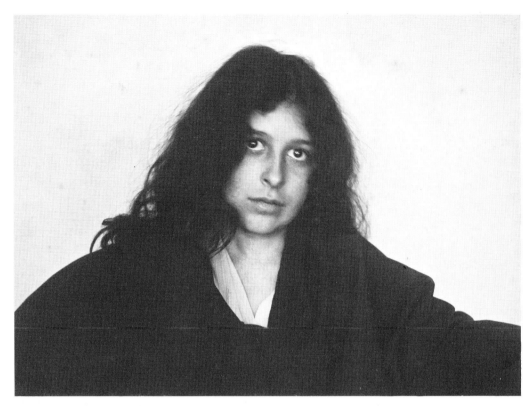

Pepita
by F. Holland Day, *c.* 1900
12 × 16.5cm (4½″ × 6½″)

Ebony
by F. Holland Day, 1899
20 × 13cm (7¾″ × 5″)

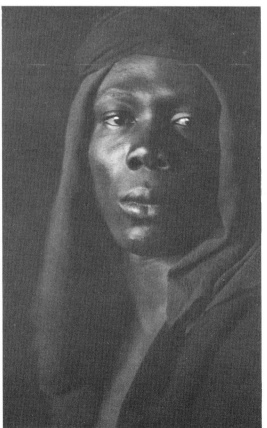

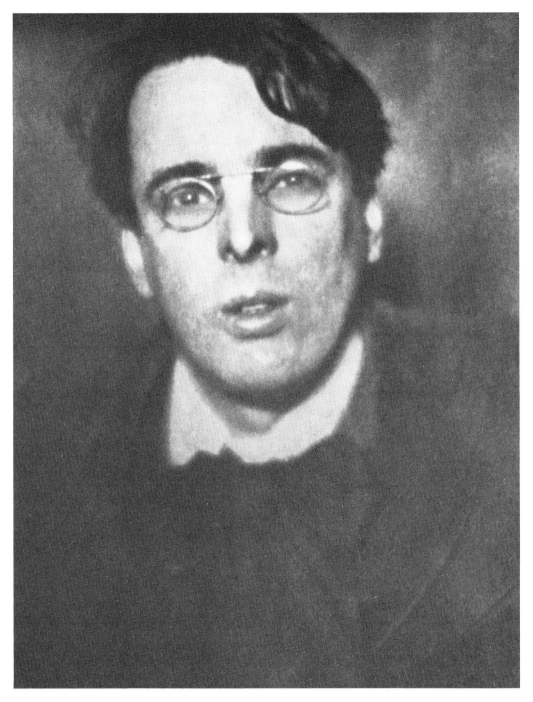

W. B. Yeats
by Alvin Langdon Coburn
20.3 × 16cm (8″ × 6¼″)

*Coburn had studied and been
deeply influenced by the economy
and the poetic feeling in Japanese
art, which he expressed both in
townscapes and portraits. For his
two books* Men of Mark *(1913)
and* More Men of Mark *(1922),
he produced revealing impressions
of the literary and artistic figures
of his day.*

G. K. Chesterton
by Alvin Langdon Coburn
20.2 × 16cm (8″ × 6¼″)

George Moore
by Alvin Langdon Coburn
20.3 × 16cm (8″ × 6¼″)

Waterloo Bridge
by Alvin Langdon Coburn, *c*. 1905
20.4 × 16cm (8″ × 6¼″)

Paddington Canal
by Alvin Langdon Coburn, 1910
20.6 × 16cm (8″ × 6¼″)

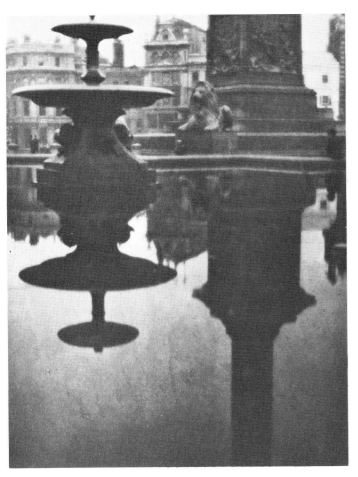

Trafalgar Square
by Alvin Langdon Coburn, 1910
21 × 16cm (8¼″ × 6¼″)

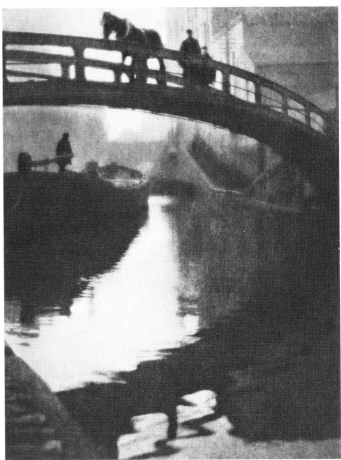

Regent's Canal
by Alvin Langdon Coburn, *c.* 1905
20.5 × 16cm (8″ × 6¼″)

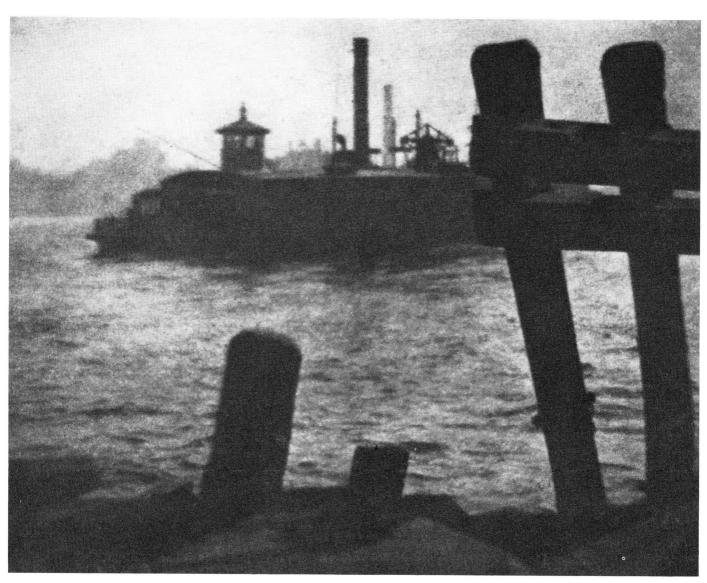

New York Ferries
by Alvin Langdon Coburn,
1910–12
13.5 × 17.5cm (5¼″ × 6¾″)

In his glimpses of London and New York, Coburn produced luminous images of quiet beauty, which also remain true to the differing characters of the two cities.

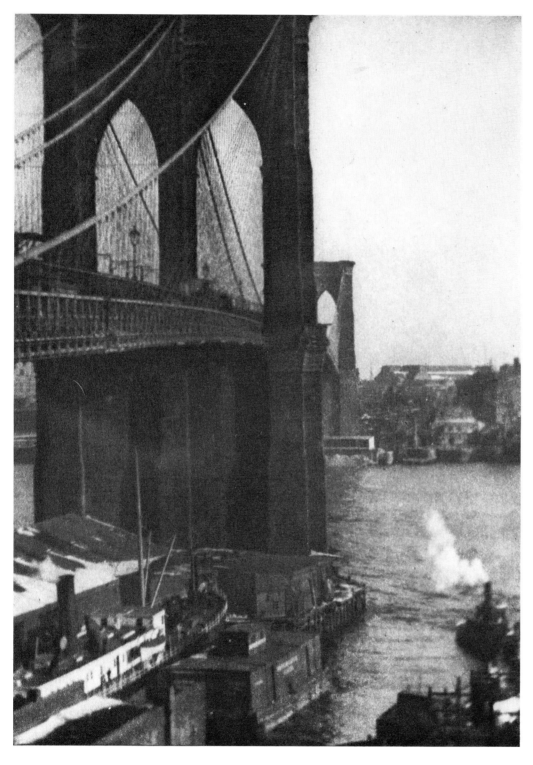

Brooklyn Bridge
by Alvin Langdon Coburn,
1910–12
20 × 14.2cm ($7\frac{3}{4}'' \times 5\frac{1}{2}''$)

In 1930 Coburn, who had settled in
Wales, made over to The R.P.S.
his personal collection of over 500
prints and autochromes, as well as
much rare equipment.

To Absent Friends
by John B. B. Wellington
28.6 × 28.7cm ($11\frac{1}{4}''$ × $11\frac{1}{4}''$)

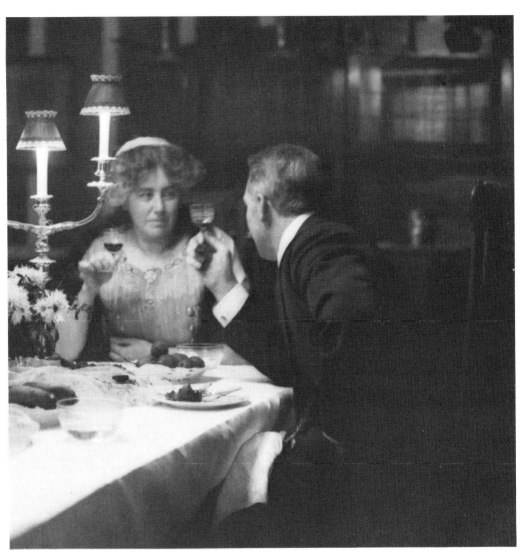

On the Sea Shore
by John B. B. Wellington
26 × 35cm ($10\frac{1}{4}''$ × $13\frac{1}{2}''$)

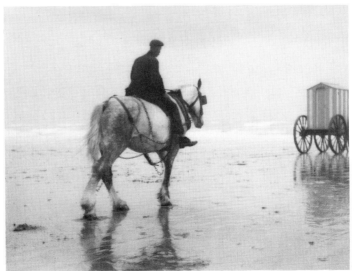

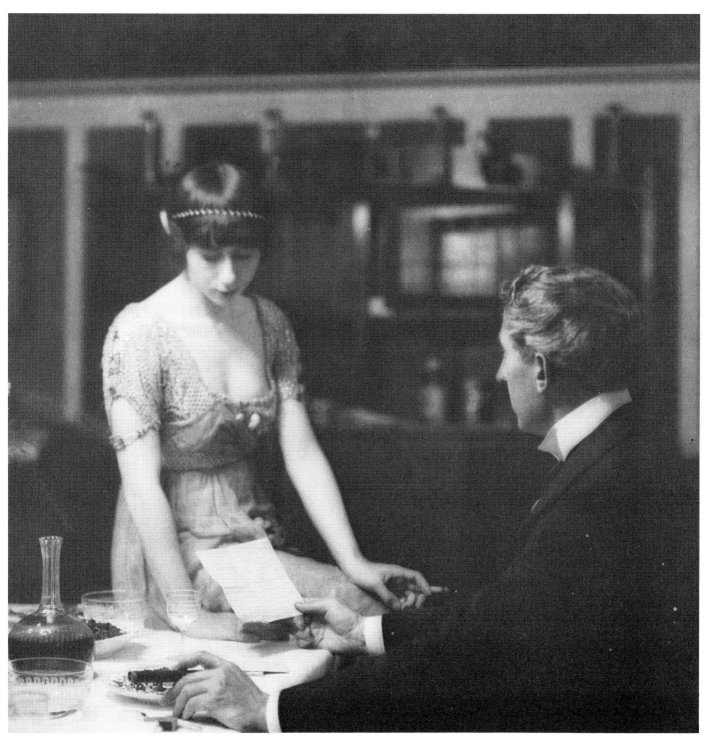

The Letter
by John B. B. Wellington,
1915
28 × 28cm (11″ × 11″)

*Wellington's interests lay in
pictorial photography. His
carefully staged tableaux suggest
scenes from an Edwardian comedy
of manners rather than
photographs from life.*

Refreshing Moments
by John B. B. Wellington,
1925
33.5 × 25.5cm (13″ × 10″)

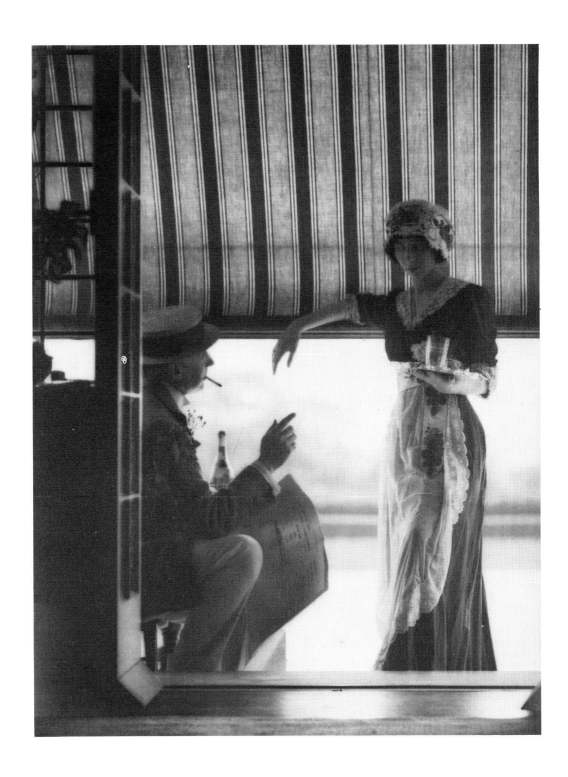

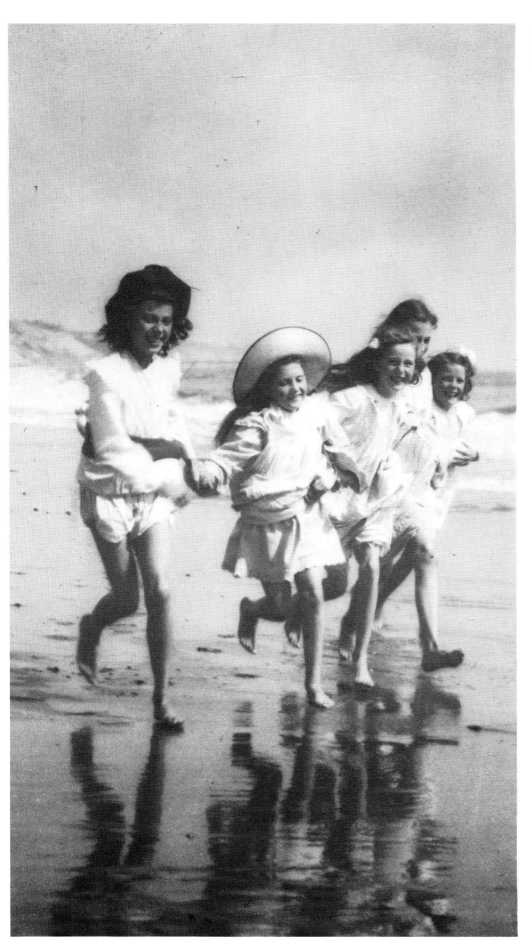

Sea Urchins
by John B. B. Wellington
33×19cm ($13'' \times 7\frac{1}{2}''$)

The Artist and His Model
by Richard Polak, 1914
21 × 17cm (8¼″ × 6½″)

In order to reproduce the effects of a particular period in Dutch painting, Polak bought a house in Rotterdam, furnishing it with seventeenth-century furniture and props of every kind. Here he staged a whole series of similar scenes.

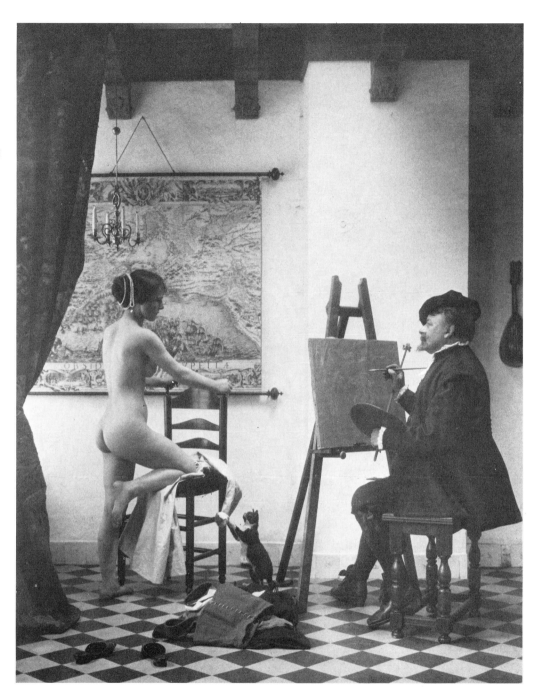

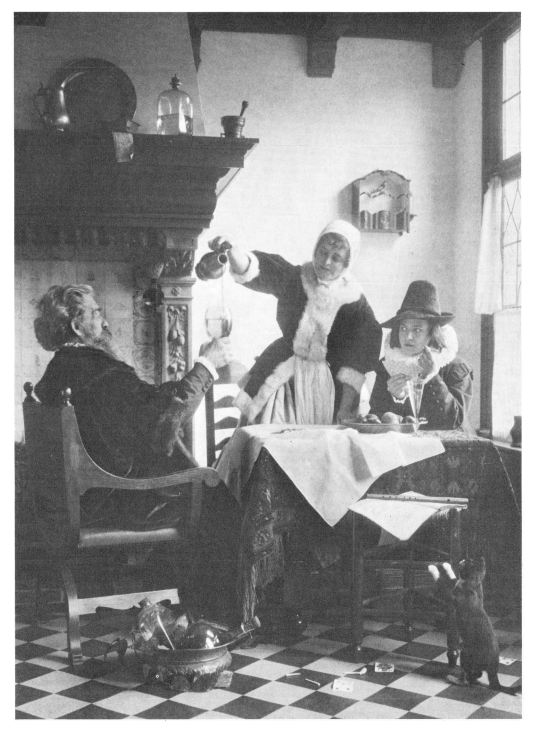

Merry Company
by Richard Polak, 1913
22.7 × 17cm (9″ × 6½″)

For three years Polak worked as though obsessed and, before retiring to Switzerland through ill-health, had produced enough prints to form a portfolio which was published in 1923.

The Pearl Necklace
by Richard Polak, 1913
21.6 × 16.2cm ($8\frac{1}{2}'' × 6\frac{1}{4}''$)

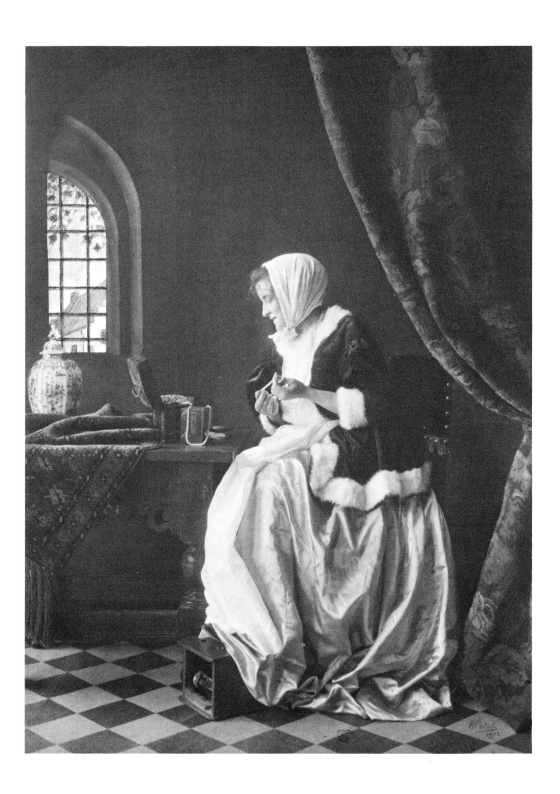

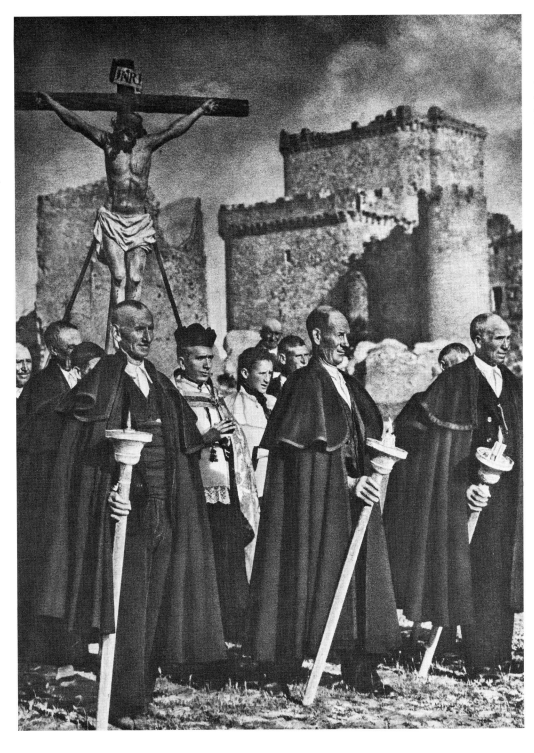

Procession in Turegano
by J. O. Echagüe, *c.* 1900
47.2 × 34.7cm (18½″ × 13½″)

*An army engineer and balloon
pilot, Echagüe's earliest
photographic work was made for
military purposes. Later he
concentrated on the life and
religious ceremonials of the
Spanish countryside.*

Où sont les Neiges d'Antan?
by Agnes B. Warburg
29.2 × 26cm ($11\frac{1}{2}'' \times 10\frac{1}{4}''$)

The Long Sermon
by T. Lee Syms, 1907
19.2 × 14.5cm (7½″ × 5½″)

The Answer
by T. Lee Syms, 1906
20.2 × 14.8cm (8″ × 5¾″)

Olga, the Baroness de Meyer
by Baron G. de Meyer
27.5 × 13.2cm (10$\frac{3}{4}$″ × 5$\frac{1}{4}$″)

A London Pattern
by Ward Muir, 1916
35.7 × 21.1cm (14″ × 8¼″)

197

Street Scene
by Camille Silvy, 1860
14 × 11 cm (5½″ × 4¼″)

*One of comparatively few early
documentary prints in The R.P.S.
Collection.*

On the Brink
by Oxley Grabham, 1908
9.5 × 7.5cm ($3\frac{1}{2}'' × 3''$)

As Curator of the York Museum from 1905,
Grabham photographed much of the disappearing
life of the countryside and the sea coast.
The purpose of the descent was practical – to secure
quantities of gulls' eggs for food.

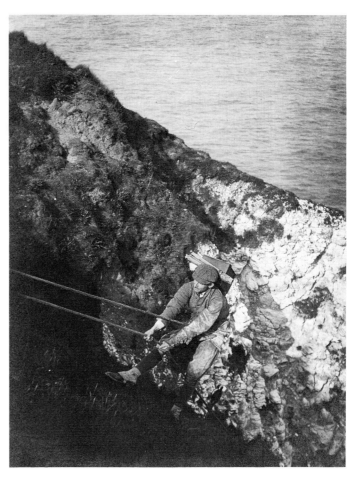

Cliff Descent
by Oxley Grabham, 1908
21.5 × 15.7cm ($8\frac{1}{2}'' × 6''$)

Arrival of the Bears
by Oxley Grabham, 1910
7.3 × 9.1cm (2¾″ × 3½″)

*At this period, the visit of a
dancing bear, often with Spanish
or Italian keepers, made a rare
diversion in the life of an English
village.*

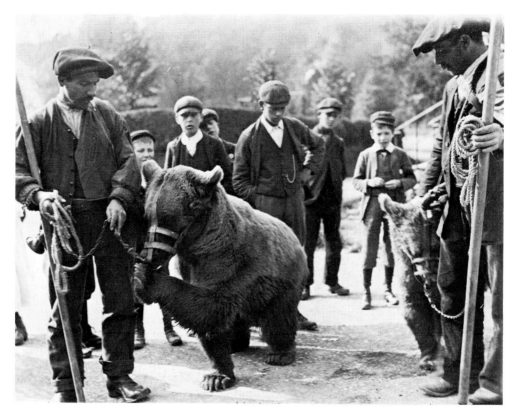

Bear with Keepers
by Oxley Grabham, 1910
7.5 × 9.9cm (3″ × 4″)

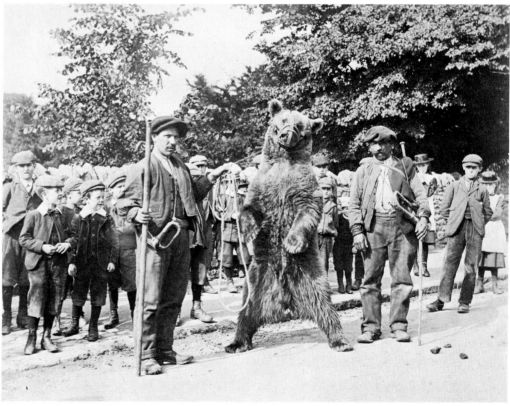

200

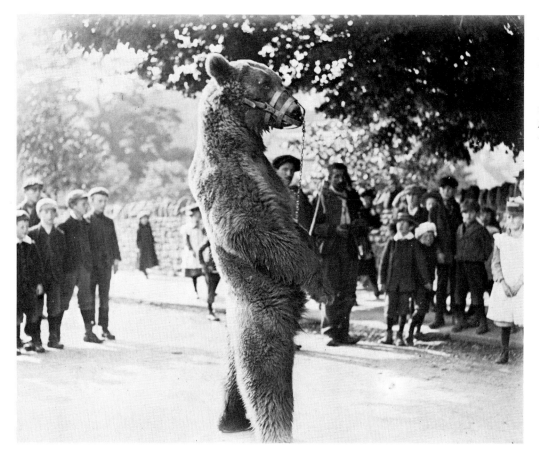

*The Dancing Bear's
Performance*
by Oxley Grabham, 1910
7.5 × 10cm (3″ × 4″)

*Shuffling, swinging its head and
rising on its hind legs, the bear
performs its 'Dance', and the
keepers take a collection.*

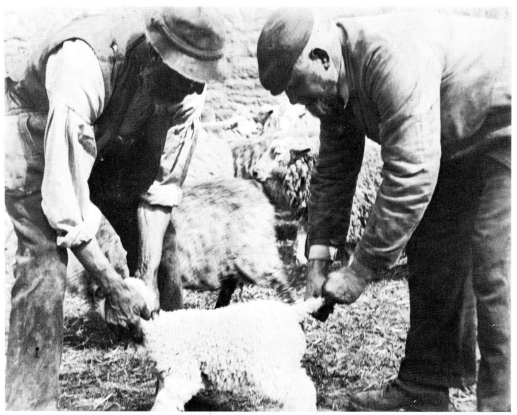

Cutting Lambs' Tails
by Oxley Grabham
7.5 × 10cm (3″ × 4″)

The Fire Brigade, Pickering
by Oxley Grabham, 1910
7.5 × 10cm (3″ × 4″)

*The appliance was drawn by
horses, manned by local worthies,
and had to take on water from a
pond or river.*

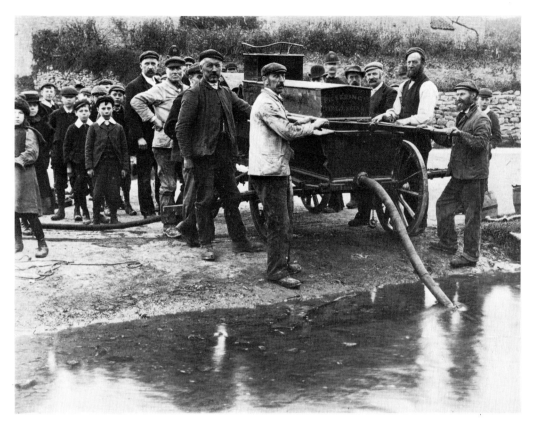

*Broom Making, Splitting the
Ash*
by Oxley Grabham
7.5 × 9.8cm (3″ × 4″)

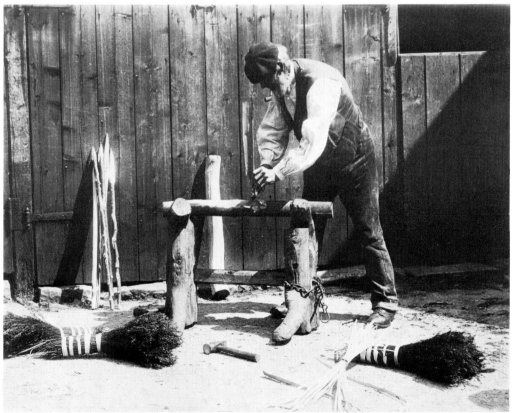

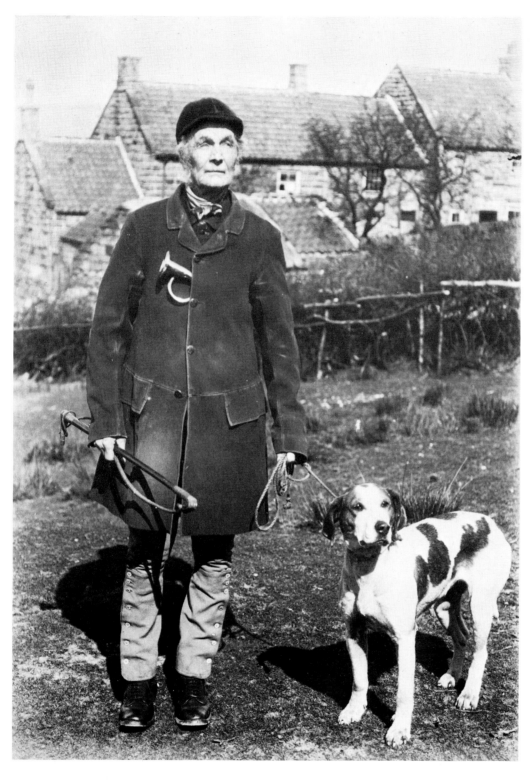

The Postman Calls
by Oxley Grabham, *c.* 1910
9.8 × 7.1 cm (3¾″ × 2¾″)

*Tommy Metcalfe, the postman,
calls on Mrs Maville. Grabham,
whose photographs have only
become known in recent years, has
left precious glimpses of village life
as well as of the costumes and
uniforms of his day.*

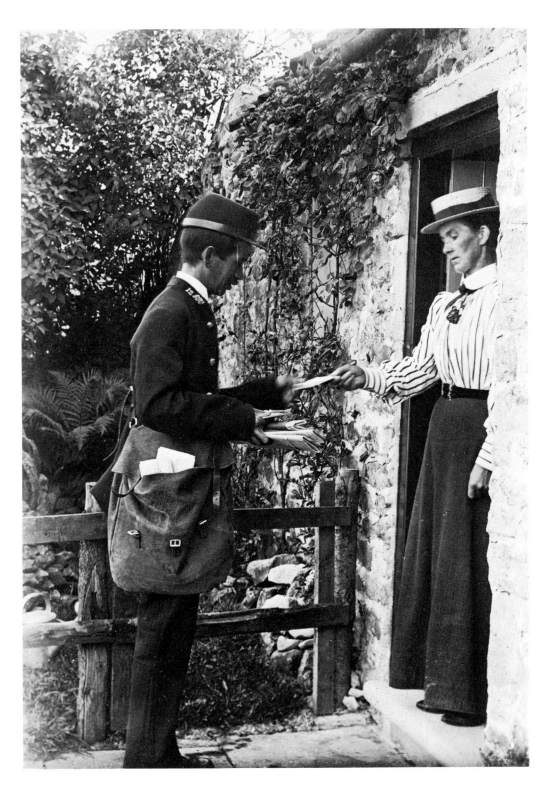

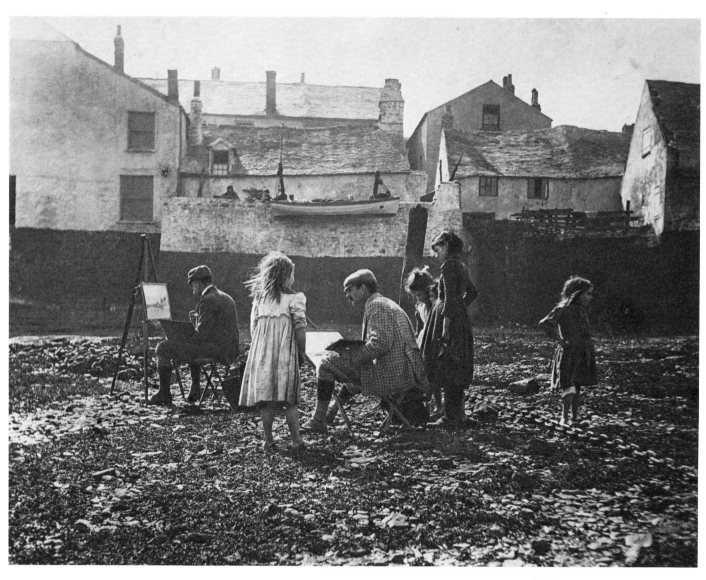

Critics
by Paul Martin
21.5 × 28cm (8½″ × 11″)

Camping Out in Quarry Woods
by Paul Martin, *c.* 1888
15.5 × 20.7cm (6″ × 7¾″)

Sometimes called 'the first candid cameraman', Martin often worked with a concealed camera, taking pictures of London street life during the week and going further afield at the weekends.

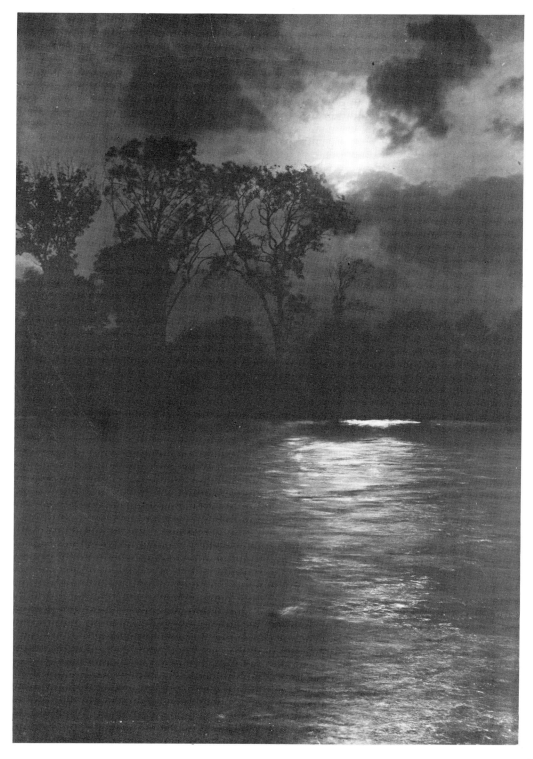

Nocturne on the Thames
by Paul Martin
21 × 15.2cm (8¼″ × 6″)

The R.P.S. possesses many of Martin's own prints, and was lately given a large quantity of his negatives. As early as 1896 the Society held an exhibition of his 'London by Gaslight' photographs.

*Ladysmith after Nicholson's
Nek*
by Horace W. Nicholls,
30 October 1899
28.5 × 44cm (11¼″ × 17¼″)

*Trained as a young man in
photography, Nicholls went out to
Johannesburg in 1892 and got to
know much of the country. During
the years 1899–1902, he made a
magnificent record of the South
African War.*

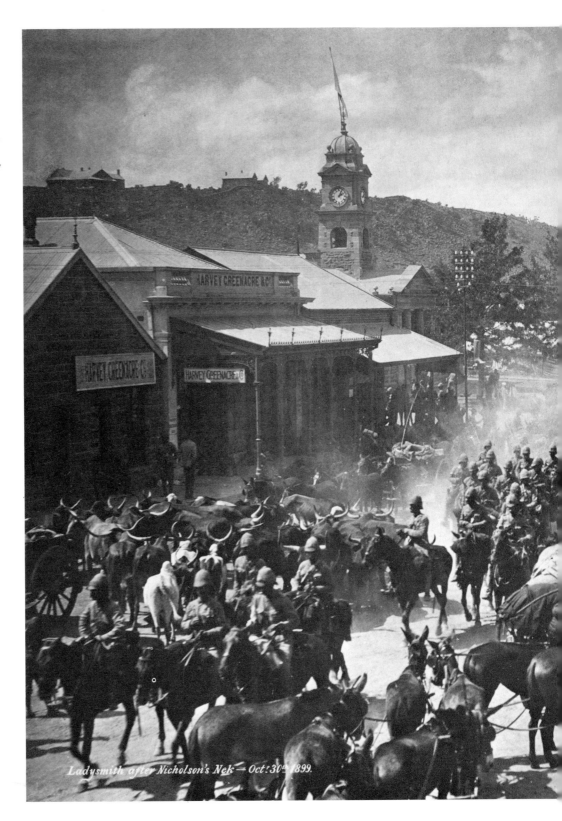

Ladysmith after Nicholson's Nek — Oct! 30ᵗʰ 1899.

208

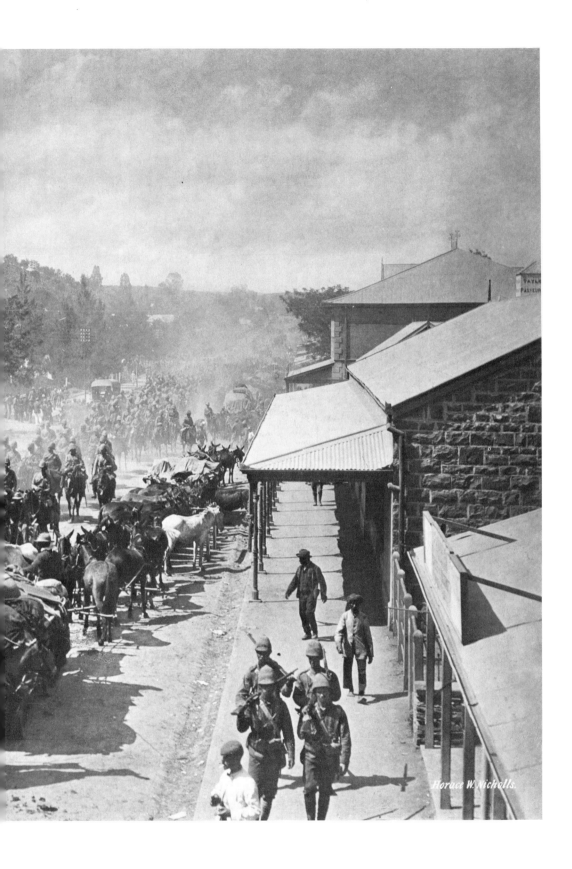

Horace W. Nicholls.

209

Lord Kitchener on Horseback
by Horace W. Nicholls,
c. 1900
19 × 14.9cm (7½″ × 5¾″)

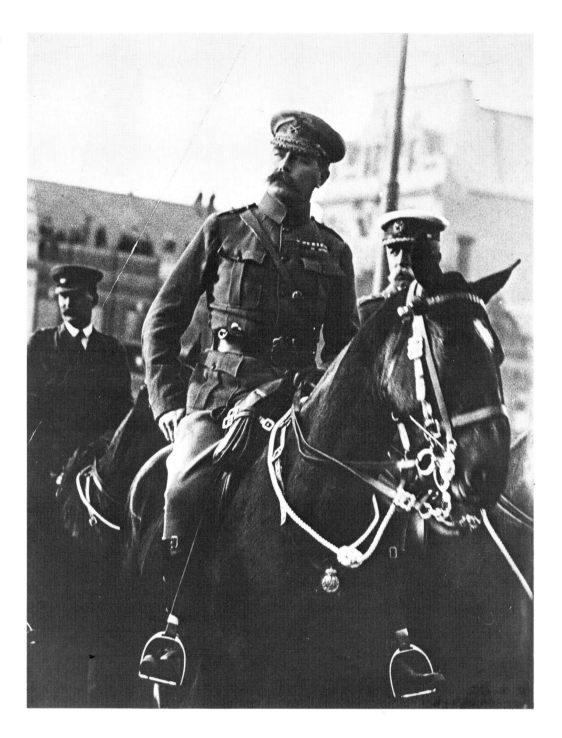

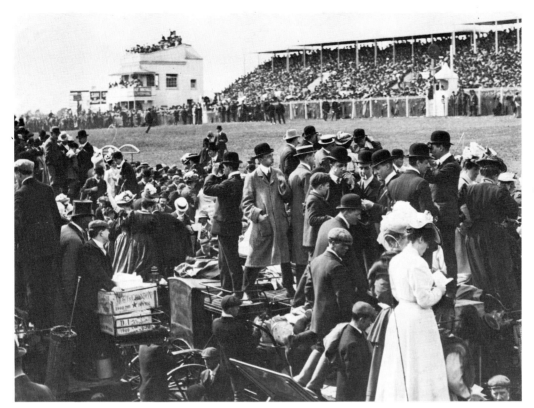

Derby Day
by Horace W. Nicholls,
c. 1910
15.5 × 21cm (7½″ × 8¼″)

In the years shortly before World War I, Nicholls photographed many of the great British sporting occasions such as Henley, Ascot and the Derby. A professional newsman, he would sometimes build up similar elements into different pictorial compositions to appeal to his varied newspaper and magazine clients.

Derby Excitement
by Horace W. Nicholls
8.5 × 11cm (3¼″ × 4¼″)

The Fortune Teller
by Horace W. Nicholls, 1910
24.5 × 20cm (9¼″ × 7¾″)

Derby Day Luncheon Party
by Horace W. Nicholls
29 × 36.5cm (11½″ × 14¼″)

Women Tarring a London Street
by Horace W. Nicholls,
c. 1916
7.2 × 10cm (2¾″ × 4″)

During the 1914–18 War,
Nicholls worked for the Ministry
of Information, making a notable
series to show the different forms of
war work taken on by women.

Woman Chimney Sweep
by Horace W. Nicholls,
c. 1916
9.7 × 7.2cm (3¾″ × 2¾″)

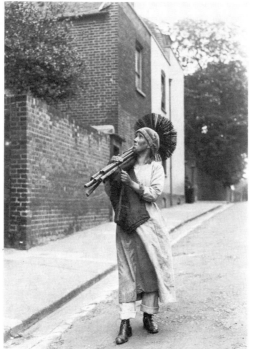

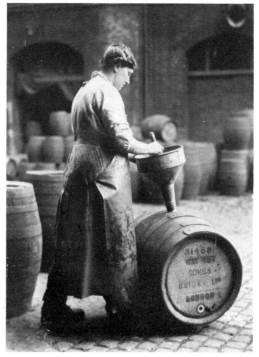

A Woman Brewer
by Horace W. Nicholls,
c. 1916
9.7 × 7.2cm (3¾″ × 2¾″)

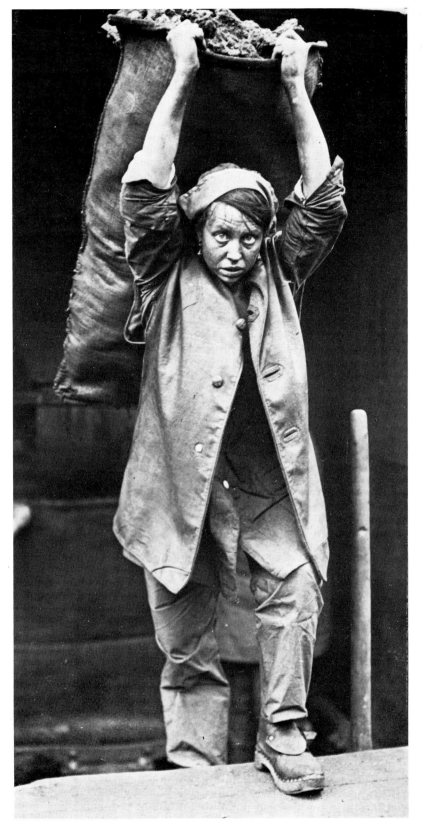

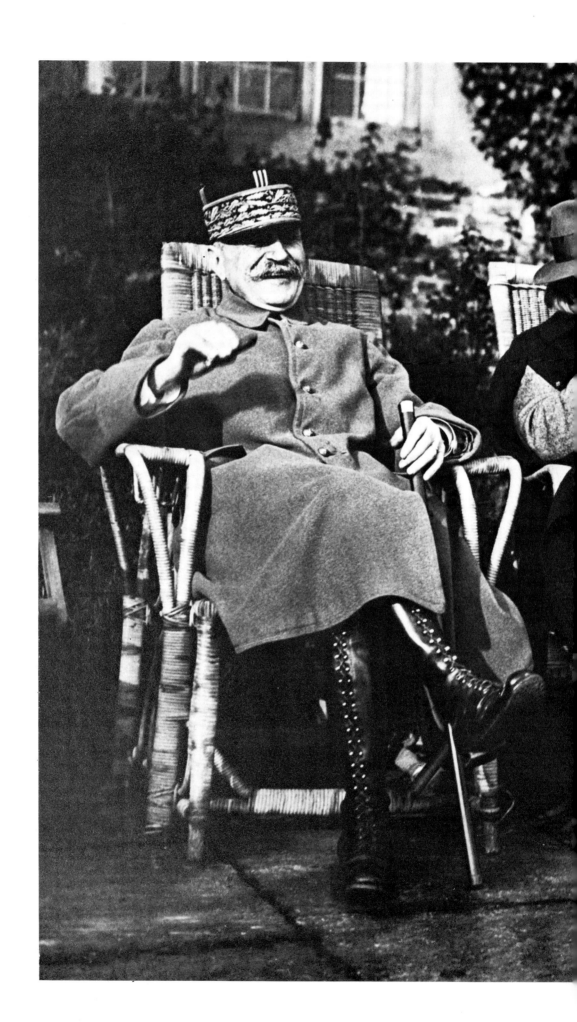

Marshal Foch, Lloyd George and Aristide Briand at Chequers
by James Jarché, 1919
38.8 × 49.5cm (15¼″ × 19½″)

Jarché was a Fleet Street newspaper photographer, who took up the miniature camera in the 1930s, and became a successful photo-journalist working for magazines. He lectured widely on photography, and published an autobiography, People I Have Shot.

*Winston Churchill at the Siege
of Sidney Street*
by James Jarché, 1911
40 × 51cm (15½″ × 20″)

*The heavy retouching considered
necessary at this date on newspaper
photographs has been left unaltered
on the print.*

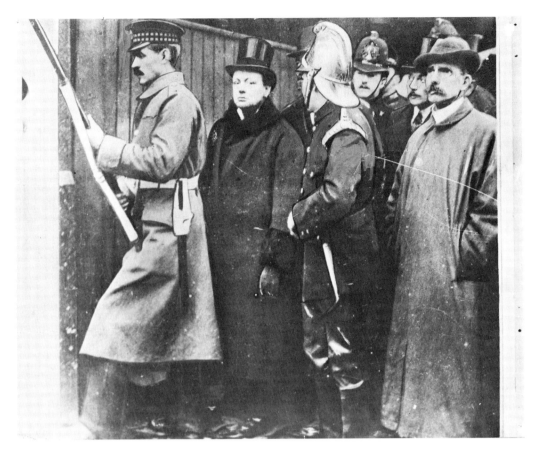

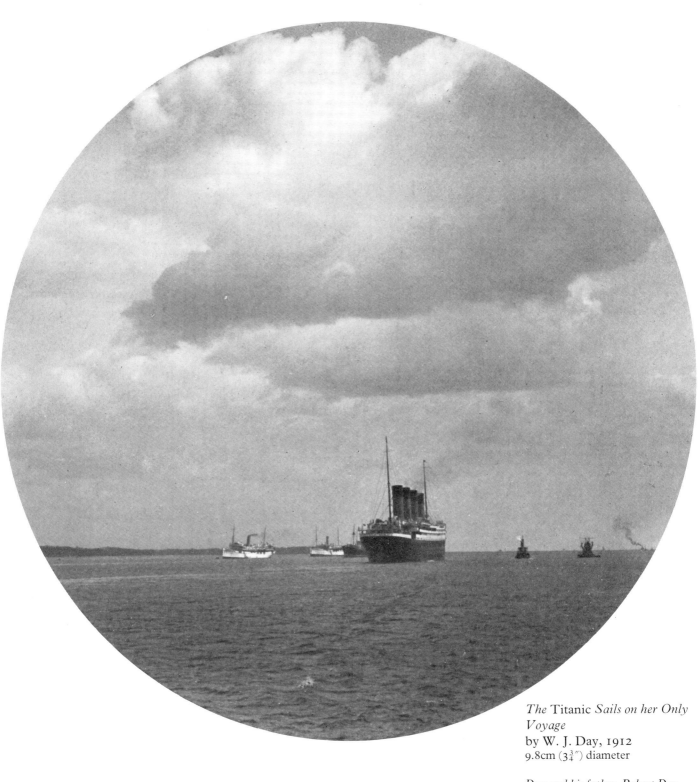

The Titanic *Sails on her Only
Voyage*
by W. J. Day, 1912
9.8cm (3¾″) diameter

*Day and his father, Robert Day,
operated in the same part of the
south coast of England for almost a
century. W. J. Day made many
fine pictures of country and seaside
scenes.*

Girls on the Beach
by W. J. Day, 1910
11 × 17.5cm (4¼″ × 7″)

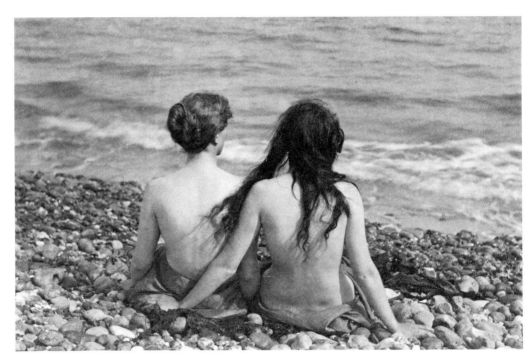

Mending the Quay Wall, Poole
by W. J. Day
10.8 × 15.1cm (4¼″ × 6″)

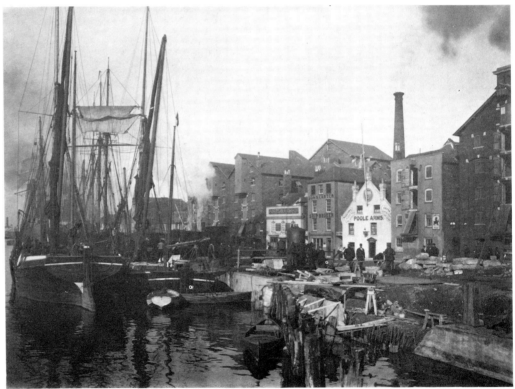

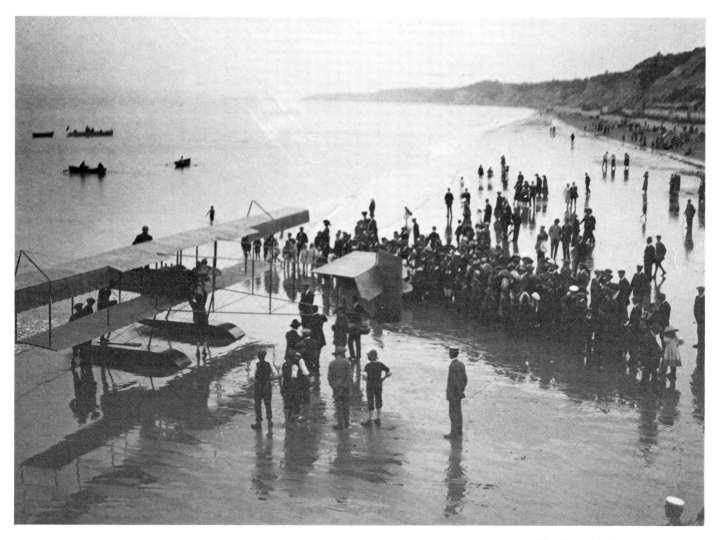

The First Hydroplane at
Bournemouth
by W. J. Day, 1912
10.8×15.2cm ($4\frac{1}{4}'' \times 6''$)